PHANTOMS *of the* HUDSON VALLEY

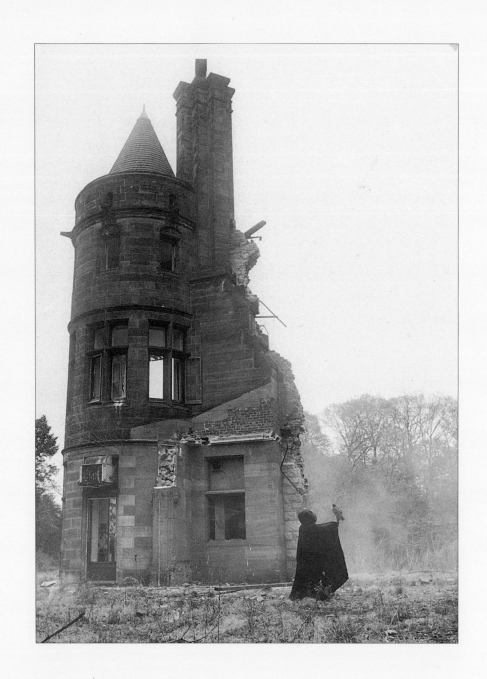

PHANTOMS *of the* HUDSON VALLEY

The Glorious Estates of a Lost Era

Monica Randall

THE OVERLOOK PRESS

WOODSTOCK · NEW YORK

This book is dedicated in loving memory to:
Miss Daisy Suckley and Mr. Alfred Mills

First published in 1995 by
The Overlook Press
Lewis Hollow Road
Woodstock, New York 12498

Library of Congress Cataloging-in-Publication Data

Randall, Monica.
Phantoms of the Hudson Valley : the glorious estates of a lost era / Monica Randall.
p. cm.
1. Architectural photography—Hudson River Valley (N.Y. and N.J.)
2. Mansions—Hudson River Valley (N.Y. and N.J.)—Pictorial works.
3. Randall, Monica. I. Title.
TR659.R36 1995 95-10990 779'.47473'092—dc20
ISBN 0-87951-617-8
Type formatting and layout by Bernard Schleifer Company
FIRST EDITION
Printed in China

3 5 7 9 8 6 4 2

CONTENTS

AUTHOR'S NOTE

Growing up on Long Island, I spent my childhood painting and photographing what remained of the great Gold Coast estates that stood along the rocky shores of Long Island Sound. With the coming of development housing, bulldozers destroyed all but a few of them. Feeling a great loss, I began to search elsewhere for inspiration, and finally turned my camera on the Hudson Valley.

What I discovered surpassed my wildest dreams, for here was a visual world worthy of Edgar Allan Poe. There were poetic secrets at every turn: back stairs leading to deserted attics, hidden passageways, and faded love letters tucked away in old steamer trunks. One crumbling old mansion housed the ghosts of five murdered virgins. They had been buried in a musty basement, and their killer's bones had been found some time later, walled up in an unused fireplace.

Many of these castles have remained vacant, untouched and unchanged, for over two hundred years. These seemed the most fascinating, for in their derelict condition they were no more than grim specters of what they had once been; vines reigned over their druidic stone walls. But the real dramas of these centuries-old estates manifested themselves after I spoke with owners who were still in residence. I was surprised to discover that more than half of them believed that they were sharing their ancestral homes with other-worldly beings. I used the word "phantoms" in the title to reflect both the presence of ghosts and the atmospheric manner in which I chose to photograph these hauntingly beautiful estates.

I especially wish to thank, Mr. Alfred Mills, Miss Daisy Suckley, Mr. John White Delafield, Mr. Richard Aldrich, Mr. Frank Vanderlip Jr., & Mr. Robert King for their moral support and enthusiasm without which this book would never have been written. I am grateful to all my friends and fellow preservationists for their understanding and shared fascination with the area and to all the property owners whose research and dusty attics I drew so much inspiration from. My further appreciation and gratitude goes to:

Mr. Joseph Pell Lombardi, Mr. Richard Jenrette, Mr. Charles Eggart, Mrs. Ann McDonald, Mrs. Mildred Rutter, Mr. J. Chapman, Mr. Richard Slavin, Ms. Nancy Richards, Mr. James Finger, Ms. Virginia Hair, Mr. Morgan Pryn, Mr. Wallace Workmaster, Mrs. Eugene DuBoice, Mr. Justin Collin, Mr. Victor Phillips, Mr. & Mrs. Jack & Lori Summers, Mrs. Dorothy M. Ulrick, Mr. Guy G. Rutherfurd, Morris & McVeigh, Mr. Gary Lawrence, Mr. Andrew Merlo, Mr. Orin Z. Finkle, Mr. Alfred Brennam, Mr. Harvey Flad, Mr. & Mrs. Ray Ruge, Mr. Jack Smith, Ms. Nancy Kelly Arthur, Ms. Susan L. Barick, Mr. Gus Thompson, Mr. John Feeney, Mrs. Smith of the Tarrytown Historical Society, Mrs. Evalyn Hill of the Warner Library, The Hudson River Museum, Mrs. Janet Grant, Mr. Chip Marks & Mr. Douglas-Banker, "Castlerock," the late Mr. John Maddocks for allowing much of this to be written at "Malmaison," Dr. Viola Bernard, Tom Finley, Neil Caplan, Montgomery Anderson, Barry Rivadue, Joyce Caine, Nancy Rhuling, Helen Barolini, Irvington Library historian, Tieomoc H. Jonston Ono and Elizabeth Vangel (Wyndcliff).

INTRODUCTION
Mansions of the Lost River World

There is a world of mystery along the Hudson River, where picturesque castles perch on tiny islands, and rainbows arch across the country's most romantic river. Here, dark, sinister fortresses brood, as great clusters of dizzying towers, Gothic spires, and battlemented walls molder on hilltops overlooking the wide river.

Through the middle portion of the Hudson Valley—the part that is located along the 150 miles between New York and Albany—one finds a spectacle of ruined buildings. "No Trespassing" signs hang from vine-drenched gates that hint at splendor, untold luxury, and ghost stories. There are hundreds of these historic estates, many still owned by descendants of the families who built them centuries ago.

Originally, these vast tracts of land were granted by the British crown to the Livingston family. It was Robert R. Livingston, chancellor of New York, who began the estate-building era in the Hudson Valley. In 1755, his property, Clermont, was passed on to his descendants, and it is now owned by the State of New York as a historic park open to the public.

The Livingston heirs have carried on the family's traditions for nearly three centuries, and the Hudson Valley is the epicenter of their world. Although their names have passed from public attention, they value their lineage and ancestral homes and continue to pass on to their descendants vast collections of crystal, china, baronial paintings, and monogrammed silver. Today some of the descendants of Dutch patrons and English land barons who remain on these estates are facing hard times. They have outlived their fortunes; many have been forced to farm their lands, rent out rooms in summer, and shut down wings of their homes in winter.

Gone are the horse-drawn carriages, the pomp and circumstance of fancy dress balls, and the well-tended European gardens, with their endless promenades. All is quiet as the gardens decay and are overtaken by vines. Statues of gods and goddesses lie in a seeming state of melancholy amid the weeds. Palaces rise from the lush blackness of the woods, and leaves drift and weave through vast empty halls. Everywhere charming ruins whisper about what once was.

The largest and most impressive concentration of historic estates is located in and around Rhinebeck, New York, along eighteen miles of the east bank of the Hudson, where time seems to hover between the eighteenth and nineteenth centuries. Everywhere stately homes rise dramatically from the trees of the vast overgrown parks, where deer and sheep graze and where the past is still alive.

Though there is an air of departed glory about the area, it is entering an age of appreciation and restoration. Most of the thirty-seven properties in the Rhinebeck district remain in private hands and are considered to be among the most historically significant in the country. Among these is Wilderstein, a spectacular Queen Anne-style castle built in 1852, complete with a five-story tower and a resident ghost. Nearby Rokeby, called La Bergerie when it was first built in 1811, was home to John Armstrong and the flock of Merino sheep that Napoleon had given him as a wedding present. At Sylvania, a neoclassical château, rows of long-dead ancestors stare down at their heirs from massive gilt frames.

Common among these grand old homes are enormous libraries, filled with thousands of rare leather-bound books. These vast, dusty chambers suggest the river elite's obsession with books. It has been noted that the Livingston descendants have privately published more books on themselves than any other family in America.

Farther north on the river, mysterious ruins stand on the far corner of Cruger Island. One hundred and fifty years ago John Church Cruger hired the explorer John Lloyd Stephens to excavate, dismantle, and ship an ancient Mayan village from the Yucatán to his private island. Thus the Hudson acquired ruins older than those on the Rhine. At nearby Blithwood, a sumptuous white wedding-cake-styled palace, guests would gather on lawns for parties and row around Cruger Island in colorful lantern-strewn boats. Elaborate fireworks displays were often part of the moonlit festivities. Now, after eighty years of jungle burial, the ruins are overgrown and barely visible.

Downstream at Wyndcliff, a long-abandoned turreted Victorian villa, one beholds a savage wilderness of ruin and decay. Built in 1853 by Elizabeth Schermerhorn Jones, a cousin of Mrs. William B. Astor, it was at the time one of the most expensive houses ever built in America and engendered the expression "keeping up with the Joneses." Edith Wharton wrote of the gloomy house often in her novels. A former owner of the house claims he sold the property because of strange occurrences; for example, a phantom hunting party would suddenly appear, and phantom horses and their riders would gallop across the sweeping lawns, and then vanish in a puff of mist just before reaching the river. Now the house stands, all hope of restoration gone, silhouetted against the sky.

10

Bannerman's Castle is perhaps the best known of all the ruined fortresses. It rises, enormous and forbidding, from a rocky island. Its derelict towers jut out of the black swirling water, crumbling and secret. In one corner, a stone gargoyle stares out at the prehistoric shapes of the Highlands that frame the horizon, as the sun sets in a smoldering, majestic glow. The locals are fond of telling harrowing tales about the castle and warning outsiders to stay away. The river currents surrounding the infamous island are so strong that they have taken the lives of many who have attempted to brave the freezing water in an attempt to reach its rocky shores. The island is now covered with rampant jungle-like growth and has been abandoned for half a century. What remains of the castle has been diminished by lichen, acid rain, and vandalism.

Francis Bannerman designed and built the Scottish-style fortress in 1900 and used it both as a residence and an arsenal; he filled it with enough gunpowder, cannons, and Gatling guns to fight a small war. Sometime during the 1920s, there was an enormous explosion that blew the north wing of the castle into the river. The blast was so powerful that one of the turrets shattered and fragments landed some 500 feet away along the railroad tracks on the mainland. Then, in 1969, a mysterious fire broke out and the castle was enveloped in a blaze of grandeur. Today, even in its ruinous state, it remains the most breathtaking sight on the river.

It is hardly surprising that (according to the proud owners) many of the great manor houses are indeed haunted. The soaring gables, crenelated towers, and turrets of these castles have stood witness to many scenes of betrayal, thwarted romance, and even murder. Restless phantoms may well glide quietly among the ruins, reaching out to those who believe they can feel and see them.

Beechwood, the sprawling manor with double sets of soaring white pillars, was built in the 1840s and was the embodiment of quiet, aristocratic luxury. It is said that the stately home has six ghosts, including five virgins who were murdered and buried beneath the basement floor. The victims were avenged when the rogue who killed them was axed to death by a devoted servant who discovered the crime. The servant then took the killer's body and walled it up in the fireplace, where the bones were finally discovered in 1909.

On the river there are endless tales of phantoms who appear at night and depart by morning. Some owners claim their ghosts toss dishes about, hurl paintings from the walls, and drag their feet along the creaking floors. At Beechwood, the sound of weary footsteps and wheezing breath betrays one ghost's struggle up a flight of sagging stairs.

In Tarrytown, a mysterious Gothic tower stands alone atop a cliff overlooking the river. It is all that remains of Warner Castle, the sixty-room mansion that was destroyed in 1980. It is rumored that the tower escaped the bulldozer when workmen spotted the figure of a woman standing in one of the tower windows, her white hair flowing like sea grass. The operator was so shaken that he turned the bulldozer around and never completed the job.

There are said to be just as many ghosts haunting the river itself, which is a virtual graveyard for old ships and rot-

ting scows. Off Bannerman's Island, near Fishkill, rivermen say you can hear orders shouted by long-dead captains of *The Flying Dutchman*. The old Dutch vessel sank near the island in the early eighteenth century. At low tide, the spars from her hull can still be seen below the water's surface.

High on the east bank of the river, in Irvington, stands a rare eight-sided Victorian manor house built in 1860, aptly called the Octagon House. Its resident ghost is said to be that of a beautiful French girl who, in defiance of her parents' wishes, escaped and ran off to marry the man she loved. Together they boarded the river ferry, but as the boat raced to New York, the boiler exploded, killing everybody on board. The would-be bride's body washed ashore, still clad in a wedding gown. Legend holds that every year, on the eve of the tragedy, the faint specter of a young girl in a luminous white gown runs across the lawn toward the river.

What does the future hold for this enchanted but endangered world? Certainly it will always be a place beloved by painters and challenging to psychics. More important, however, the area's architectural treasures have been recognized by historical preservation organizations. Funding has begun to bring about changes, and many of the decaying houses are at least being stabilized and protected from further damage.

Few places left on Earth are blessed with as many surprises and mysteries as the Hudson Valley. It is a noble and historic area, home to legends, ghosts, and banshees, as well as breathtaking architectural achievements. There is much here to be treasured.

PHANTOMS *of the* HUDSON VALLEY

THE OCTAGON HOUSE

In the mid-nineteenth century, while castles and marble palaces were sprouting up along the Hudson River with increasing frequency, there was one house that was unlike any other and soon became known as a spectacular curiosity. The Octagon House in Irvington is the only known surviving domed eight-sided house in America. It stands high on the east bank of the river and is considered one of the world's most visually unusual nineteenth-century manor houses.

Built in 1860 by Philip Paul Armour, a New York financier, the house was substantially embellished in 1872 by its second owner, Joseph Stiner. Stiner, a successful tea merchant who had traveled to the Far East, brought a Chinese influence to the house. In its day, the house was surrounded by an extraordinary park of carefully chosen rare trees that bloomed in gorgeous colors all summer long. Marble statues and urns stood amid Japanese cherry trees and magnolias. There was also a gigantic Kentucky coffee tree, tulip trees, and rare Chinese ginkgoes, with their distinctive fan-shaped leaves. A charming well house in the shape of a pagoda stands to this day along the entrance drive. The house rises up four floors to a domed slate roof with a Roman temple-style observatory tower at the center. Surrounding the main floor is a magnificent colonnaded porch with ornate cast-iron railings. There is a secret tunnel leading from under the porch out to the garden; it is unclear why it was built.

In building the house, Armour was influenced by the architectural theories of Orson Squire Fowler, a well-known phrenologist of the day who promoted eight-sided spaces and pie-shaped rooms, which in his view represented the human brain. Fowler believed that living in eight-sided structures created a healthy force of energy that had a positive influence on the brain, and he called the octagonal house "a machine for healthy living." Fowler gained a following with the publication of his book *The Octagon House: A Home for All.* When he wasn't writing, he earned his living identifying the character traits of people by reading the bumps on their heads.

The rooms in Armour's house were supposedly laid out following Fowler's ideas about the cranial areas, with, for example, the first-floor music room corresponding to the cranial location of "tune" (over the left ear) and the second- and third-floor bedrooms situated in cranial spaces devoted to "sublimity, cautiousness, hope and approbativeness." This may all seem rather unconventional and New Age for the nineteenth century, but with his charismatic personality and new ideas,

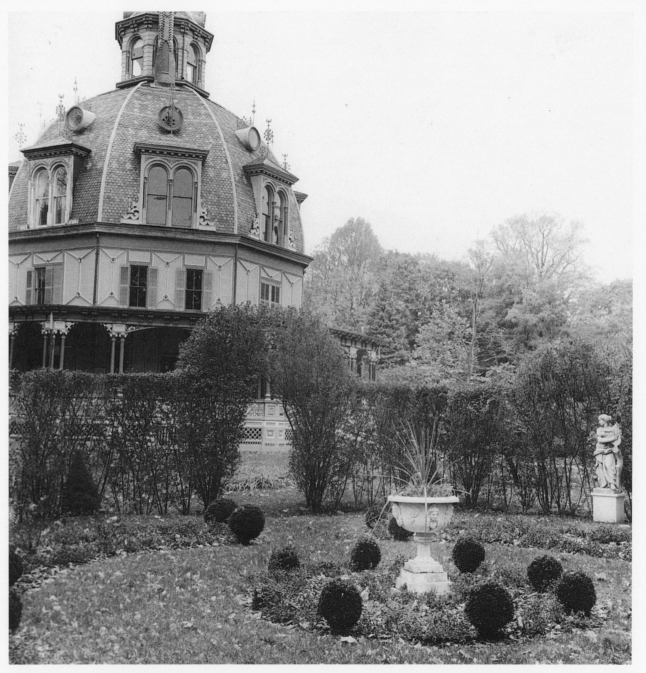

The Octagon House stands today restored to its glory days.

Fowler had for a moment a strong influence on the architecture of his day, as hundreds of eight-sided houses were built all over the country almost overnight.

When Joseph Stiner bought the house in 1872, he added the slate dome. When he added the porch, he topped the columns with capitals that embodied in wood the flowers that grew in his well-tended garden, rather than with the classical acanthus leaves. The colorful tea merchant added another charming personal feature to his home: the cast-iron railing panels on the porch are topped with the carved face of his beloved dog Prince. As he put his hand to the exterior of the house, it became a complex mixture of Gothic, Italianate, and Second Empire, all with Far Eastern influences and painted in carnival colors to amuse and delight the eye. The house was once described by an admirer as an "arrested carousel."

The interiors were just as remarkable and unconventional. A pair of snarling lions guarded the front staircase, and ceilings were painted in floral patterns in most of the thirty pie-shaped rooms. An elaborate system of parlor stoves kept the house warm in winter. Curiously, the massive ballroom was on the fourth floor, its unusual large round, porthole-like windows providing a sweeping view of the river below. Also odd for its day, there was a women's gymnasium that took up most of the third floor. A magnificent Victorian glass palm conservatory, a drawing room, and a dining room occupied the main floor.

Stiner had many happy years in the house, but when his beloved wife died unexpectedly, he could not go on living there without her. He quickly sold the house, his prized possession.

It has been said that people are like tuning forks, that we vibrate at a certain frequency and that what we attract to ourselves reflects our true nature. If that is true, it is not surprising that the noted author Carl Carmer bought the Octagon House in 1946. Carmer wrote over thirty books on the folklore and legends of the Hudson Valley; it is possible that living in the eight-sided structure may have served as an inspiration for some of his tales. During the thirty years Carmer lived there with his wife, Elizabeth Black Carmer, they came to believe that the house was haunted by the spirit of a woman who would make her presence known by filling the room with the sweet scent of cherry blossoms. While painting the porch one day, the Carmers discovered an odd twelve-foot-square bricked-in room hidden under the porch with a tiny wooden door just big enough for a child and apparently no other way in or out. The room was damp and cold and more like a crypt than a storage space. The room puzzled the Carmers for years, and although they never found out what it had been used for, they did turn up an even darker legacy of one of the earlier occupants.

After Joseph Stiner's wife died, he sold the house to a headstrong Frenchwoman of noble birth, recently widowed. She moved into the house with her only daughter, Yvette. The daughter was said to be very beautiful, with long dark hair, a girl of high spirits and great charm. On a nearby estate there was a rich and aristocratic family whose eldest son, upon seeing Yvette, fell madly in love with her. His parents, upon discovering his regular visits to the Octagon House, forbade

him to see the girl; they had already planned his marriage to a young lady from a suitable background. The young man disregarded his parents' wishes, and the young lovers continued their relationship in secret, meeting whenever they could in an abandoned boathouse pavilion on the edge of the river. To signal that the coast was clear, the girl would sneak up the spiral staircase to the observatory tower of the Octagon House and leave an oil lamp burning in the window.

But before long, the girl's mother discovered them together, and she too ordered her child to stop seeing the man she loved. Soon their situation became intolerable, and they planned to elope. One spring morning they met on the river's edge at dawn. As she slipped out the servant's entrance, she grabbed some branches of cherry blossoms for her bridal bouquet. She wore the wedding dress she had made for herself, concealing it under a long heavy cape.

It was a gloomy morning, and a heavy fog rolled in from the Hudson. There was a chill in the air, and the young girl shivered as the couple hastened on foot to nearby Tarrytown. The thought of her mother's fury paralyzed her for a moment, but her lover grabbed onto her as they ran for the dock. They boarded a steamboat, the *Silver Dutchess*, that was headed for New York City, where they planned to be married later that afternoon.

Unhappily, one of the servants of the young man's family saw them hurrying along the riverbank and reported what he saw to his master. At once the father mounted his horse and set out to stop them. At the same time, his wife drove her carriage down to the Octagon House, where she accused the girl's mother of conspiring with the lovers. The pursuing father galloped in a rage onto the Tarrytown dock only seconds after the steamboat took off down the river.

As it turned out, the steamboat was engaged at the time in a race to New York against a competitor, the *Black George*, owned by a rival line. As both boats raced along in the shadow of the Palisades, the *Silver Dutchess*'s boiler, subjected to terrific pressure, burst. There was a shattering roar that echoed menacingly on both sides of the Hudson as the boat's engine exploded, killing most of the passengers, including the intended groom. Soon the boat was engulfed in flames, and the wooden floors burned with a blowtorch hiss as a great billow of black smoke and orange flames wreathed up toward the sky. Those who weren't killed in the explosion screamed, as panicked passengers were forced to jump overboard or burn to death. A series of tidal-like waves radiated from the doomed boat and moments later crashed upon the rocks of the shore.

The next day the body of a young girl, still in her wedding gown, was found among those who had drowned. Later that afternoon a neighbor drove a farmer's wagon slowly up the drive to the Octagon House. Inside was a pine box. The mother walked out onto the porch and stared silently at the wagon. "I'm sorry, ma'am," the man said. Her mind in chaos, half hysterical from shock, she refused to accept the coffin.

The girl's body was buried in an unmarked grave near the river. Days later, when the mother realized the cruelty of what she had done, she climbed into her carriage and drove herself to her daughter's grave. She stayed long after dark, until a servant from the house came to fetch her. He found her sobbing uncontrollably, her face pressed to the cold, damp

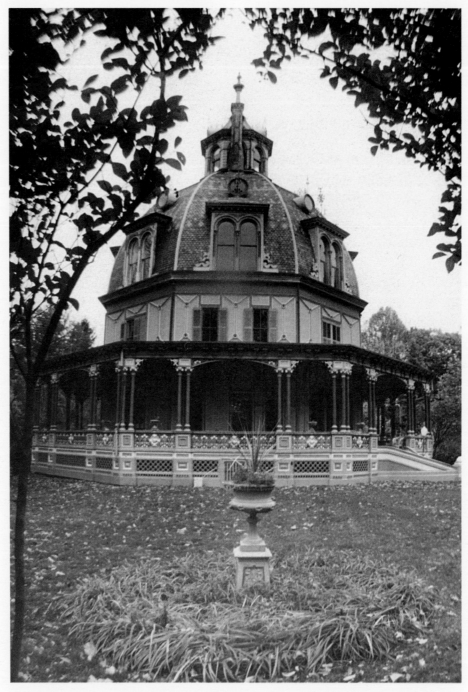

The restored Octagon House as seen from the garden.

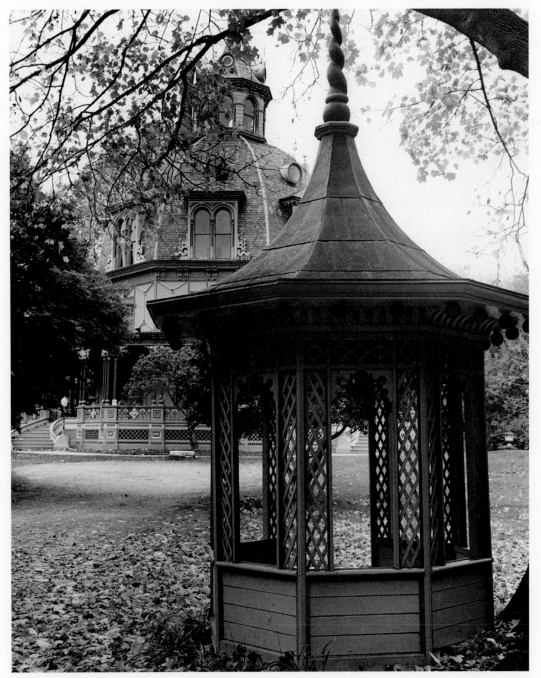

A Victorian gazebo stands restored at the entrance of the estate.

19

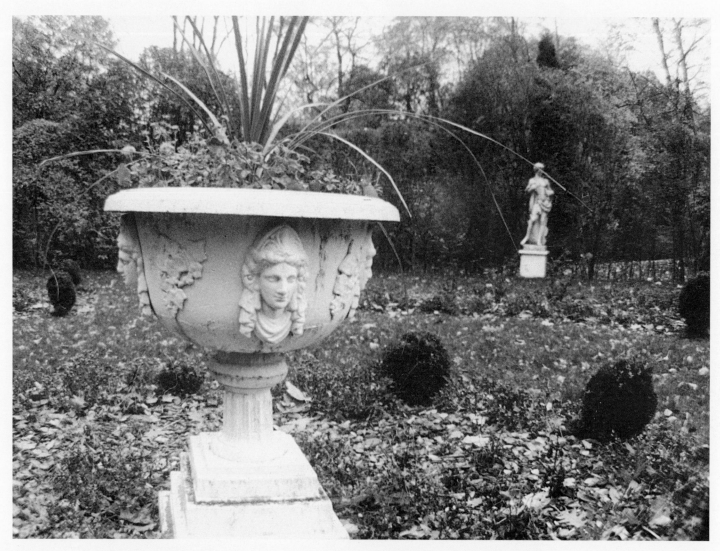

Antique urns and statues stand in the formal garden.

A marble statue of a goddess watches over the garden.

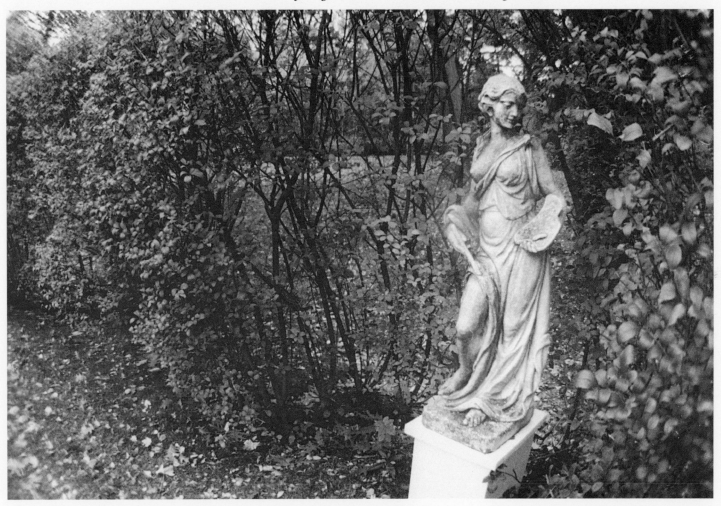

The ghost of a young woman in a diaphanous white gown has been seen running through the garden of The Octagon House.

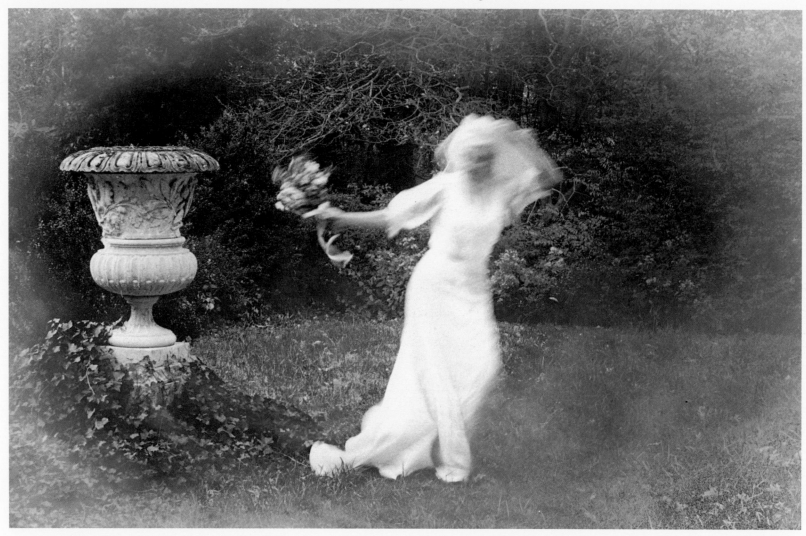

earth. The mother never recovered. Reclusive and bitter, she no longer received visitors at the house, which took on a dolorous atmosphere as she walked the halls in her black gowns. Her face became a baleful, ghost-like mask, as neighbors began to whisper that she had lost her mind. At the very least, her tragic end casts serious doubt on Fowler's theories that living in pie-shaped rooms promotes mental health.

After the mother died, the house stood empty for many years, but the people who lived in the area claimed to see a dim light flickering in the observatory tower from time to time. On other occasions, they said, a kind of shadow surrounded by a radiant light appeared to float past a glade of trees in the garden, then move on in the direction of the river, where an old boathouse used to be.

In his essay "The Screaming Ghost," Carl Carmer describes a recurring dream that his wife had about a ghost that shared their house. She dreamt she saw the mother standing outside the front door, beckoning her daughter to come back to her. Mrs. Carmer believed the two were reunited after death.

The story of the Octagon House does have a happy ending. In 1979, prominent preservationist and architect Joseph Pell Lombardi bought the building and set about to restore it to its original condition. I last saw it when Lombardi hosted a magnificent turn-of-the-century party in the surrounding gardens. Hundreds of guests wore vintage costumes, and to the best of anyone's knowledge there were no sightings of any spectral beings. The house stands today, completely restored.

THE GARDENS OF GREYSTONE

In a most unlikely place, amid teeming traffic, parking meters, and graffiti-covered sidewalks in Yonkers, is an eight-foot wall that protects the gardens of Greystone. Now called Greystone, or Untermyer Park, it had once been one of the country's most extraordinary residences. The gardens were conceived by the visionary Samuel Untermyer, a lawyer with a passion for classical Greek and Roman architecture. After he bought the estate in 1899, he commissioned architect William Welles Bosworth to recreate the glorious marble gardens of Rome. Perched high above the rocky cliffs along the Hudson, the classical temples are still visible from the river.

Marble stairs connect multiple levels of shimmering fountains, canals, and lily pools reminiscent of the water gardens of Persia and the Temple of Love at Versailles. The most impressive structure is a mosaic Greek temple surrounded by gleaming white marble Corinthian columns. In the summer, brilliant annuals and exotic plants line the seemingly endless paths. Water flows from the mouths of marble lions' heads into a large pool. Massive pillars support griffins, Greek gods, and voluptuous goddesses. Mythical deities are found throughout the gardens and inside the limestone loggias.

Untermyer spent over a quarter of a century overseeing the construction of his fabled gardens. At one time, huge ferns and rare tropical plants sprouted from colorful ceramic pots and wooden tubs. A series of half-acre enclosed gardens seasonally released their vibrant colors. There were also trellised rose gardens, a riverside rock garden, and extensive fruit and vegetable gardens.

The estate was originally owned by hat manufacturer John T. Waring, who built a hundred-room stone villa in 1864. He named his estate Greystone and later sold it to New York State governor Samuel J. Tilden. After Tilden lost his bid for the presidency, he took to altering the house and its grounds and made room for his outstanding collection of rare illustrated books. Samuel Untermyer bought the estate in 1899 and made the gardens one of the Hudson's showplaces.

The massive villa that was north of the gardens has long since been bulldozed, and a hospital now stands in its place. Just beyond it, as one walks through the brambled woods along the river, one finds ruins of the old garden: stone pediments, toppled loggias, pieces of trellises, and parts of an old potting shed. These are no longer encompassed by the reduced grounds of the estate.

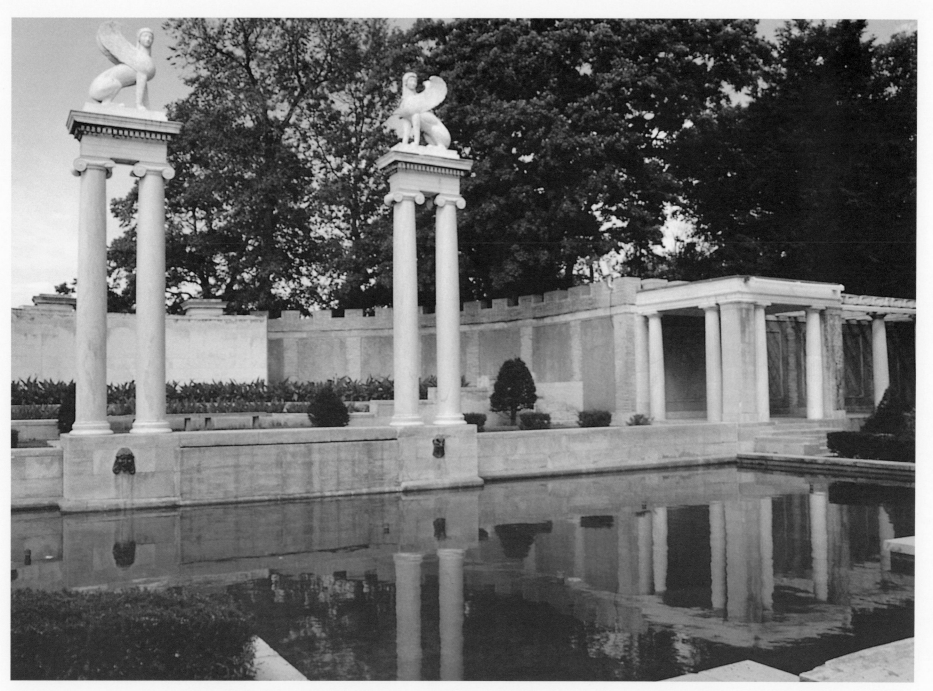

Marble statues and reflecting pools grace the former Untermyer gardens.

ESTHERWOOD

Estherwood is a palace of stoic grandeur that stands on a hilltop overlooking Dobbs Ferry. A towering copper gazebo crowns its roof and offers a sweeping view of the landscape, as well as the turrets of other castles that peek out from the foliage. This French Château-esque structure is often referred to as the most haunted house in Westchester County.

It was built in 1895 by James Jennings McComb, who came to Dobbs Ferry and bought what used to be the old Ryder property. McComb had earned a fortune with his patented invention: the ties that secured bales of cotton after they emerged from the baler. After his first wife died, leaving him with three young daughters, he was eventually introduced to a tall, handsome young girl from Dobbs Ferry named Esther Mary Wood. She had dark, almond-shaped eyes and shared his love of music. They married, and for their honeymoon, he built a clapboard Victorian-style house named Park Cottage.

Later, on a visit to England, McComb returned to the modest house with an enormous, ornate octagonal desk, around which he built a massive octagonal library. The unusual room rose thirty feet to a domed ceiling, set with a stained-glass skylight. Carved woodwork of Honduran mahogany was polished by a staff of uniformed servants.

After a time, the hugeness of McComb's library began to bother him, as it dwarfed the modest structure around it. In 1895, he commissioned Buchman & Deisler to construct what was considered to be the grandest manor house ever built in the area. It rose three and a half stories, with the number of bays varying on each of the four façades. A massive Victorian palm conservatory extended out from the south wing. The exterior of the mansion was detailed with scroll-bracketed dormers, a massive granite porte cochère, and a veranda with a Guastavino tile ceiling. Inside, the main staircase was divided by a Renaissance balcony, and its walls were gloriously gilded with baroque designs.

The McCombs lived there very happily and hosted many elegant musicals in the ornate front parlor. Candles blazed in the tall glass windows as the sound of violins floated across the freshly trimmed lawn. It is rumored that on one of these music-filled evenings, McComb met a young musician who was performing at the house and fell in love with her. Esther Wood, who was of a sensitive and artistic nature, heard the rumors and tried to ignore them.

One of the guests at the house that night had seen McComb give the young woman a nosegay of gardenias from his own wife's greenhouse. No one knew anything about the girl; only that she was a cello player who had arrived with the other performers. She was not strikingly beautiful—in fact, some thought her rather plain—but there was something quite

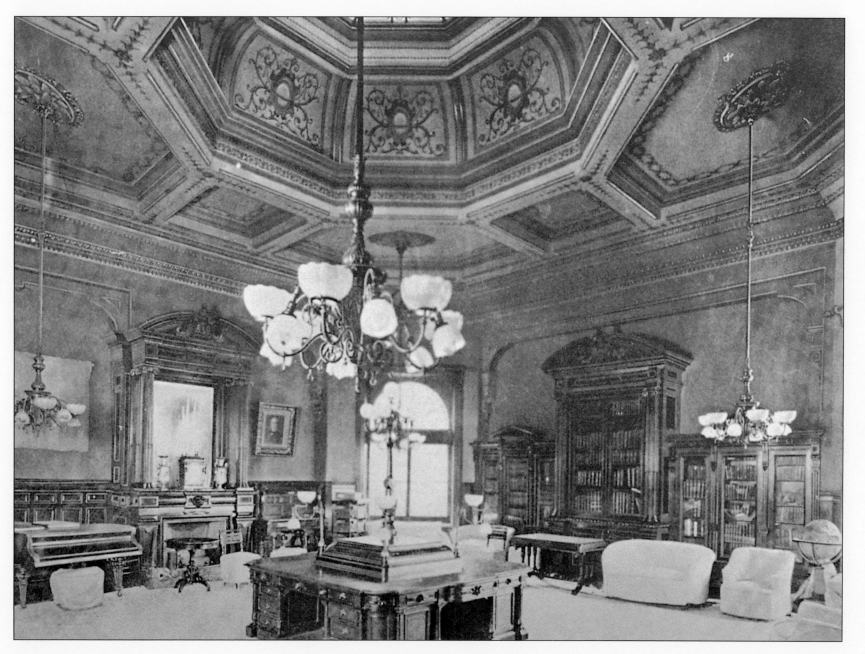

The octagonal library at Estherwood

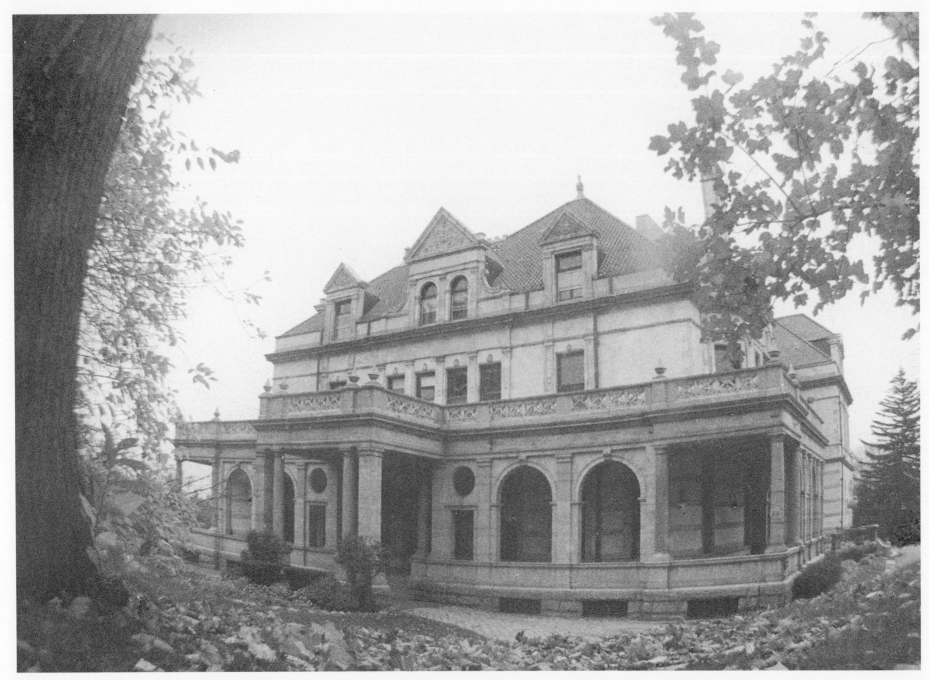

28

The massive renaissance manor stands high on a hilltop in Dobbs Ferry.

compelling about her eyes. Everybody said that whoever she was, she had bewitched McComb and that he could not hide his feelings for her. McComb was hard-driving, inventive, animated, generous to local causes, and one of the most respected men in the community. But he was also impetuous, and he gave himself over to sudden impulses.

Esther Wood kept up appearances and remained a devoted mother to McComb's three daughters. Acting as if nothing were wrong, she would walk the second-floor halls each night with a candelabra, enter each of the girls' rooms, and kiss them good night. She would then return alone to her own room on the second floor and cry herself to sleep.

No one is really sure what happened on the night of July 2, 1901. It is believed that, unable to sleep, Esther went down the stairs to her husband's library and began rummaging through his prized octagonal desk. She may have been searching for something that would put her fears to rest, but instead she came across an engraved cream-colored program from one of the many summer musicals held at the house. There was apparently an inscription scribbled on the inside of it in an unfamiliar feminine hand, though nobody knows what it said. Esther Wood was found dead the next morning, having hanged herself from the second-floor balcony. The music program was found crumpled on the floor by her husband's desk.

The music stopped playing at Estherwood. The servants were dismissed, and James McComb fell into a deep depression. He died a short time later. The massive house was boarded up and abandoned for many years. The grass was left untended, and vines wound their way around the garden statues and paths. A "For Sale" sign stood on the front lawn amid the weeds.

Finally, in 1910, Elizabeth Masters bought the house and all the original furnishings for an estimated $500,000. She turned the house into a girls' school and dormitory. Just before moving into their new home, the first students marched across the lawn, built a huge bonfire, and hurled the "For Sale" sign into the flames.

Shortly after the girls had settled into their new quarters, strange things began to happen. Some of the students claimed to see a white shadow floating down the staircase and out the main door. These reports have continued over the years. In 1952, the noted author Carl Carmer, who lived nearby at the Octagon House, wrote of his experience while passing by Estherwood one evening, in his book *My Kind of Country* (David McKay, 1966).

Sunset was still red in the sky above the west bank of the Hudson. Then I saw what may have been a ghost. She was tall and dressed entirely in white . . . and its whiteness was so stark I remember being surprised that her long, oval face nearly matched it. Obviously, it seemed then, she had so covered her features with talcum powder that any semblance of flesh color had disappeared. Only her black eyes, with no tinge of brown in them—stared beadily out of the whiteness that surrounded them. A high collar circled the whiteness of her neck and seemed to be stretched upon narrow white bone supports. A plain but voluminous white skirt fell in folds

to the top of her white high button shoes. The woman neither hastened nor dawdled as she walked towards me. Her pace was rhythmic . . . but its rhythm seemed exact and precise—like that of a machine, and when we passed each other I had the feeling that she was unaware of me, though my eyes sought to meet hers. In another moment she was across Broadway and had begun climbing the slope on the other side. Dusk was now settling swiftly and I saw lights flash from the ornate Victorian mansion that has long stood on the campus of Miss Masters' School, which crowns the rise towards which she moved. When I lost sight of her she was moving toward those lights, and I remember that she did not bend forward as most people do when they climb a hill. Indeed, her straight figure seemed to be moving up the slant at an unnatural angle.

Over the years, there have been countless reports by students of similar sightings both inside the house and on the grounds. Some of the girls claimed to have made contact with the tragic woman while holding séances in her former bedroom. My own experience came by way of an old journal and a letter I'd found in the attic at nearby Irvingcliff.

I had gotten permission to photograph the doomed house just days before it went down. While going through an old trunk filled with papers and letters, I came across some curious references to a ghost at the school. The journal was written in the pages of an old school notebook and appeared to have been recorded during a séance in the dormitory one night. The letter was written on heavy bond paper with the school's insignia embossed on it. Dated October 26, 1917, it read:

> Dearest Mother,
>
> I don't want to stay here any longer. For some months now I have tried to ignore the feeling of sadness that seems to hang in the air affecting everyone who lives here. Last night I saw something that has so frightened me I fear I should become ill if I stay much longer. At first I thought it was one of the older girls playing one of their cruel games, but it was not one of us, but some ungodly thing. I have spoken to no one about this. Please come for me as soon as you receive this letter.
>
> Your loving daughter,
>
> Beth

In a journal kept in an old school notebook, the following was recorded during a séance held in the mansion dormitory one night.

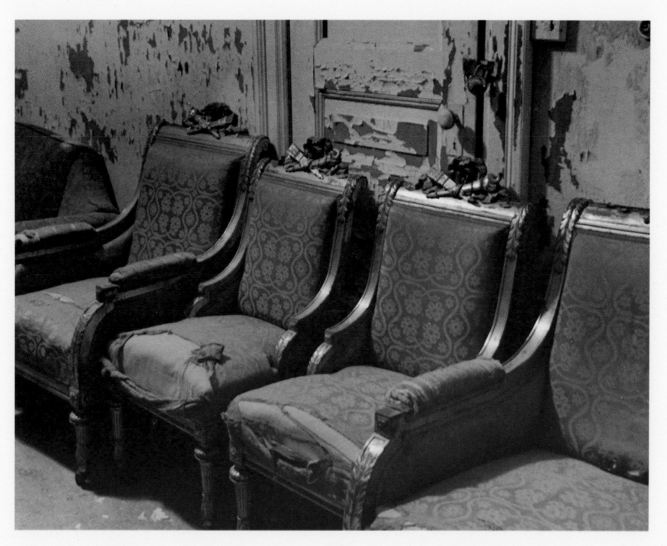

The once elegant chairs now molder away in a forgotten room.

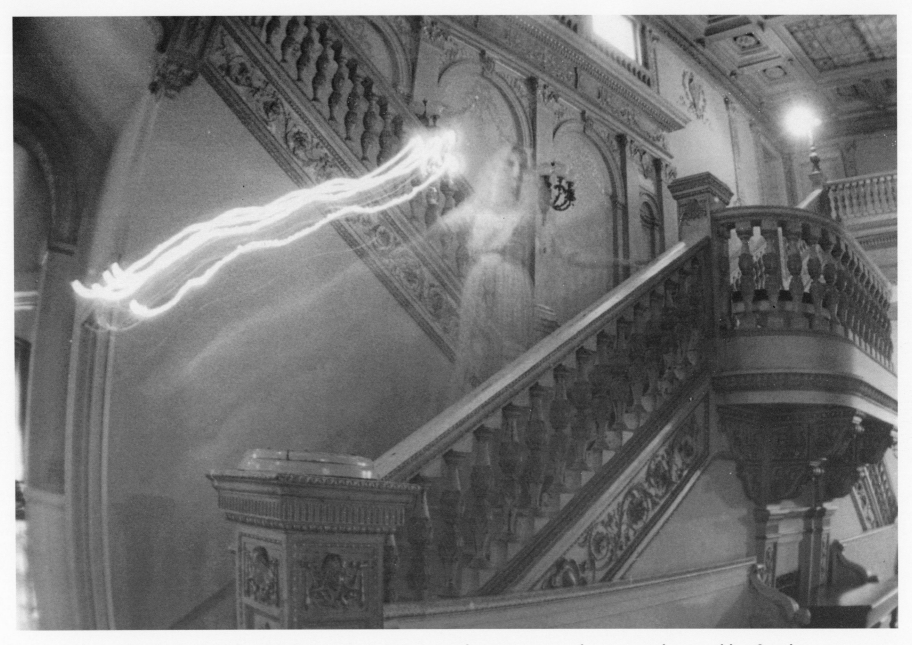

The ghost of Esther Wood is said to appear on the staircase each year on the eve of her death.

Esther sat upright in her massive Gothic bed, unable to sleep. A cold, gray light filtered through the tall, majestic windows. With red, swollen eyes, she gazed about the ornate room with a feeling of utter desolation. She found no comfort in the beautiful possessions that surrounded her—everything her eyes sought only amplified her sense of failure and abandonment.

As she rose from the bed, her long, thin fingers nervously clutched the fabric of her white silk robe. She glanced around the room one last time, then opened the door to the shadowy hall, making sure no one saw her.

Dragging her footsteps in dull resignation, she made her way down the long hall, then paused at the top of the stairs. With remote, unseeing eyes, she moved herself along the cold, balustraded balcony that encircled the second floor. At the base of the staircase, an ornate bronze-and-glass torchiere lit the massive entrance hall. She stood motionless, taking everything in with a febrile gaze. It was as if the house and all it represented had been a sham.

Her body was suddenly besieged by numbing cold, and a rising panic took hold of her. She began to hear voices mocking her. "An outstanding talent," she heard them say. "She came from nowhere and cast a spell on him," said another. "He was in love with her, he was in love with her," the last cruel voice echoed in her head, again and again.

Esther hesitated for only a second more; then, she removed the silk cord from around the waist of her long white gown. With trembling hands, she tied one end tightly around the marble banister. Her face shone like pale marble in the dim light as she tied the other end around her neck.

In that final second she thought about her daughters asleep in their rooms and wondered if she had remembered to kiss them good night. Yes, she had, as always. "Sweet dreams, my children," she thought.

Then with a sudden convulsive movement she heaved herself over the balcony ledge, her last breath escaping her in a tortured gasp. Her eyes flashed with regret, and all color drained from her face. One satin slipper dangled from her foot, then fell with a dull thud to the gleaming floor below. There was a full moon that night, and its light shone eerily upon her through the frosted glass panes of the skylight above.

The next morning, a chilling scream was heard throughout the house when one of the servants discovered her body floating in mid-air like some tragic apparition—an apparition that would appear again and again each year on the eve of her death.

The memory of Esther Wood seems to be very much alive at the Masters School. I am told that each year, the students revive the story of her untimely death. It may be that this tragic woman in vaporous white will remain in the shadows of her great palace for as long as the building stands.

VILLA LEWARO

So far, this study of dynamic personalities and their estates has concerned men, but perhaps the most strong-willed and enterprising individual to own a palace on the Hudson was a black woman known as Madam C. J. Walker.

Born Sarah Breedlove on a Louisiana cotton plantation in 1867, young Sarah was the first member of her family to be born free. For the first eighteen years of her life, however, she worked as a laundress on the plantation for $1.50 a week. At the age of fourteen, she married a Vicksburg, Mississippi, laborer, Moses McWilliams. Sarah was widowed in 1887.

Sarah's drive to succeed was formidable. After a grueling workday, having washed dozens of tubloads of clothes, she would experiment with a hair formula in those very same tubs. After inventing a pomade called a "hair groomer," a medicinal hair oil, she started selling her product to coworkers and friends. Sarah seemed to have an instinct for selling, and she used her own before-and-after image on the product's packaging.

Having saved most of the money she earned from her modest job, Sarah eventually began making her hair product at a manufacturing plant in Indianapolis. More driven than ever, she then went on to establish her own school for black beauticians. Sarah referred to her pupils as "beauty culturists." She took them under her wing and instilled them with pride in themselves and their race. Her courage and ambition proved infectious, and her business continued to expand.

By the early 1900s, Sarah was rich and famous. No other woman, black or white, had ever marketed a product that caught on so quickly. She was her own best salesperson, dynamic and down-to-earth. Many black women could identify with the adversity into which she had been born, and they wanted to look and be like her.

In 1906, Sarah married Charles Joseph Walker. From then on she was known as Madam Walker, a name she felt gave her dignity and status she had never known. Her business continued to expand, and before long she became the first black millionairess in America.

Madam Walker then declared war on prejudice. She knew how to fight and how to attract the attention of the press. Movies were the new excitement, and Madam Walker was outraged when she was charged twenty-five cents to enter a theater while whites were only charged a dime. Walker hired a team of lawyers, sued the theater, and won a settlement out of court.

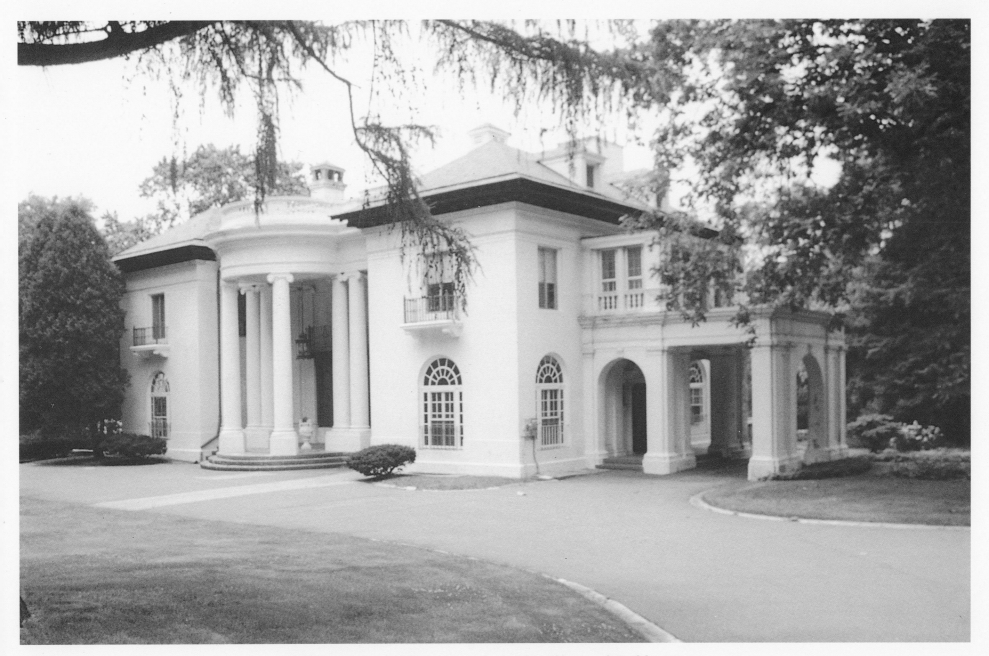

Villa Lewaro in the quiet riverside village of Dobbs Ferry.

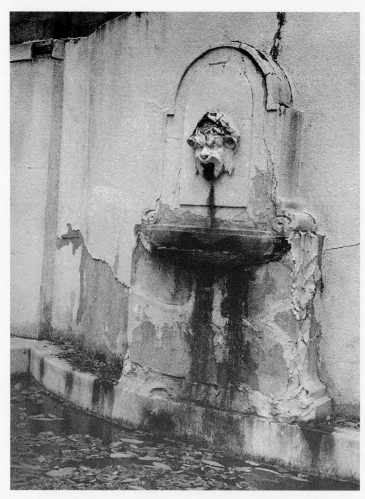

A fountain begins to crumble in the formal gardens.

The reflecting pool to the rear of the house.

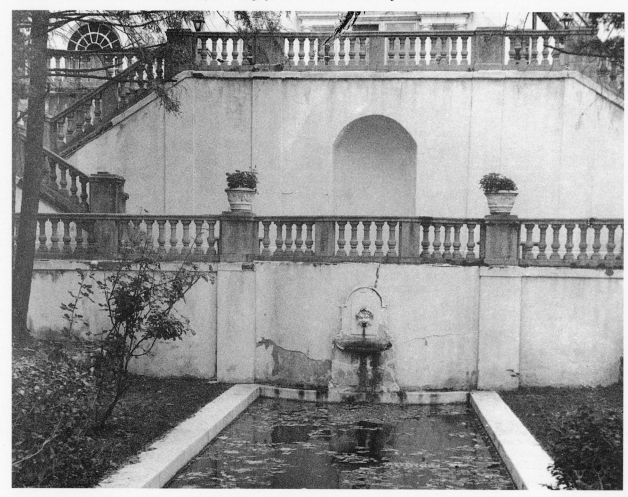

George Herbert coined the phrase "Living well is the best revenge" just for people like Madam Walker. In 1917, she blew into the quiet riverside village of Irvington-on-Hudson like a fireball and built a palace that resembled the White House right in the middle of town. That same year, her neighbor Dr. Pierre Bernard was parading up his new driveway with his pet elephants. Even so, the residents were not prepared for the arrival of Madam Walker.

Walker hired a black architect, Vertner Tandy, to design a spectacular manor house, and she became the mistress of one of the most envied mansions in the area—Villa Lewaro. The white stucco neoclassical house stood behind a tall iron fence on Route 9. Behind its pillared façade were all the hallmarks of aristocratic splendor. The interior boasted a white-and-gold French ballroom that rivaled those of Versailles. There was also an Estey pipe organ worth several hundred thousand dollars. All about the house were fine examples of rococo decorations; garlands of plasterwork set off splendid murals of French country scenes. Off the main hall was a marble staircase; above it, on the ceiling, was a twenty-foot oil painting of the heavens. In the main drawing room, a pair of Austrian crystal chandeliers cast delicate patterns of light on the richly decorated walls.

The grounds surrounding the house were magnificent examples of neoclassical design. To the rear, there was a formal reflecting pool filled with water lilies and exotic goldfish. In the center, water sprayed from the mouth of a lion's-head fountain. Rising above the fountain were staircases that led to the rear veranda, overlooking the river. The balustrades along the rear of the house were graced at the corners with statues of nymphs and marble urns. Also on the property was a stucco carriage house, which housed the chauffeur and the Walkers' fancy black cars.

The building of such a home by a black woman created a furor. Locals gasped in astonishment and were overheard saying, "No woman of her race could own such a place!" When the dust finally settled, however, Walker won over some of her neighbors by becoming active in worthwhile causes.

When Madam Walker died in May of 1919, there was a much-publicized auction of her possessions. One newspaper stated: "The glory that was Madam Walker's provides an optical orgy for curious white folk." Thousands came and paid high prices for rooms full of red velvet chairs and gilt-framed paintings of French court scenes. The Oriental rugs were rolled up and sold along with the marble statues, fine china, and silver tea sets, until the house on Route 9 stood empty. Walker's millions were willed to charities and noble causes, including the NAACP, several black schools, the YMCA and the YWCA. Villa Lewaro was later purchased by two millionairess sisters. In the south wing, just off the ballroom, arched stained-glass windows added by the sisters diffuse color upon the white walls and the tile floor. They founded Companions of the Forest, a foundation that provided homes for elderly women. Today the estate is still a showplace on Broadway. It remains in private hands.

WARNER CASTLE

Until recently, the last vestiges of a great Gothic castle stood atop a steep hill overlooking Irvington, for one lone turreted tower had mysteriously survived when the sixty-room castle it had once been part of was bulldozed during the early 1980s.

Few residents of the quiet community knew how the tower had come to be there. But after taking a photo of the ruin to the Tarrytown Historical Society, a local historian was able to find an original photograph of the castle to which the tower had been attached. Originally called Osborn Terrace, the castle turned out to have quite a history.

The stately English Gothic-style manor house was built in 1896 by Dr. Luchien Warner, known as the Corset King. Warner made millions in the foundations industry and is probably responsible for more women fainting than any other man during the last century. It is hard to believe that an esteemed doctor would encourage young women to wear corsets, but such was the fashion of the time.

Today, little remains of Dr. Warner's kingdom. Along Route 9, about a quarter of a mile south of Lyndhurst, there is a wrought-iron gate, chained shut. Amid the rubble of what used to be a formal garden, several marble staircases and an empty fountain can be found. An unusual Olympic-sized swimming pool, adorned with frolicking dolphins and paved with thousands of blue and gold mosaic tiles in wavelike patterns, was bulldozed only recently to make way for a housing development. Only the pool's small terra-cotta-tiled gazebo, hidden away behind a clump of trees, managed to escape the bulldozer. Nearby are two small marble gravestones inscribed with the names Lucky and Strike, the prized show dogs of the eccentric third owner of Warner Castle.

Another curious relic, visible until a few years ago, was a subterranean grotto located halfway between the remains of the tower and the pool. The entrance, made of fossil coral, led to a gloomy crypt, and there was a rusty gate with a creak that echoed deep within a chamber no one had dared to investigate. Vines worked their way into the small openings above, where earth and sagging timbers had given way. No one seems to know what the crypt was used for; perhaps it contained the bones of ancestors or beloved pets.

Dr. Warner commissioned architect R. H. Robertson to design his fairy-tale castle, which was one of the largest ever built in the area. As lord of the manor, he enjoyed entertaining his friends, and even designed a coat of arms for himself.

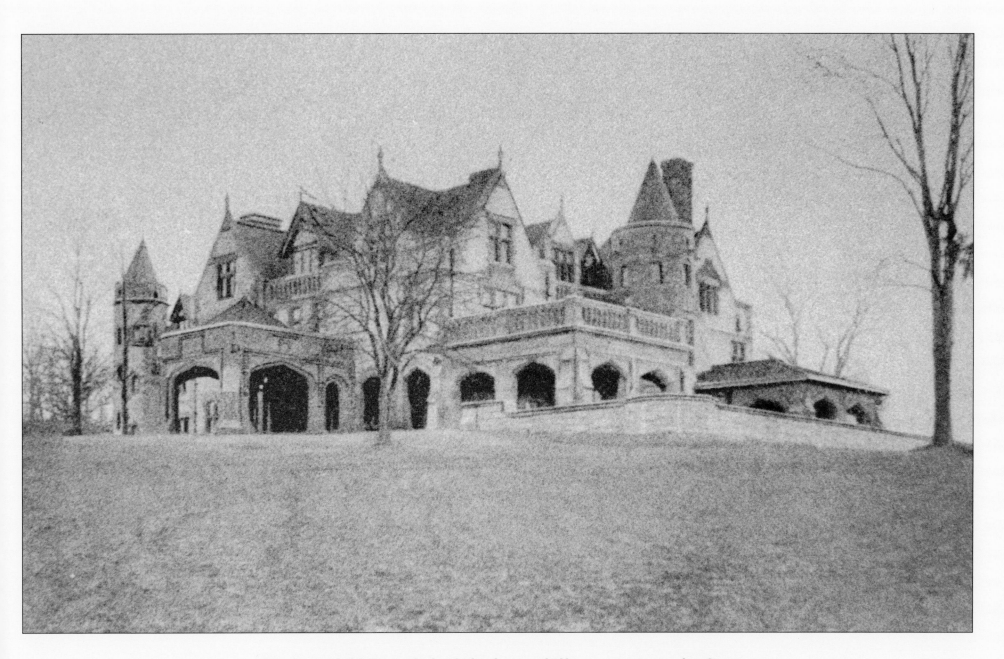

Warner's fabled castle built high on a hill, as seen in its heyday.

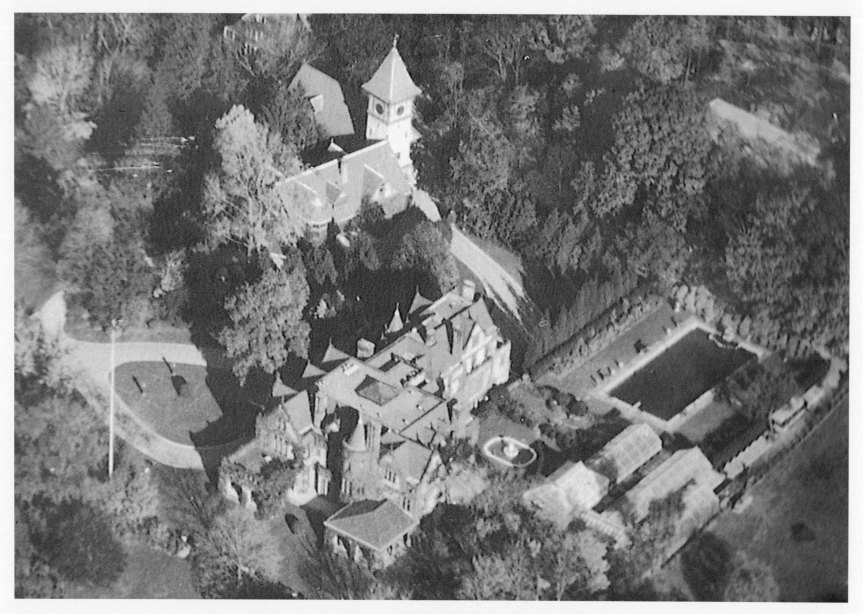

Warner Castle as it looked when it was first built.

He delighted in pointing up to the porte cochère entrance and asking his guests, "See anyone you know?" For carved into the brownstone façade were the faces of his wife and himself crowned in fifteenth-century headdresses. Keeping them company were assorted gargoyles, mounted along the roof of the tower turrets.

Charming stone bridges had once been part of the beautiful thirteen-acre park, lush with rare trees, magnolias, and mountain laurel. Marble staircases graced with giant urns led down to a swan-filled lake. Warner also helped design and build a magnificent palm conservatory that extended out from the southwest corner of his sprawling mansion. In the center of the Victorian-style all-glass structure was a fountain made of fossil coral and lava rock, surrounded by an inlaid mosaic-tiled floor. Hundreds of tubs of gardenias, orchids, and verbena plants filled the room, and bronze and marble statues of nymphs peeked out from behind giant Boston ferns. Colorful tropical birds were free to leave their ornate wire cages, fly about, and perch in the palm trees.

There was also an enormous Victorian clapboard stable, topped by a four-storied clock tower, which stood at the north end of the property. Some of the finest horses and carriages were kept there. The building was destroyed by fire some time during the 1960s.

The original entrance to the house was set off by a circular gravel drive with a massive urn at the center. One entered the house through a series of stone arches completely covered with wisteria vines. Inside the main hall, rich oak paneling was set off by gold-embossed ceilings. A heavily carved staircase, flanked by a pair of life-sized marble statues, was illuminated from above by a delicately executed stained-glass skylight. Rare ancient tapestries hung from the walls over the balconies and the staircase landing. There was a ballroom with gilt-carved walls and heavy red velvet drapes. At Christmas, a twenty-foot tree trimmed with rare glass ornaments stood in the middle of the room, and hundreds of presents were placed beneath it for the Warner children and their friends. The men had their own lavish billiard room that was off-limits to the ladies. The marble hearth was guarded by massive bronze snarling dragons, and ornate carvings in the style of Grinling Gibbons graced the walls. Everywhere there were statues by Remington. There was also a moose head or two, and on the desk sat a mahogany box filled with Cuban cigars.

Upstairs, no expense was spared. Most of the bedrooms were done in the French style, with silk-damask walls and drapes that were fringed, tasseled, and bound with gold cords. There were gilt furnishings, richly carved wood, and filigreed plaster walls, all illuminated by Waterford crystal chandeliers. At the end of the hall was a bright, sunny room, and in it was a three-tiered fountain set into a Venetian-styled niche, with a bronze cupid with a bow and arrow at the center.

The third floor was reserved for the servants, and as many as twenty-four occupied the tiny rooms in Warner's day. Until recently, the tower that survived had a spiral staircase that went up to its peak. It was rumored that one of the servant girls took her life there after she lost her job as a laundress.

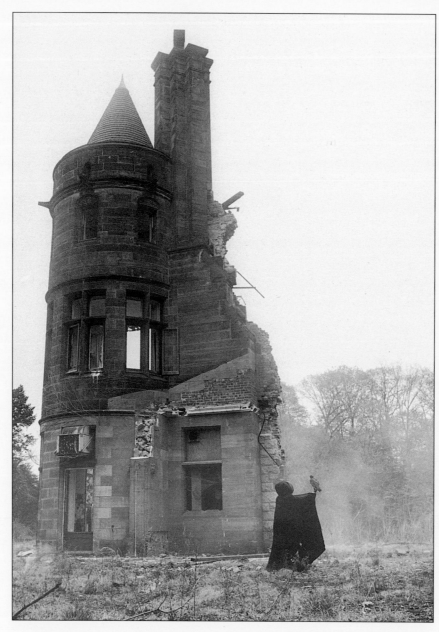

All that remains of Warner Castle is this lone tower.

The Warners eventually sold the house to Daniel G. Reid, the tinplate magnate. He enlarged and embellished the ballroom with an illuminated dome and a stage with gold-trimmed red-velvet drapes. Invitations to his Saturday night galas and theatrical events were much sought-after. Reid also had one of the formal gardens plowed to make way for one of the largest privately owned swimming pools ever built. Aside from the elaborate tiled designs of the pool floor, the crowning glory was the famous life-size statue of the Durham Bull, with a nude riding on its back. Jets of water sprayed high into the air and surrounded the statue, creating a rainbow halo.

In the early 1930s, the estate was sold again, this time to George Washington Hill, the flamboyant president of the American Tobacco Co. He renamed the castle Richmond Hill and embarked upon transforming the formal gardens into tobacco fields, which were dotted with life-sized statues of nude women. He also sent the estate's white swans packing and replaced them with rare black ones.

Records indicate that during his heyday (which included the Great Depression), Hill spent $250 million on advertisements for Lucky Strike cigarettes, more than was ever spent on any other product in history. With such clever slogans as "reach for a Lucky instead of a sweet," he enraged America's candy manufacturers. He spent a great deal on his surroundings as well, and installed a radio in every room (including the outbuildings) so as not to miss any of his advertisements. While an ad was being broadcast, no one was allowed to talk or move.

Hill was known as a perfectionist, obsessed with conducting the orchestras and singers on his broadcasts. Supposedly, during an incident with Hill, Frank Sinatra stormed off the stage and quit. In fact, many believe that the character of Evans in Frederic Wakeman's bestselling book *The Hucksters* was modeled after Hill, for both were extremely demanding men who wore hats indoors and were rarely seen without cigarettes dangling from their mouths. *The Hucksters* was made into a movie in 1947, starring Clark Gable and Deborah Kerr.

In the course of Hill's popular Lucky Strike campaign, the American public had gone from smoking 30 billion cigarettes a year to smoking 300 billion. After Hill died, at the age of sixty-one, his Irvington estate was abandoned for some time and then leased to Philips Laboratories, Inc. Following some drastic changes and modernizations, the building was abandoned again when the lease ran out. It fell into ruin and was vandalized.

By the late 1970s, Warner's dream castle had been destroyed, and all that remained of it was the mysterious tower. It is rumored that the tower escaped the bulldozer when the driver operating the machine caught a glimpse of the specter of a woman standing in one of the tower windows. The sight so unnerved him that he turned the bulldozer around and hastened back down the hill, and the job was never completed.

BEECHWOOD

On a foggy day in the dead of winter, I was heading north on Route 9 when I spotted two monolithic stone pillars that supported a rusty gate, bound with a chain. A ganglion of dead vines had worked and woven its way through the iron bars. I was so drawn to the gate that I just had to find out what was on the other side.

The property was surrounded by an eight-foot brick wall that seemed to go on forever. Not knowing if there was another way to get in, I parked my car at the nearby railroad station and followed the wall until I found a place where it had collapsed. I climbed over and jumped down, landing in a bed of soggy leaves.

Once on the other side, I found myself standing in a dark forest of pine trees, but I could see no buildings. Nearby there was a great stone bridge, made in part from fossil coral, that was covered with moss. Tiny ferns that had turned gold from the frost sprouted from the porous rocks. The sound of a waterfall mingled with the peaceful whisper of pines swaying in the breeze. Beyond the bridge, there were several magnificent beeches and a clearing where I could now see a massive plantation-style manor house in the distance.

Age had mellowed the color of the house to a lovely fusion of raw wood and ghostly white, which enhanced the shape of the wings and pillars. There were two sets of pillars at each end, giving the illusion of two antebellum-style mansions joined together. At the south end of the house, there was a glass Victorian palm conservatory. In the center there was a porcelain fountain with frolicking nymphs set in a weathered floral-decorated niche. Pale-green trellis-work covered the walls and ceiling in intricate patterns.

I continued to walk along the back of the house, looking for some sign of life. Heavy velvet drapes with gold braid, faded and worn, covered the French glass doors of the adjoining rooms. The remaining doors and windows were shuttered closed.

At the far end of the house, on the north side, there was a huge Palladian arched window that rose twenty feet at the center of an extremely large library. Thousands of old leather books stood collecting dust on the shelves. A massive fireplace graced the far end of the room, above which hung what looked like a Van Dyck painting of a young warrior bearing a sword. All along the ceiling were ornate plaster bas-reliefs of Greek and Roman figures. To the left was a rotunda

44

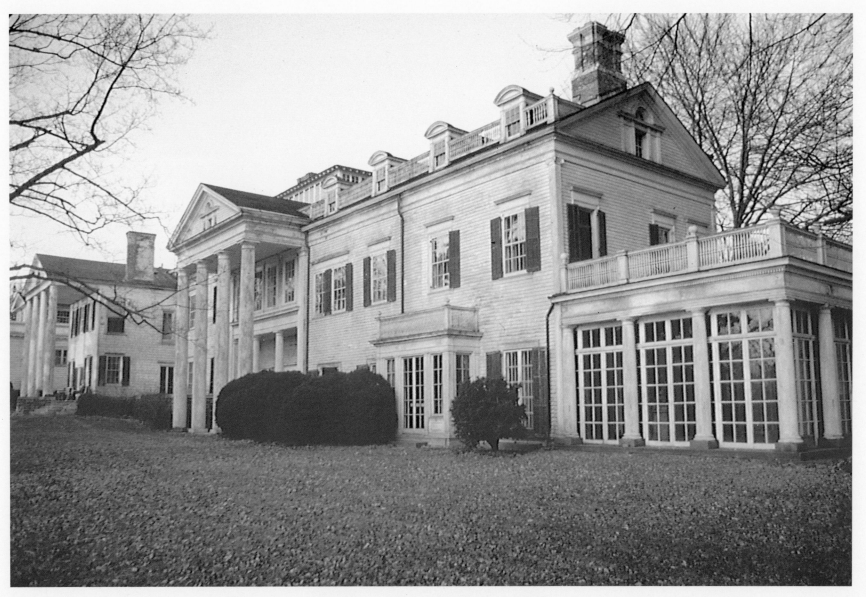

Beechwood as it looked in 1982.

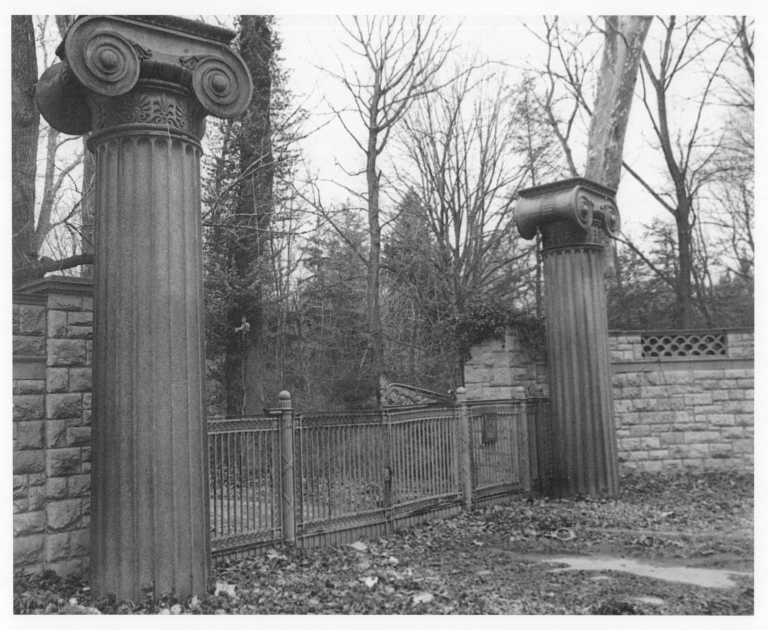

The granite ionic pillars guard the entrance and Beechwood.

filled with more books, accessible only by the ladder that slid along the wall on a brass track. The room had no windows, but it was flooded with light from a frosted-glass skylight.

The house gave the impression of not having been lived in for some time. Nearby, there was a summer pavilion or guest cottage that also seemed abandoned. I followed a stone path that led to the servants' wing; then I looked up and spotted a rose-tinted shade glowing dully in the window.

I climbed up the stairs, which led to a wooden porch sagging at one end, and then noticed a small brass plaque on which was engraved the name "Mills." I was about to knock when the door opened, and there stood a man in his seventies with a welcoming smile.

"Ah, I have a visitor," he said good-naturedly. I was taken aback for a moment.

"I didn't think anyone lived here," I said.

"No one does except me and Angelo, the gardener, who lives over in the carriage house." Before I could introduce myself, he held the door open and said, "Come in, come in out of the cold. I'm Alfred Mills, the resident ghost. I watch over the place."

Before closing the door, he poked his head out of the entrance, looked around, and asked, "Where's your car?"

"It's at the train station. I climbed over the wall," I answered, realizing how odd this must have sounded.

He looked at me and smiled. "Do you make a habit of climbing over walls?"

"I'm afraid so."

"How did you know to find this place?"

I looked around at the vast hall behind him and then into his warm gray eyes. "Mr. Mills, I think it found me." We shook hands, and I told him about my project.

"If you're photographing old houses, you'll find this one very interesting. I'm told it's over two hundred years old and has a fascinating history. Mr. Frank Vanderlip Jr., owns it—was born here, in fact—but sometime during the sixties he just up and walked out one day, leaving everything, even his shaving set and watch. The family comes by now and then to check on things and to remove bits and pieces of furniture. But I guess it's too much for anyone to manage these days," he added with a weary sigh.

"The whole place is falling apart, as you can see. It was built by Walter Webb in 1840, but there are parts of the house that began as an old farmhouse way back before that," he explained, moving toward a pair of doors that led to the main part of the house. We walked the length of a very long and dark hall, lined with old portraits. Suddenly I realized, looking behind me, that we were being followed by a black-and-white dog, whose head was low to the floor.

"That's Edward," Mr. Mills said. "He's been with me forever."

47

We passed several pleasing rooms, all plastered and corniced in the classical manner. Most of the furniture was covered with muslin sheets. After what seemed like a mile, we came to the main entrance and stair hall, with its magnificent white pillars. Leaning against the stair wall was a huge life-sized portrait of a beautiful woman in a lavender gown. She seemed lost in her own grandeur. A tag hung from it that was marked in pencil: "To be picked up."

"That's Mrs. Narcissa Vanderlip, Frank Vanderlip's mother," Mr. Mills said, crossing the floor to pull back one of the draperies. "She was a remarkable woman. The house got its name because of her; the name Beechwood was inspired by all the beech trees on the property. She smuggled the seedlings over from England in a large mink fur muff," he said with admiration.

I noticed a Chippendale chair, gray with dust, on the landing. I followed my guide to a pair of carved oak doors with ornate brass handles. He wrapped both hands around them, and the doors gave way with a creak.

Inside, the smell of brittle decaying books mingled with the musty curtains. We stood there, taking in the room's atmosphere. All was very still. I watched as the dog took his place beside his master, and I wondered how long it had been since anyone else had been in this room. A pair of towering lamps with silk-fringed shades stood on either side of a massive carved fireplace. The wall above it was still bare, but one could see where a portrait had once hung.

The house seemed to echo with the sound of butlers announcing dinner, and one could easily imagine servants in aprons standing solemnly before the high fireplace, their silver trays laden with porcelain teacups as music drifted in from the next room. The effect was dispelled, however, by the sudden roar of a New York City-bound train speeding along the tracks at the water's edge. Mr. Mills pointed up to the dozens of carved emblems that were mounted along the rich oak paneling.

"Those seals are from colleges that gave Mr. Vanderlip honorary degrees," he said, moving ahead to the palm conservatory. "The fountain with the nymphs was added by Webb; it came from the World's Fair in 1910. Over there in the corner is a statue of Vanderlip when he was a boy. The collie he is holding was a present from J. P. Morgan. It used to stand out in the gazebo, but Angelo and I brought it in here for safekeeping."

"It's beautiful. The whole house is so beautiful," I said.

"It was, fifty years ago. But now you can't even imagine what it was like. You're so taken by it, but it's practically a ruin," he said, looking up at the chandelier.

"I'm drawn to old houses. But more often than not, I seem to find them just before something drastic happens to them. Sometimes I think it's my mission in life—to record them," I said.

"I only wish you had discovered this place sooner. It's been sold, you know, and everything has to be cleaned out. Last week they started in the attic—you can imagine the clutter after almost two hundred years. There were dozens of old trunks filled with all these old clothes; some of them were so old they had corsets built into them. Most of them were falling apart.

"There were hundreds of them, enough to fill the entire dumpster that was parked out in the drive. It got so they just tossed the stuff out the attic window to save time."

I felt myself grow pale. "Oh, no," I said feebly. "They were probably priceless."

"I don't think any of us around here realized. I once saw Angelo use one of those old gowns to wash the truck," he said with genuine remorse. He glanced around the room, as though looking for a distraction. "Come, I'll show you the sky parlor, if you don't mind hiking up to the fourth floor."

He turned, and I followed him up the wide staircase, then down a long hall and up another staircase, where we passed a charming nursery. We paused to look at the fancifully colored hand-painted murals that ran along the walls. There were scenes of children in white ruffled dresses dancing around a Maypole. On one of the walls, there were ladies with parasols wheeling elegant wicker prams in a beautiful Victorian garden. On the mantel sat several woeful teddy bears and a red iron toy cannon. Under them, carved into the wood of the mantel, were the words: "The Beeches say Children Obey!" At the far end of the room there was a small green door. Behind it was a twisting staircase that led to a glass room, built into the tower on the highest point of the roof.

"There's a wonderful view of the river from here, but you can only see it this time of year. In the summer the beech trees block most of it." Mr. Mills stared out at the sweeping view for what seemed like a very long time. "Mrs. Vanderlip loved this room. She used to sleep up here alone in the summer. I think she felt closer to nature or God perhaps....She was like that."

We had to duck to keep from hitting our heads when we went back down. This time, Mr. Mills took a different turn in the hall, and we came to a curious Japanese room that was completely out of character with the rest of the house. Instead of a door, there was a sliding bamboo screen. The walls were all hand-painted with scenes of the Japanese countryside. There were tiny red-fringed silk shades on the wall sconces. Even the mantel, made from what appeared to be carved jade, matched the room.

Mr. Mills was about to show me something else when a faint, croaky voice called out his name from somewhere off in another wing. It turned out to be Angelo, asking about some boxes that were out in the garage. As we headed back down to the main floor, I noticed that Edward, the faithful dog, hadn't gone beyond the stairs. He remained frozen in place, making a strange noise. His master patted him gently and said, "Come along, ol' pal." I assumed the dog was too old to climb the stairs, but I was to find out later that there was another reason.

Mr. Mills disappeared for a few minutes; he then returned and graciously offered to make us some tea. I thanked him for all his help but told him I had to get back to Long Island. He walked me to the door where I had first come in and showed me another entrance to the property, adding that it was okay to climb over the wall if I preferred to do so.

Several days later I received a letter from Alfred Mills. He had contacted Frank Vanderlip Jr., who now lived in nearby Bedford, and had arranged for us to meet with him at the house the following weekend. The letter came as a surprise, and I was excited about having the opportunity to speak with one of the original owners about what life was like at Beechwood in its heyday.

The night of the meeting was a very stormy one, but somehow the atmosphere in Beechwood was enhanced by it. Mr. Mills had gone to great lengths to make the parlor homey. The room, which was off the library, smelled of fresh furniture polish. It was smaller than any of the downstairs rooms, but it had a cozy feeling to it, and a fire blazed in the marble fireplace. A silver tray with teacups was arranged neatly on the coffee table, next to which was a bright flowering amaryllis plant. Mr. Mills was adding more wood to the fire when we heard Mr. Vanderlip coming in the side door.

Frank Vanderlip's presence filled the room. A man in his eighties, he was still handsome, and his blue eyes sparkled. Alfred Mills greeted him warmly and helped him with his heavy, wet overcoat. Mr. Vanderlip smiled and gazed about the room as though he hadn't seen it in a very long time. After we were introduced, he shook my hand, then took his place in a comfortable brown leather chair next to the fireplace.

"So I hear you're interested in learning more about Beechwood," Mr. Vanderlip said enthusiastically.

"What was it like to grow up here?" I asked.

"It was idyllic. Not just the house, it was everything. My parents, their imagination, the people who came to visit—I wouldn't know where to begin.

"My dad was president of the National City Bank and had once been assistant secretary of the Treasury. Just about everyone had stayed here or attended a party or dance at some point. My parents loved people, and they did things on a rather grand scale. Ignace Paderewski played the piano for us in the library. Isadora Duncan danced for us out on the lawn by the old rose arbor. You must go down and see it during the day; it's a bit of a ruin now.

"Franklin D. Roosevelt, John D. Rockefeller, Jr., the last king of Poland, and Henry Ford were all guests here. Even the Wright brothers landed their new plane on our back lawn. They invited me along for a short ride, but my mother didn't think it was a good idea, so they sent my stuffed teddy bear instead."

Vanderlip's face was silhouetted against the flickering flames of the fire. He looked up at Mr. Mills and asked, "Alfred, whatever happened to those old photo albums that were in the attic?"

"I believe they're still up there, along with those glass plates, or stereoptics, I think you call them," Mr. Mills responded.

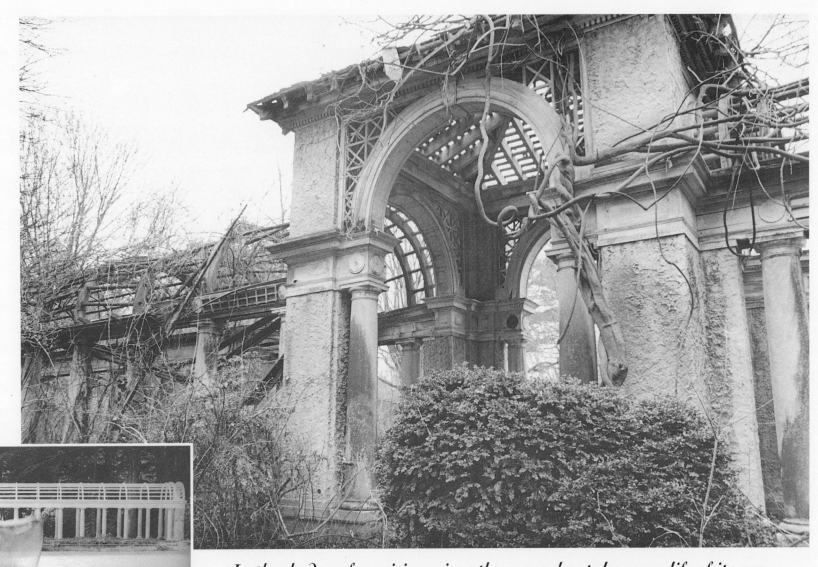

In the shadow of capricious vines the rose arbor takes on a life of its own.

Left, the formal rose arbor, now restored, evokes the memory of Isadora Duncan, who danced there in 1909.

Vanderlip continued. "Everything that happened here was recorded, you see, and it's a good thing that it was. My mother, Narcissa, she made a big fuss over holidays. She loved to host parties, and everyone was infected by her originality and spirit.

"She once raised half a million dollars to rebuild Tsuda College for Women after it burned to the ground during the great Tokyo earthquake in 1923. My mother came up with the idea of having the first air race from New York to Washington between a biplane and a carrier pigeon. Back in those days, a plane had to make three circles in the air before it could take off—so did the pigeon. Both the bird and the pilot of the plane carried an invitation to give to the Japanese ambassador for the party that was to follow. The race was one of the most publicized events. It was almost a tie—the plane won by only a few seconds. The party was a huge success, everyone came in authentic Japanese costumes, and there were paper lanterns everywhere. My mother was also good friends with Eleanor Roosevelt, and together they started the League of Women Voters."

"Of all the famous guests that stayed here, who did you most enjoy meeting?" I asked.

"They were all unique, all very special in their own way. There were so many of them, and the house was so big you only saw them when we came together for meals. I remember Sarah Bernhardt wanted to borrow my father's car. She couldn't walk because of a leg injury, but she had a grand time driving around the village in my dad's Pierce-Arrow. One year they had the Ringling Brothers' Circus do their entire show on the back lawn, and we had Annie Oakley shoot up the place."

"What an incredible childhood you must have had! How could you leave this place?"

There was a long pause, and the sound of the rain outside seemed to invade the room.

"Well . . . it was time for a change. That life had long since ended, and once my parents were gone, it was hard to live with all those memories. I'd walk from room to empty room remembering them and how they filled this house. I'd think of all those remarkable people, knowing they'd never be back...." His voice trailed off sadly, but his eyes didn't register any regret.

"I think you're a very fortunate man, Mr. Vanderlip," I said, looking around the room. "Even with the house half empty, it's such a warm and inviting place. It feels so safe, as though nothing unpleasant could ever happen here."

"Well, that wasn't always the case. You see, my dad didn't buy the house until 1905; it was built by a man named Walter Webb. I'm told that the property dates back to 1790, when it was a two-story colonial—then another wing was added in the late 1800s. My father added some of the more extravagant features: the ballroom, library, and rotunda. At one time, there was a statue by Rudolph Evans called *The Golden Hour* that stood on a marble pedestal in that octagonal room. The conservatory was also added, along with the fountain that came from the World's Fair in 1910. By the time my dad had finished, the house was longer than a football field," he exclaimed with pride, then continued.

"About a hundred years ago, some really terrible things did happen here. Didn't Alfred tell you about the murders?"

We both looked up at Alfred Mills, who had been standing there the whole time as if ready to deal with some emergency. His hand was resting on a sideboard next to a flashlight and a box of candles as though he expected the lights to go out at any moment, but they flickered only slightly as the storm raged outside. He shook his head. "I don't like to stir things up by talking about them. I think they hear us, and it's best to leave things be."

"Oh, you really must tell me. I'm not afraid of these things, really. . . . Please." I sat back in my chair.

Alfred proceeded. "I forgot all about the mad bishop, really. You kind of get used to him after a while. It's rare, but every now and then I do still hear him skulking about in the hall at night. He wouldn't hurt anyone—he's quite dead, you know.

"We have a kind of gentlemen's agreement: I don't bother him, and he doesn't bother me. I forgot all the details about what really happened here, but they're on file at the White Plains Village Hall—I mean, about the murder trial and all."

Mr. Vanderlip leaned forward and took a deep breath. "I'm afraid it's all true. I was about eight years old when they discovered one of the bodies walled up in the old Dutch oven in the basement. I saw them remove the bones one by one, along with a large gold crucifix. It was very unsettling.

"As I understand it, there was this self-proclaimed prophet, a religious fanatic. 'The Mad Mathias,' they called him. He wore a heavy gold cross around his neck. I'm told he was something of a flamboyant character. He had a footman who drove him around town in a gold chariot with six white horses—not exactly your normal thing for this conservative community.

"Anyway, the story is that he poisoned, stabbed, and strangled five beautiful young virgins here in this house and buried them in the floor in the basement. There was enough evidence to convict him of the crimes, but during the well-publicized murder trial Mathias disappeared and everyone just assumed that Mathias had somehow escaped and fled the country. In fact, the footman, who had been in love with one of the murdered girls, killed Mathias with an ax.

"The murder went undiscovered for some time, until we moved into the house and one of the servants noticed that there were more chimneys than there were fireplaces," he stated very calmly.

"The Dutch oven was in fact hidden from view by a large wooden armoire," he continued. "It wasn't until it was moved that they noticed there was something odd about the way the hearth had been walled up with bricks. I remember the servants had, from time to time, claimed to hear and see things that were unusual, but no one had paid them any mind. I personally have had no such experience of the kind, but Alfred here..." He looked up at our watchful host, who respectfully nodded.

Alfred responded: "Yes, indeed, you can hear footsteps and a kind of wheezing or labored breathing. You see, after

Mathias was attacked so brutally, he tried to struggle up the stairs to get away, but he ended up being buried alive in the oven," he concluded, shaking his head at the horror of it all.

"Good God!" I said. "That is the worst story I've ever heard!"

Just then, some sap from one of the logs in the fireplace exploded, causing a cloud of hot, swirling ashes to fill the room. Mr. Vanderlip bolted from his chair and covered his eyes as if something had burned him. Edward, who had been sleeping soundly on the floor, jumped up and ran from the room.

"The natives are restless," Mr. Mills mumbled under his breath as he ran to snuff out a cinder that had begin to burn the Persian rug. "Sorry about that. I'm afraid I was using the wood from that old cherry tree that fell down a few weeks ago—didn't give it time to age properly," he explained. "Well, I'm going to have some mess to clean up in the morning."

Mr. Vanderlip rose and brushed himself off. "I think I'd better be heading back to Bedford before this storm washes away all the roads," he said.

"Mr. Vanderlip, I don't know that it's a good idea to be out traveling on a night like this. Your old room is just as you left it," Mills suggested.

"I think not," answered Vanderlip with conviction. "I'd rather brave Mother Nature than this house," he said with a smile.

"What happened? I mean, to the body in the Dutch oven?" I asked with morbid curiosity.

"Oh, they just pulled all the bones out one by one, collected them in a box, and buried them out by the gazebo next to a forsythia bush," he answered as he headed for the door."

"What about the police?"

"Why make a fuss?" he responded, as though finding a corpse in your basement was just part of a normal childhood.

Mr. Mills and I thanked him for coming to talk with us, and we could hear the rain coming down very heavily when he opened the back door. There was a loud clap of thunder that shook the house as the wind continued to roar, whipping the house with branches.

After that evening, I returned several times and was to discover that the attic at Beechwood was a treasure house of old faded decorations from parties long forgotten. There were dinner invitations and dozens of mahogany boxes filled with stereoptic color glass slides of the Vanderlips and some of their famous guests: Eleanor Roosevelt, Sarah Bernhardt, Isadora Duncan, and a President or two. In an old dresser there was a drawer filled with original yellow crepe paper hats, the words "Votes for Women" inscribed on their white bands. Next to these was an invitation from the 1920s listing as entertainment a circus of trapeze artists, dancing bears, and performing elephants. An old, worn photo album revealed scenes of a garden

party with dozens of women in large, frilly hats and elaborate silk gowns. I found myself more eager to return with each visit.

Alfred Mills had become a good friend by then. He seemed to enjoy my visits and always had some new discovery to share. He was refined and gracious. I had the feeling that he rarely ventured out into the world, for he seemed as much a part of that house as the walls themselves.

I enjoyed his ramblings and memories of the place. There was something almost supernatural about his ability to unearth forgotten treasures from a home that had not been used in over twenty years. He was like a master magician as he wandered from room to room, from basement to attic, turning up things that were rich in historical significance, as well as other paraphernalia that had accumulated over the last two centuries. This renewed in me the purest sense of discovery. I was becoming caught up in the drama of the house: its aura of timelessness, its odyssey of bizarre tales, and the materialization of things long forgotten.

ABANDONED TRUNKS

I often had the vague feeling that there was something hidden, yet to be discovered, in that endlessly sprawling building. That premonition proved right when one day I got another call from Alfred Mills, saying he'd found something in the carriage house that I might find interesting. He had a way of understating things, so, unable to contain my curiosity, I drove up to Tarrytown the next morning.

When I arrived, I found Mr. Mills standing in front of the massive stucco carriage house at the northeast corner of the property. He waved and smiled in an engaging way, then slid one of the huge doors open.

The interior was divided into three large rooms on the main floor, with a narrow staircase that led to the gardener's apartment upstairs. An old pickup truck, covered with dust, was parked in the main garage. Beyond it, there was a long hall that led into a large, dark storage room with a high ceiling. It was filled from floor to ceiling with huge wooden crates of marble statues and shredded excelsior. There were also bits and pieces of furniture with broken arms and legs, and a Victorian swooning couch with faded rose-colored fabric hanging from it, along with a border of straggly fringe.

Alfred Mills stood in the doorway and switched on the lights. He then pointed to three black lacquer steamer trunks, with brass handles and hinges, standing in a corner. There were skid marks in the dust and straw on the floor where Alfred had apparently dragged them closer to the light.

"I knew these trunks were somewhere. I'd seen them up at the big house years ago—don't know how they got down

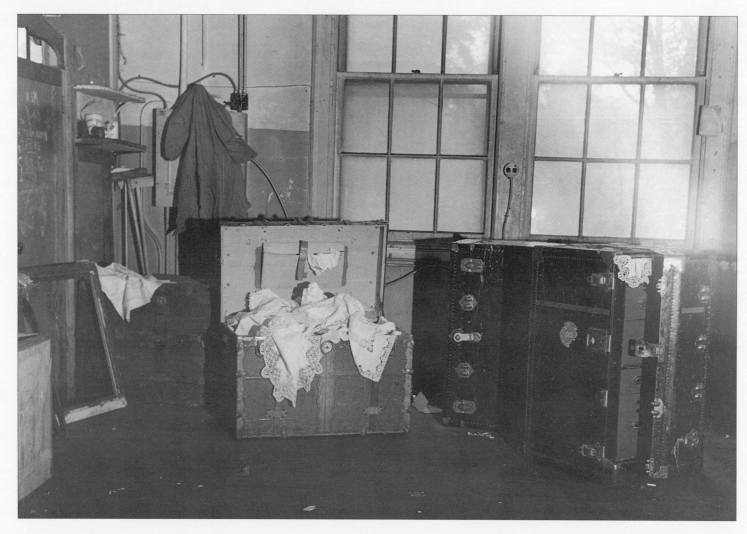

A tangible legacy of Beechwood was found in these abandoned trunks.

One of the gowns found at Beechwood evokes the memory of the five murdered girls who were buried there.

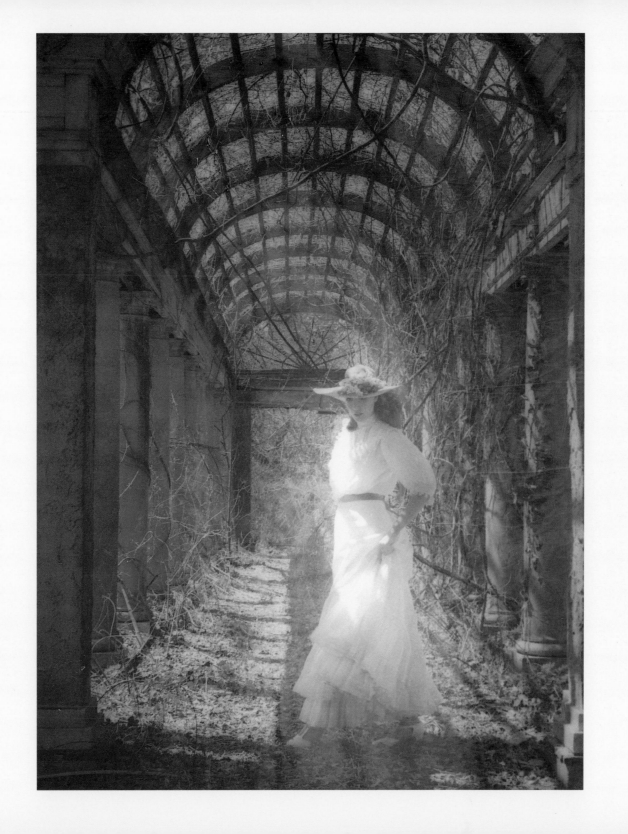

here. What with your fancy for old dresses, I thought you'd like to have them before they get tossed out," he said, beaming with pride over his discovery.

I opened the first trunk and what I found took my breath away. The trunk was filled with resplendent gowns, Victorian dressing robes, and vintage dresses with shimmering crystal beads. There were tea gowns and lawn-party dresses, trimmed with flowers and arabesques that were entwined in fanciful configurations. Among them were gowns with Paris labels, and two were original Worth gowns. There was a silk dressing robe lavishly embellished with pale satin ribbons that trailed down to the floor. Wrapped in tissue paper, yellow with age, was a great phantom of a ball gown so thin and frail it seemed to float when I pulled it out to look at it. The satin bodice was trimmed with tiny pearls shaped like orange blossoms that formed a wreath across the top. Tucked amid the delicate folds was a piece of blue stationery, the ghost of a perfume still clinging to it. Written in a bold, sweeping hand were the words:

> There is a lady sweet and kind
> Was never a face so pleased my mind
> I did but see her passing by
> And yet I will love her 'till I die.

It was unsigned.

The second trunk was filled with flamboyant beaded, feathered, and sequined frocks from the 1920s. Matching shoes and beaded bags were stored in red lacquer drawers on the left side of the trunk. One blue dress was trimmed with mirrored tubular beads of flowers in amethyst glass. It reminded me of a dress described in Fitzgerald's *The Great Gatsby*. Alfred Mills's face lit up when he saw my reaction, for as I carefully laid out each gown on a nearby chaise, I realized that many of them were the same gowns I had seen pictured in the colorful stereoptic slides in the attic.

"The family never threw anything out, as you can see. All these clothes were packed away so carefully, as though they'd planned to wear them again one day. Glad I found them when I did," Alfred beamed.

He then helped me move the third trunk closer to the light. I opened it, and a dead moth fell to the floor when I pulled back a brittle sheet of yellowed paper that lay across the top. Inside were two Japanese dragon robes, lavishly decorated with gold coiled dragons and embroidered at the hem with brightly colored wave designs. One robe was of a bright orange color, with clouds on bright polychrome silk. It was studded with tiny round mirrors and jewels set into brass clasps that shimmered as it caught the light. I noticed the name "Frank Vanderlip" was embroidered on the label inside. The remainder of the trunk was filled with beautiful antique linens and lace, the finest that money could buy. All were embroidered with the family's initials.

58

We continued to sort the gowns and costumes; there was a pile three feet high. The more I gazed at the gowns in those surreal surroundings, the more I knew that there was a reason that they were being given to me. They were not going back into the trunks to be crushed and forgotten. Despite the cruel metamorphosis that comes with time, though they lay there faded and frail as butterfly wings, there was something unfathomable about them. They seemed to breathe with a quiet grandeur, and I felt in them a subtle energy, something distilled from their former owners that continued to live in them.

I was determined to find some way to bring them back to life, as I had first seen them in those glass images taken in 1909. I set about mending, washing, and ironing them as best I could, and spent most of that summer at Beechwood photographing the gowns in the abandoned rooms and gardens. I tried to recreate the original scenes, using the ruins of Beechwood as a background. The effect was quite evocative.

While working there, I sometimes thought about the five murdered virgins sleeping forever under the floorboards of the basement and of Mad Mathias's bones moldering beside the gazebo. But I never heard or saw any ghosts at Beechwood. There were only the ghosts I had found in those clothes.

Alfred Mills was forced to leave the estate just before the house was gutted and turned into condominiums. He took his life savings and bought a small farmhouse upstate. I continued to visit him and bring him copies of the photographs I had taken of the wardrobe. He died a short time later, before I had a chance to tell him that my climbing over the wall that day was one of the best things I ever did and that, thanks to him, my work as a photographer had finally found its inspiration.

IRVINGCLIFF

Once upon a time, there stood a great Gothic villa on a cliff near Tarrytown overlooking the river. It is no more. But seeing Irvingcliff for the last time was well worth the six months it took to find it.

I had seen a photograph of the house in its heyday; it was in an old magazine dated 1890. Very few mansions from that time had survived in the area, with its close proximity to Manhattan and the Tappan Zee Bridge. After questioning some of the local people, I found the general belief to be that the house had long since been bulldozed.

Then, one day in March 1983, when the trees were still bare, I thought I spotted its stone tower in the distance while I was standing on the roof at Estherwood. I spent the rest of the day driving around in search of a gate or driveway that might lead to it, but I could not find one.

It was months before I came back, this time with a friend who shared a love for old houses. After driving around for some time, we found an old dirt road hidden behind an abandoned stable just off Route 9. There was a large rusty gate bound with a chain and completely covered with vines. The drive beyond it was impassable now, as it wound up toward a dense, dark forest.

We climbed up the steep mountain, following what was left of the road to see where it might lead. Ancient trees thrust great knotty roots through the open gullies, and weeds sprouted from jagged boulders. Strange plants worked their way out of the wilderness and entwined themselves around the giant trees. Vines stretched across what was once a road, and broken branches lay rotting in a muddy ditch.

Halfway up, we passed a huge fallen tree that had the shape of a monster; its branches spread like claws in all directions. As the road twisted and turned, rocks gave way underfoot. Finally, just as the drive began to level off, we turned a sharp bend and were startled by a great stone ruin with a tower that rose to a dizzying height. Swallows swooped and darted around its highest point, persistently shrieking.

There Irvingcliff stood, secretive and still, its jagged blocks of rough-hewn stone and mansard roof catching the light of the afternoon sun. Tall glass windows reflected the weeds of what was once a manicured lawn, and relentless vines stretched across the grounds and inched their way up the porch and walls of the house. A giant oak that had been hit by lightning now leaned indifferently against the side of the collapsed porte cochère.

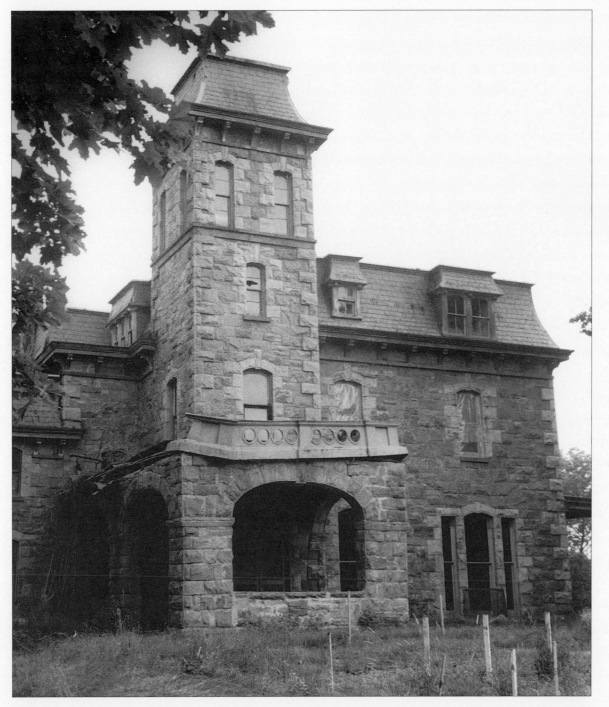

61

This photograph of Irvingcliff was taken just before it was bulldozed in 1983.

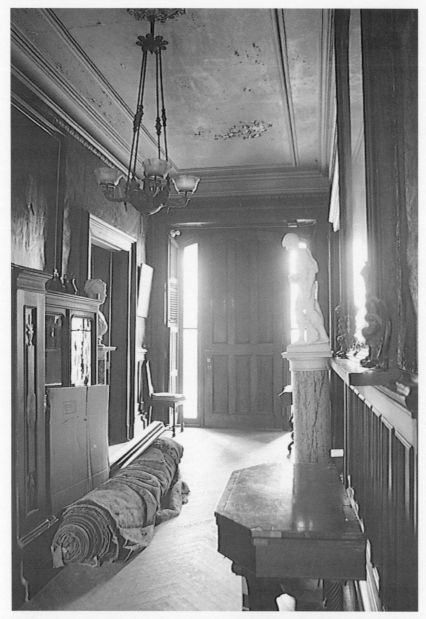

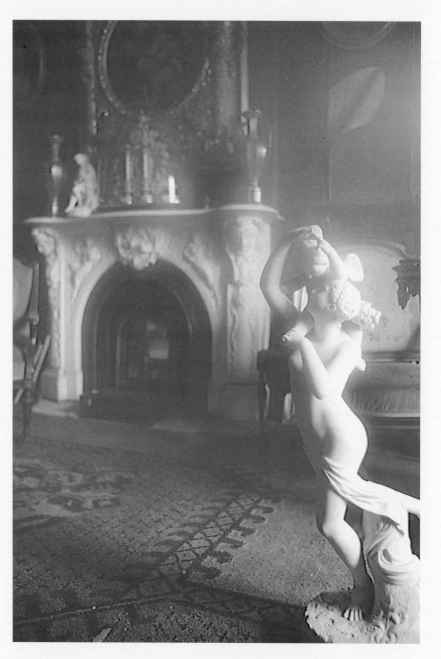

Above, a long gallery was lined with marbled statues and ancestor portraits. Right, a marble nymph dominates the grandest room in the house.

As we moved toward the house, a cloud rolled across the sky, momentarily blotting out the sun. The house stood in shadow. The glass was broken in one of the top-floor windows, and a frayed curtain blew softly in the breeze. As it moved, the house appeared to breathe. In the center of the wide lawn stood a huge marble urn carved with mythological faces. Growing out from it was a wan cluster of untended geraniums.

As we got closer, I noticed that most of the windows were shuttered up from the inside. Off to the right of the house, amid a mass of brambles, was an old Victorian carriage now bleached bone white by the sun. One wheel had broken free and lay rotting on the ground.

When we stepped onto the porch, the wooden slats creaked, and several gave way with a crunch. The front door was almost lost from view in a tangle of wisteria vines. They also concealed the slow rotting of the ancient pillars that supported the overhang of the entrance. An odd bat-shaped brass door knocker was bolted to the door. I tapped it several times, and it produced a faint echo inside the house.

There was an open loggia around the side of the building from which one could see into some of the windows. Through faded lace curtains I saw that the rooms were completely furnished. A faint shaft of light cast an eerie glow on a marble winged angel, her arms outstretched as though she were about to take flight. Toward the back of the house there was a room that appeared to be a library.

I stared in disbelief when I caught sight of a crystal vase, filled with fresh flowers, standing on a mahogany table in the center of the room. Even through the thin gauze of the curtains, I could tell the flowers were real. There were pink snapdragons, purple asters, and white cosmos. I had long since learned never to assume that a house was abandoned, but from its condition, this one appeared to have been so for at least forty years. The flowers reminded me of a famous Long Island mansion, where a mysterious servant came each day to change the flowers in all the vases long after the mistress of the house had died.

I looked at my friend, and we agreed someone had to be taking care of the place. We tried the back door, then called out, but only heard the swallows above our heads. I was so intent on watching the windows that I crashed into a spindly wicker stand and knocked over a pottery bowl of dead flowers. Suddenly the gaunt face of an old woman appeared in one of the windows, startling us. She stared at us for a moment, then motioned toward the back door. There was a long pause; then a massive oak door inched its way open with a creak. "Can I help you?" the woman asked in a faint, gravelly voice.

"We're looking for the owner," I said, sounding too much like the Avon lady. I glanced up at the great stone fortress that looked as though it might topple down on us at any moment.

The old woman stepped out onto the porch. She considered us solemnly for a moment, and then there was the trace of a smile. I was relieved to find she was friendly, and she didn't look at all like a ghost.

"How did you get up here?" she asked. "I didn't hear a car."

I pointed in the direction of the prehistoric jungle through which we had just climbed.

"Oh, that's the old road! You're lucky you weren't hurt. There's a new road on the other side where they're starting to build. I'm Mrs. McDonald," she said, extending her hand. "I sort of oversee the place, but I'm not the owner. Mrs. Rutter is. She lives in the carriage house at the foot of the cliff. She never comes up here any more. It makes her sad, I think."

I explained I was doing research on the old Hudson River estates, and that I wanted to capture them on film before it was too late.

"Would you like to come in?" she asked, as though she were an innkeeper and we were potential guests. Eagerly, we followed her into the darkened hall.

The air was different inside. There was a long gallery lined with marble busts of ancestors set on white marble pillars. Above them, somber portraits in gilt frames gazed disapprovingly down on us. A bronze statue of a warrior was mounted on the banister, and a faint golden light shimmered from the globe that balanced in his hand.

Then I caught sight of what looked like a long-extinct stuffed bird with its talons extended. It was bolted to a branch high up near the ceiling. I looked at my friend and pointed silently, thinking the place looked too much like the Bates Motel. Persian rugs muffled the sound of our footsteps as we passed bookcases filled with old leather-bound volumes. It was a house unlike anything I'd ever seen.

"All the furniture is in its original place, where it has always been since the house was built over a hundred and twenty years ago," said Mrs. McDonald, undaunted by the dust and decay around her. Seeing our interest, she walked toward a set of oak doors that rose to the ceiling and were almost as wide as the room itself. Despite their weight, she slid them open with ease.

"This is the library, where most of the family used to gather," she explained, adjusting her wire-framed glasses. It was a splendid room, filled with the richness of the past. Carved Gothic bookcases stood twelve feet tall, and two Ming vases sat atop them gathering dust, well out of reach. The vase of fresh flowers I'd seen from outside stood in the middle of the room. I walked over and admired them.

"I brought them over this morning as a kind of final farewell," she said sadly, then turned and walked out of the room.

"The house was never wired for electricity, you know. All the gas lamps still work," she called from out in the hall. She then reached into a small wooden box, pulled out a match, and lit one of the ornate brass fixtures on the wall. I watched it flicker behind the delicate cut-glass shade. "These walls are all black walnut, including the staircase." She ran her hands over them softly. "Come, I'll show you the grandest room in the house."

Ahead of her was another pair of massive doors, and there was a rumble in the hall as she pushed them open. She

moved through the shadowy doorway and glided into the room. Just ahead of her was the winged angel I'd seen earlier. Stacked up in front of the marble fireplace were dozens of old framed portraits that looked as though they had only recently been removed from the walls.

"This is where they held the special events," she said as she moved toward one of the shuttered windows. When she opened it, puffs of cobwebs stretched and fell to the floor.

"There, now you can see." She seemed at home in her faded surroundings. In that light, she was a ghostly presence as she moved about the room. Then she sat down in one of the gilt French chairs and watched us as we stood there, entranced.

"The family held their weddings here, and the christenings, and such wonderful Christmas parties. The furnishings were made for the house when it was built. They're Louis XIV Revival," she said with pride.

I gazed about the room, then caught my reflection in an enormous gilt rococo mirror that covered the entire east wall. Above it, fine pinpoints of light shimmered from delicate prisms in the massive cut-glass Victorian chandelier. I could almost hear the music as I pictured guests dancing beneath that gaslit fixture, twirling round and round in whispers of lace.

At that moment, the huge gold clock emblazoned with cherubs struck the hour. Moments later, we found ourselves back out in the hall. Then we were led through several shadowed corridors, past the butler's pantry.

"The old kitchen's been boarded up for twenty years now. The floor gave way." A faint light leaked through a broken board, and we could see a huge wood stove with a black iron canopy hanging over it. The sink was made from a solid piece of walnut with a copper basin and an old rusted hand pump. Off in a corner was a bentwood coat rack, a straw picture hat hanging from it by a faded ribbon.

We continued down the length of yet another dark hall, then turned left through an arched door and found ourselves back at the foot of the main stairs. Mrs. McDonald looked up, then turned to us, her eyes glistening a little in the faint light.

"I don't usually do this, but I'll show you the upstairs." We followed her up to the second-floor landing, which seemed to have more piles of books, trunks, and furniture than it could hold. There were stuffed birds under glass domes. There was another passage that led to the third floor, and beyond it was another staircase that led to the tower. Light from a fan-shaped window illuminated the cobwebs as we passed.

She paused for a moment and searched her pocket for a key, then realized she didn't need it. She opened the door to the master bedroom without saying a word. It was a large room with classic lines, a carved fireplace, and soft beige walls. Dominating it was a great mahogany four-poster bed that rose up to the ceiling. The gauze-like canopy hung in shreds from the wooden frame. Lying on top of a waterstained floral bedspread was a huge gilt mirror.

"I put that there to catch the rain," she said in a resigned tone. "There are leaks everywhere. The whole house is beginning to dissolve. It's the mortar, something to do with the mortar and the acid rain."

"What will happen to the house?" I asked.

"I'm afraid it's doomed. All the furniture is being picked up this week to be auctioned off in the city, but the house... It's coming down any day now." Her voice trailed off, and she seemed lost in her own thoughts. Stunned by her words, I thanked her for showing us the house and suggested I come back and photograph it before it was too late. She agreed it would be nice to have a record of it.

I never saw Mrs. McDonald again, nor did I ever find out just what her relationship to the family was. The following week I was given permission to photograph the house, but by that time all the furnishings, mirrors, and paintings had been tagged for the auction. The winged angel, which had stood in the drawing room like an ethereal sentinel for over a hundred and twenty years, now had a lot number tagged to her outstretched arm. All around her was a pervading feeling of utter desolation and gloom.

On the day I was to photograph Irvingcliff, it was like visiting a war zone. It all seemed so surreal, the dissection of a ruin, the violation of a monument. Soon there would be no trace of Irvingcliff's existence. It was chaotic. There were work crews loading endless boxes of books, statues, rugs, and furniture into trucks bound for New York City. I suddenly felt an ache in my soul, though I was grateful to Mrs. McDonald for sharing that secret sanctuary on that special day. It filled the artist in me with a sense of rapture, and its aura of timelessness could never be duplicated.

While leafing through a box of old photographs in the attic, I was struck by a curious photo of a stern-looking woman with cold, unyielding eyes. She was dressed in black, and she stood rigidly in front of the house in its heyday. Standing next to her were two young girls with pained expressions on their faces. There was a feeling of unrest about all three of them, despite the beauty of their surroundings: ornamental gardens in perfect order, with lush bowers of roses trained on wire trellises. I was staring at the photo intently when a handsome woman in her seventies entered the room, taking me by surprise.

"Oh, I see you found them. The real treasures of the house are all up here, all the memories. I'm Mildred Rutter; I believe we've spoken on the phone a few times. I'm glad you could make it; there isn't much time." She bore no visible sign of regret. "I was just coming up here to go through some of these old things. I wouldn't want all this to go down with the house."

"This must be a difficult time for you," I said.

"I've been resigned to this for a long time now." Her eyes roamed the room as though she were looking for something. "It was something in its day. It was originally built by Eliphalet Wood around 1857. There was once a tennis court; it's completely overgrown now. There was a wrought-iron gazebo, too, and stone barns for the cows and sheep. There were

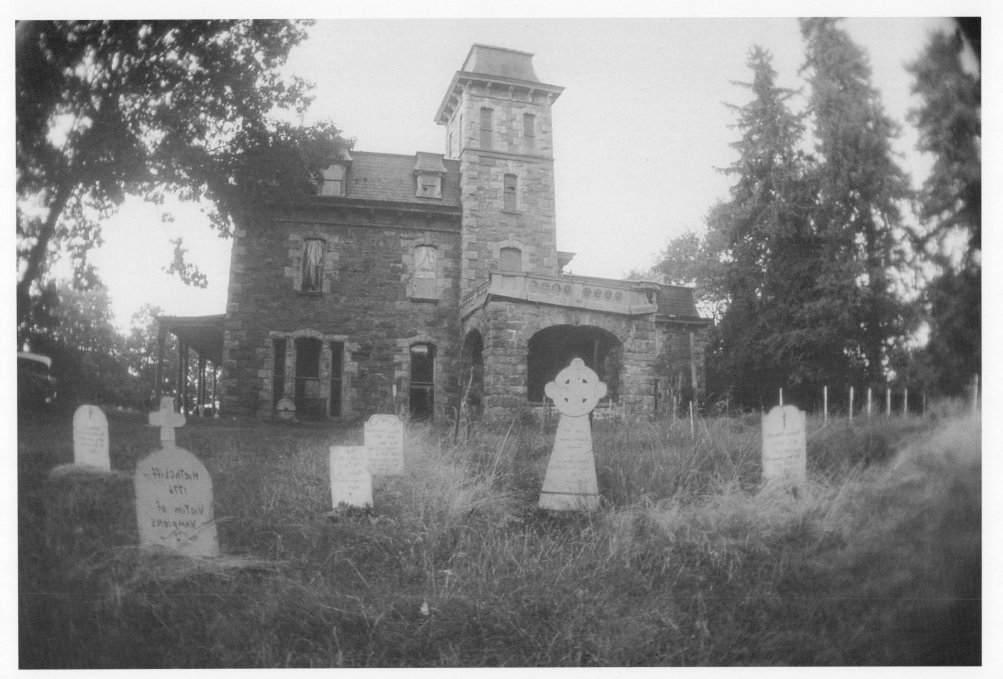

As the sun rose hazily from the east, Irvingcliff cast its final shadow.

The nursery with the old dollhouse and the shabby teddy bear with the chewed off nose.

lots of sheep everywhere. They used to walk right into the house when the doors were open during the summer. I always think about that wonderful fresh cream; we would eat it off the top of the milk buckets with a spoon. You don't know what real cream tastes like today," she said, appearing to savor her memories.

"Do you know who the people in this photograph are?" I asked. She leaned forward and adjusted her glasses to get a better look.

"I believe that's old Mrs. Rutter. Those two girls are her spinster daughters, Esther and Daisy. They lived like prisoners in this house; never married, either of them. The one was somewhat attractive, the other plain and on the heavy side. Poor things. The mother hated children. Didn't try to hide it, either. She was so very selfish and cruel; treated those girls like servants. Put the fear of life into them, so much so they grew up unable to face the world, so they lived out their lives here in this house. Never had any friends that I know of. Daisy carried a lock of George Washington's hair around with her. It was apparently the only thing her mother ever gave her. It was all very sad," she said, turning to rummage through some old boxes.

"We used to play up here as children. This was the nursery. I see my old dollhouse is still here, and the magic lanterns. Then her eyes lit up as she spotted something lying amid the dust and cobwebs. Reaching down, she gathered up an old, shabby teddy bear in her arms. The nose was chewed off and bits of straw fell from a broken joint in one leg.

"I'm glad I came up here," she said, holding the bear to herself with a faint smile. "I wouldn't want anything to happen to him." She then turned as if suddenly distracted. "It was nice meeting you," she called out as she disappeared into the hall. I could hear her footsteps fade as she made her way down the long stairs.

I went back several weeks later. Everything was gone; only a few pieces of broken china remained on the pantry shelves. A beautiful blue-and-gold vase, marred by a hole in its side, stood abandoned on the windowsill. I climbed the stairs and took one last look out the tower window. There were papers, old letters, and journals strewn about the floor. I picked up a letter with the Masters School insignia on it and put it in my pocket.

September 1, 1983. D-Day dawned misty and overcast, but the sky began to clear as the first of the bulldozers arrived. A low, restless wind blew from the river. Branches of the surrounding trees bowed weirdly as though bereaved, and as the sun rose, Irvingcliff cast its final shadow across the barren lawn.

CARROLLCLIFFE

Carrollcliffe (or Axe Castle, as it is now known) stands on the highest point in Tarrytown. Like a vision from the dark ages, the fortress peeks out from behind ancient trees. Though few commuters on their way to the Tappan Zee Bridge miss this sight, many are unaware of Carrollcliffe's history.

Carrollcliffe was built in 1900 by General Howard Carroll, son of the Civil War general who was killed in the Battle of Antietam. The young general made his fortune as a newspaperman and a playwright, and received much recognition for his production of *The American Countess*, which ran for two hundred nights on Broadway. A man of many talents and interests, Carroll was also assistant to New York governor Levi Morton and was inspector general of the New York troops during the Spanish-American War.

Carroll designed much of the castle himself, inspired by the Norman castles found along the Welsh marshes and on the Scottish borders. Carroll was particularly taken by a fortress he had seen in Ireland, called Castle Linsmore. He was intrigued by the ancient castle's legends and ghosts but realized his own Hudson River fortress would lack the drama of older ones. With his theater experience, however, he was quite skilled in creating atmosphere.

The stones for Carrollcliffe were quarried from the property by local masons. The main tower, which stands over eighty feet tall, can be seen for miles. Carroll brought many father-and-son carpenter teams over from Germany, and they spent years carving the oak girders, beams, joists, and furniture. An oak room was brought intact from General Carroll's house in Saint-Germain, outside Paris. That residence had been given to James II by Louis XIV after the British monarch had fled to France. According to legend, it was in the oak room that James's grandson—prince Charles Edward, the young pretender—had plotted the uprising of 1745 with Angus MacDonald.

Carrollcliffe contains one of the largest banquet halls ever built in this country. It is in the north wing, and as many as a hundred guests could be seated in the matching hand-carved chairs that surrounded the massive oak dining table. The dining hall was dominated by a huge medallion-shaped stained-glass window, set high into a forty-foot wall. Its multicolored prisms diffused a soft, ethereal light about the room. At formal dinners, musicians played for guests on an ancient carved-oak balcony at the opposite end of the vast hall. There was also a ballroom with hundreds of gilt-framed mirrors; crystal chandeliers shimmered from the elaborate ceiling. The vast kitchens were located in the lower level of the house, and as many as twenty-five cooks exercised their culinary skills around the huge ovens.

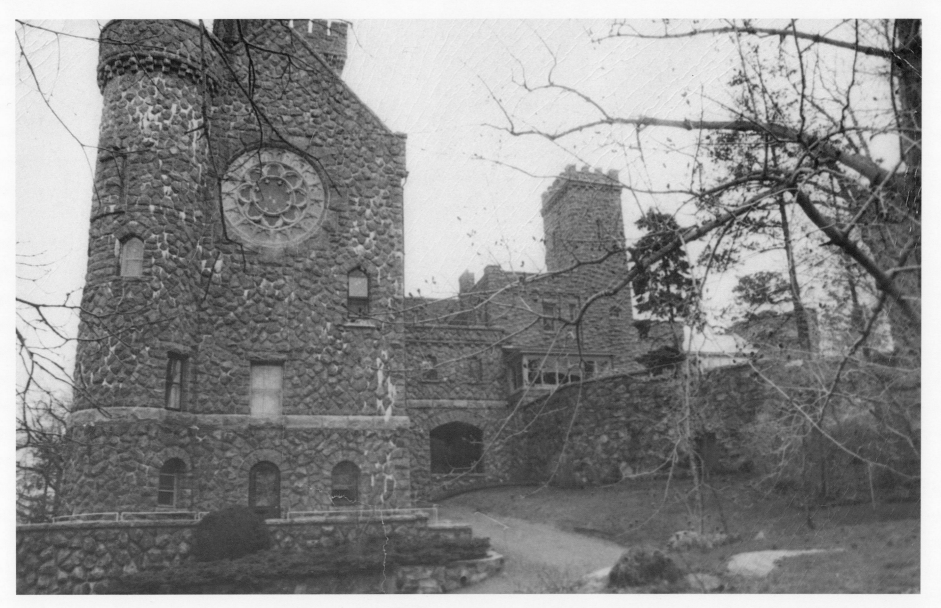

A massive stained-glass window sets off the main wing.

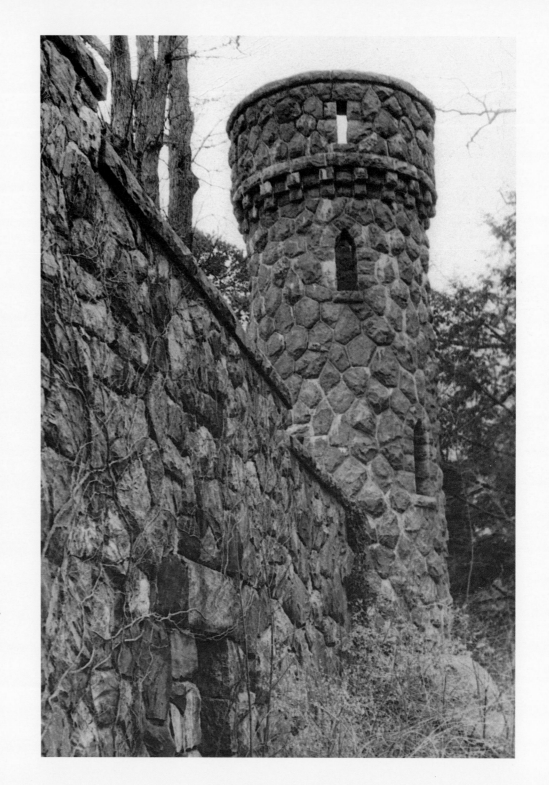

One of several feudal-styled towers found around the castle.

Much attention was given to the grounds' sixty acres. In the spring, the gardens bloom with pink and white dogwood, and there are hundreds of rare varieties of lilac trees. Rhododendron and many varieties of flowering shrubs and trees also abound. Farther down a wooded glade, there was once a rock garden, with a stone swimming pool graced by a pair of gargoyles.

In 1941, the castle was sold to Emerson and Ruth Axe, who turned it into a financial center known as the Axe Organization. Many of the original furnishings, artworks, and tapestries were sold off during the Second World War. One of the custom-made linen tablecloths from the great dining hall was cut up into sixty bedsheets for wounded soldiers overseas. Today, the rooms at Axe Castle remain intact, but they are filled with computer installations, advanced communications equipment, and modern offices. The gardens are maintained as in the old days, and the Tudor-style carriage house, with its charming Old World clock tower, is now used by staff members. At the main entrance there is a small replica of a feudal castle that serves as a guardhouse.

KYKUIT

Kykuit, the Rockefeller estate in Pocantico Hills, just above Tarrytown, has a security system comparable with that of Fort Knox. Armed guards, police dogs, TV cameras, alarmed fences, and gates keep trespassers out. It wasn't always this way— at one time, the grounds and magnificent gardens were open to the public. But things have a way of changing.

The land had originally been called Signal Hill, after its high ridge with a thirty-mile view of the river, and had been used by the Indians to send smoke signals. Later, Dutch settlers claimed the land, and it became Hill Kykuit. John D. Rockefeller, chairman of Standard Oil, purchased the property in 1893.

Rockefeller already controlled 95 percent of all U.S. oil refineries by this time and had come to the Hudson in search of a more peaceful life. Upon taking in the river view, the "robber baron" (as he was referred to by some) waxed poetic; he was quoted as saying "Fine views invite the soul." He envisioned his future home as a sanctuary. He put on work clothes and shoveled dirt with his crewmen, helped plant the trees, and set the rocks and stones along the paths in his garden. Unable to limit himself to his estate, he also extended his project to the New York Central Railroad. Rockefeller used his formidable power to close the Pocantico Hills station and move the tracks a mile to the east, demolishing the trestle and all else he deemed unsightly in order to create a private golf course.

When the historic wooden house that stood on the hill burned down in 1902, Rockefeller commissioned the firm of Delano & Aldrich to build a Georgian-style mansion out of fireproof granite, a project that lasted the next seven years. Inside, the sixty oversized rooms were done in a traditional English style. The four-story building had a blue-green copper roof that was visible for miles.

But Rockefeller was by no means finished. Upon learning of John Jacob Astor's sporting palace farther up the river, Rockefeller added a recreation playhouse the length of a football field. It had two outdoor clay tennis courts; both an indoor and an outdoor swimming pool, a bowling alley, and a billiard room—all behind an English country façade. And Kykuit was to be a very proper place: vices such as profanity, card playing, gambling, drinking, and smoking were not allowed.

Indeed, Rockefeller had built a lavish retreat for himself and his family. In 1914, however, following some labor trouble in one of his factories, industrial workers from all over the world, armed with knives, clubs, and rifles, marched

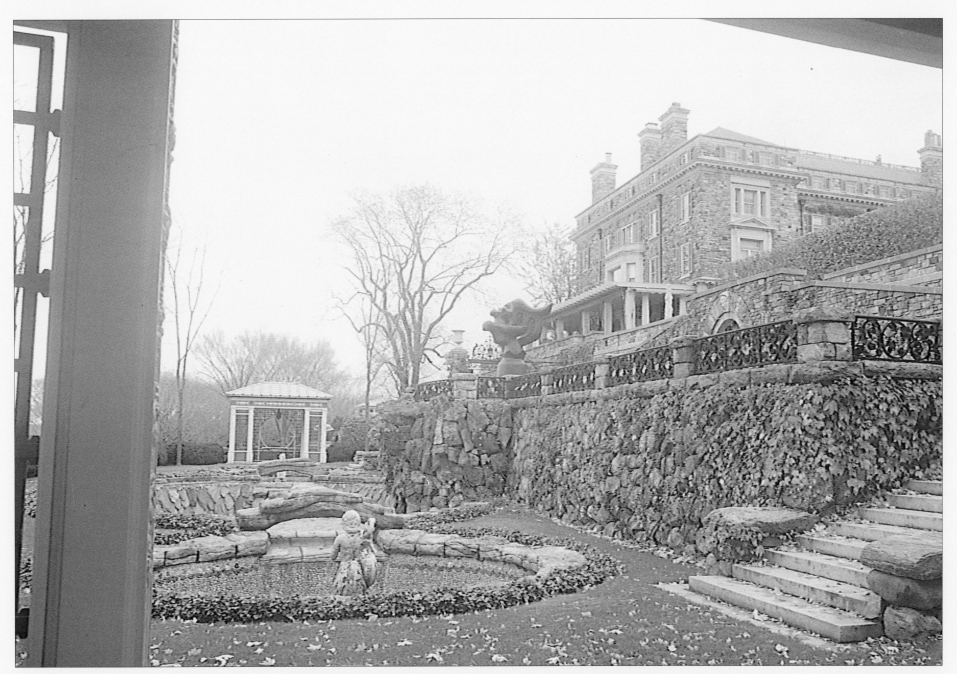

Kykuit on an overcast day as seen from the river.

Twin reflecting pools set with thousands of stones.

across the manicured lawns of his sprawling estate. Squadrons of police were called in to halt the invasion. Shaken by the experience, Rockefeller made sure this was the last time the masses would set foot upon his property. Stone walls went up, gates were kept locked, and guards stood watch twenty-four hours a day.

Although he had some enemies, Rockefeller was well liked in the community. His neighbors called him "Neighbor John," and he often drove around the village in his carriage, handing out newly minted dimes to the children. He also built playgrounds, a school, a firehouse, churches, three new roadways, a welfare center, and a hospital in the neighborhood.

His son, John D. Rockefeller Jr., devoted his life to philanthropy, spending much of his resources on art and artists. The Rockefellers donated a huge stained-glass window to the nearby Union Church. The window, created by Marc Chagall, depicts radiant angels flying through the heavens.

The Rockefeller children, despite their family's advantages, were not spoiled by money. John D. Rockefeller Jr., made them work from the ground up, just as their enterprising grandfather had done. Nelson Rockefeller and his brother Laurence, while young boys, formed their first businesses on their own. They ran errands, worked as gardeners on neighboring estates, shined shoes, and killed flies at a penny per bug.

Nelson A. Rockefeller went from being a fly-swatter-for-hire to governor of New York, and later vice president of the United States. The family was not without its tragedies, however. Nelson's son Michael, who grew up on the family estate, went off to explore the South Pacific and drowned when his yacht sank during a storm.

Kykuit is now open to the public. The Rockefellers' vast art collection is well known, and what is not displayed in the house is hidden in bombproof underground chambers that form a vast network of rooms and tunnels beneath and beyond the house itself. In one such room, there is a cavelike chamber of fossil rocks, stalagmites, and stalactites, all adorned with ancient life-sized carvings of elephants. Also in the room is a beautifully illuminated waterfall. Outside the entrance to the underground chamber, there is a classical temple. A brook, which begins to the west of the estate and flows through the entire length of the garden, sets off a Japanese teahouse. Designed by Junzo Yoshimura, it was inspired by the sixteenth-century pavilion of Katsura Villa.

There are many outstanding works of art to be seen all around the estate's gardens, including a Florentine statue of Aphrodite, attributed to Praxiteles. The Oceanus Fountain is a replica of a fountain in the Boboli Gardens in Florence, and there is a twenty-foot bowl carved from a solid block of granite from Stonington, Maine.

THE "ELEPHANT" HOUSE

Every once in a great while someone with an indomitable spirit comes along and acts as a catalyst for his fellow men. Dr. Pierre Bernard, known to his friends as "Oom the Omnipotent," was such a man. While his name is no longer recognized, he deserves to be remembered as one of the Hudson Valley's most colorful and innovative free thinkers.

During the first half of this century, it was not uncommon for passersby on Route 9W in Nyack to bring their cars to a screeching halt while half a dozen elephants trotted across the highway on their way to a playful dip in the river. These were no ordinary elephants. They were believed to be the most talented in the world: they played drums and chimes, rode tricycles, walked tightropes, and danced. When they were not performing, they amused themselves by drawing and painting with brushes and pencils they held in their trunks.

The elephants' unusual skills were due to the loving attention and training of their master, Dr. Bernard. Born in 1875 on a farm in Illinois, he hopped a freighter as a teenager and eventually made his way to India. There he became fascinated with Eastern religions. He also developed a great love for elephants and animals of all kinds and believed they possessed special spiritual powers. Carved into the mantel in his home was a quote from an ancient scripture: "If you want to discover the kingdom of heaven, listen to the birds and follow the animals."

When Bernard returned to America, the news media followed his every move. He was something of a showman— an occultist with psychic abilities that were astonishing. He delighted in bizarre publicity stunts, which sometimes involved his giant playmates.

Though a serious scholar, he lived out his fantasies on a grand scale. He had mastered Sanskrit at an early age and taught it at several prestigious universities, but when he founded his own Sanskrit College in New York in 1909, he was arrested. Police thought it was an occult language and therefore illegal. He was released when they found the subject was taught at colleges across the country.

A short time later Bernard was again in the news, this time over his famous "Temple of Mystery" on West Seventy-fourth Street in New York City. Here he taught tantric yoga, hypnotism, and soul charming. The police raided the building after neighbors accused him of hosting wild orgies and abducting young virgins to sacrifice to his elephants. The charges were dropped when officials realized that Bernard and his friends were simply practicing yoga in traditional white robes and there were no elephants to be found in the building.

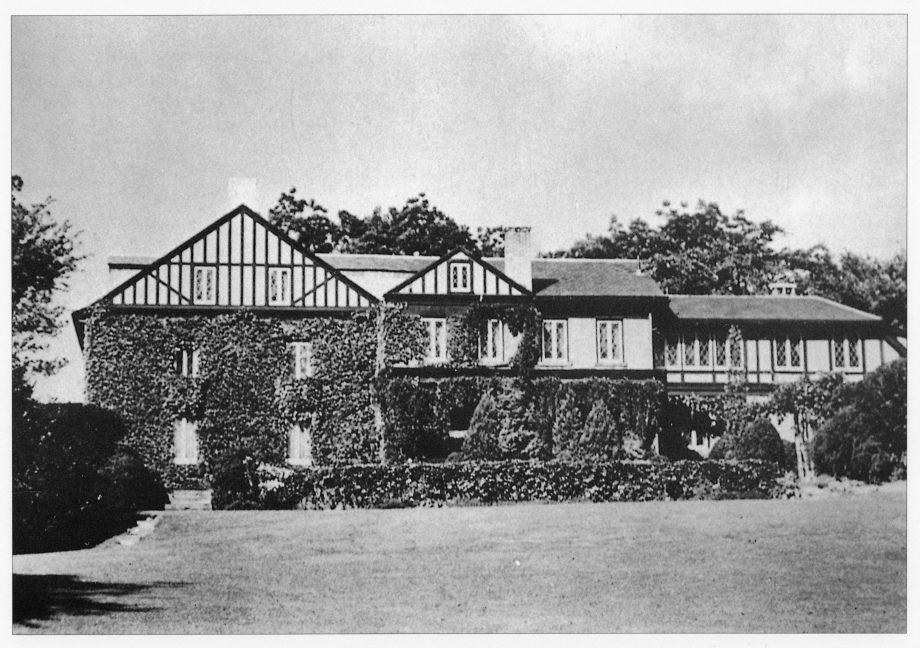

Dr. Bernard shocked his neighbors by building an oversized wing for his pet elephants at his Tudor mansion in Nyack

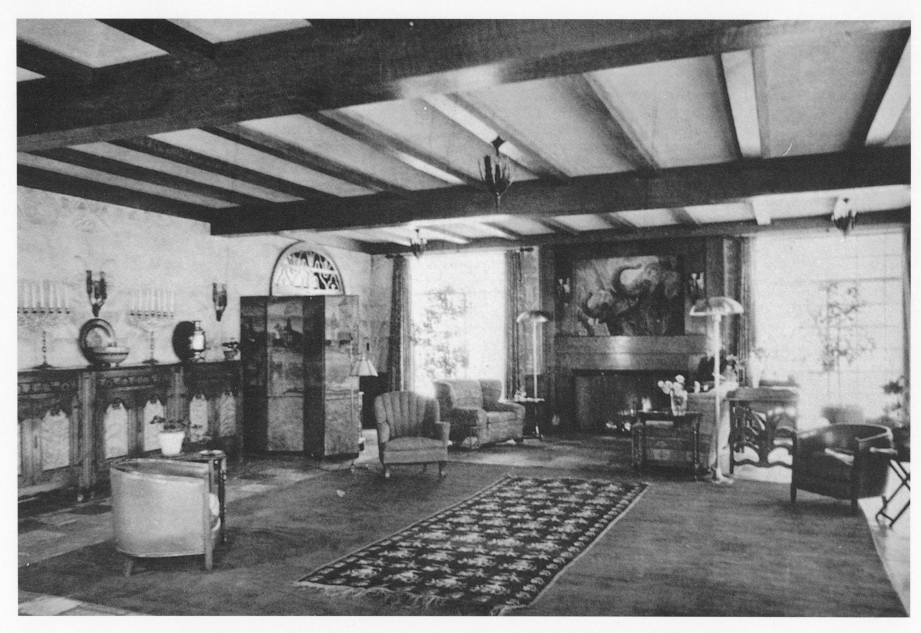

In the living room a massive painting of his elephants hung over the fireplace.

Though Bernard thrived on sensationalism, he decided it was time to take to the country. He married Blanche De-Vries, a professional dancer, and together they built a sprawling Tudor-style mansion on the river in Nyack. He chose the location because of the view of Hook Mountain, which, from his house, took on the shape of a colossal elephant. He purchased what was then known as the old Maxwell estate, as well as several surrounding properties, which in all came to 160 acres.

This caused quite a stir among the locals. Speculation ran high as to what he might be doing there. Despite his credentials, Bernard made a lot of people nervous. He was by then a leader in the field of preventive medicine and the healing arts, as well as the president of a bank, a mortgage and construction company, and a realty firm in New York. He was a brilliant success at everything he did, and his investments grew. At one point, he owned over $12 million in real estate, a figure surpassed only by the Rockefellers, who lived directly across the river.

Construction began on his Nyack estate: walls and massive gates went up, strange tunnels were dug, and cages were built. A total of thirty-four buildings were erected, including a temple and a theater. There was even an Olympic-sized pool for the animals, complete with classical marble statues and elaborate fountains. Then came the dancing elephants, followed by a gorilla named Gonzo, a tiger, a leopard, some llamas, several reptiles, and enough exotic birds to fill a large aviary. A man-made lake filled with rare black Australian swans was added, along with a seven-acre airport, to and from which Bernard flew guests in his private plane. An existing greenhouse was dug out to make way for an indoor pool, and a professional-size baseball stadium was added to the north side of the property. Bernard's name did not appear on the mailbox outside the entrance; instead, carved in stone, were the words: "Here the philosopher may dance and the fool wear a thinking cap." The local papers reported Bernard's progress; they had never known anyone like him before.

The first evidence of his arrival came when one of his elephants found the iron gate open and wandered off in search of more exotic food than that provided at home. A neighbor recalls that while making apple pies one day, she heard a noise. She looked up and saw what looked like a monster reaching in through the window and sucking up two of her best pies. Again, the police were called. On another occasion, Gonzo the gorilla escaped and terrorized the streets of Nyack before he was caught and returned to his master. The rumor persists that Bernard belonged to a secret cult that worshiped the noble pachyderms.

In fact, Bernard had acquired a love for elephants while in India, where they were revered for their strength, stability, and wisdom. Furthermore, he was moved by their similarities to humans in that they stood by one another and cared for their sick and elderly. In Eastern cultures, it is said that when an elephant dies in the wild, its fellows will hold up the body as if forming a funeral cortege. They bury their dead, covering them with leaves and palm branches, and return to visit the graves months or even years later. It is believed they communicate with a vocabulary of audible and subsonic sounds that constitute a surprisingly nuanced and expressive language. Perhaps the most astonishing thing about them is

their ability to draw and paint with their trunks, and their apparent appreciation for music and the sound of human chanting. It is interesting to note that in the Hindu religion, the elephant-headed god Ganesha was regarded as the divine patron of the arts. Eastern myths also say that a sacred white elephant was the father of Buddha himself. Images of elephants have been carved on the walls of caves since the dawn of man. They appear in Egyptian tombs, as well as on Roman coins and Mayan temples. Bernard's Nyack estate and its outbuildings were decorated with carvings, ceramic designs, and murals of pachyderms in jungle settings.

Rumor has it that in order to avoid further controversy, Bernard built a tunnel from the main property to the elephant house. In this way, the elephants could come and go as they pleased without being seen. On special occasions, the animals were treated as honored guests at the mansion; they dined on papyrus leaves, fruits, rice grains, and palm toddy. They were lovingly draped with garlands of flowers and orange blossoms. Bernard and his friends sang, chanted, and danced the night away with the elephants.

It is unclear as to whether or not these events were part of some ancient religious ritual, but from all accounts it would appear that the mysterious animals were more than just pets to Dr. Bernard. His life seemed somehow enriched by close contact with these wise and playful creatures. Bernard continued to study Eastern philosophy and mysticism and was so skilled in the control of his body that he was able to slow his heartbeat so as to appear dead. Some witnesses say he was able to levitate while in a trance. He was also notorious for his powers in the realm of the paranormal. During the First World War he brought in clairvoyants to assure worried parents that their sons would return home safely. Again these activities didn't sit too well with meddling neighbors, who repeatedly called the police. His rights to privacy and property were repeatedly violated.

Bernard was not exactly what one would call a matinee idol. He was wiry and pale with a high forehead, a long nose, a thin upper lip, and piercing blue-green eyes. Still, women flocked around him and behaved strangely in his presence. Some claimed he had a hypnotic power over them; his female students were known to walk around him three times, then kiss what they described as his "lotus feet." Others bowed and called him "Oom" or their "love guru." Several of his followers said he possessed a cosmic punch or an electric arch that would jolt them, sometimes to the point of causing them to fall backwards.

Most puzzling to locals, who were known to roost in the trees with binoculars just outside his property, were the sightings of men and women frolicking together naked in the glass-enclosed pool. These reports further fanned the flames of gossip; rumor had it that Bernard was running a sex-crazed love cult.

Concerned Nyackians filed a complaint with the local public officials. A squad of troopers on horseback galloped onto the estate, then burst into the room where Bernard was standing on his head wearing a loincloth. The sergeant in charge did a double take, then read off a list of licentious charges. Bernard, used to such things, righted himself with a single athletic flip and responded: "I'm a religious scholar, a man of common sense in love with beauty and that sort of thing.

There ain't no nudist cult here. No, sir, nothing like that. Acrobatic exercises for men and women, lectures on art and philosophy, nice little things like that. Now, get off my property or I'll sue you."

The troopers retreated sheepishly, never to return.

In an effort to change his image, Bernard opened his doors to the public. He named his estate The Clarkstown Country Club, but it was not a country club by any definition of the term. It was a world unto itself, the stuff of a Steven Spielberg fantasy. The residents of Nyack were aghast when Bernard raised the largest circus tent ever seen, then invited thousands of people to attend the gala opening of his Clarkstown Circus. It was a circus made up entirely of his friends and his animals. Bernard was an acrobatic artist himself and often did routines along with his amazing elephants. There were unusual dance troupes, operas, Greek plays, and fireworks displays.

Bernard was a phenomenon, unlike anything the Hudson Valley had ever seen or experienced before. His spectacles and theatrical events became legendary. His events were attended by the social elite, such as the Vanderbilts and the Morgans, as well as by political leaders and members of the literary, art, and musical communities.

When not performing for the public, Bernard and his creative wife lectured, trained, inspired, and transformed people's lives with a unique and successful health system called the Sacred Order of Tantrics. This society had a surprisingly large following, and its members included Mrs. Ogden K. Mills, Margaret Rutherford, Catherine Turnbull, Cyril Scott, conductor Leopold Stokowski, B. F. Goodrich, and a few of the Vanderbilts. His healing system incorporated tantric yoga, meditation, expressive dance, psychophysical education, hypnosis, and even the development of clairvoyance and psychic abilities. These disciplines were then put to regular tests by Bernard, who masterminded games of telekinesis, balancing on wires, and other extraordinary feats demonstrating the powers of mind over body.

Bernard managed to cure diseases the medical profession claimed were incurable by combining age-old Indian methods with western medicine. Those who worked with him and lived on his estate had to commit themselves to a rather strenuous, disciplined way of life. An intensive regimen of mental and physical gymnastics was the order of the day. Smoking, liquor, and sex were forbidden. Members of the fellowship were up at dawn, and they ate only organic food grown in the estate's garden. They cared for and trained the animals, stood on their heads, learned to swallow swords and walk on fire, and worked out on trapeze equipment. Bernard's rigorous training program was all part of a commitment to the pursuit of knowledge, truth, beauty, fitness, and higher levels of consciousness. It was his belief that when the mind was in harmony with the universe, the body would function in perfect order and be free from disease.

When World War II broke out, Dr. Bernard closed his Nyack estate and donated it to refugees from Nazi Germany. Bernard died in 1955 at the age of eighty; his Tudor-style manor house was demolished along with the swimming pool and gardens in order to make way for Nyack Missionary College. Several of the original outbuildings remain on the property,

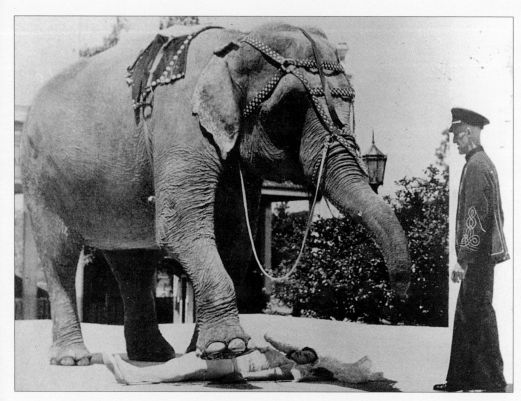

Dr. Bernard's beloved elephants at play at his estate.

Several of his oversized pets had been circus performers.

but they were gutted and turned into student dormitories. When the estate was leveled to construct new school buildings, the sacred burial grounds of Bernard's prized elephants were discovered along with their bones and marble markers. Generally, it is not a good idea to disturb the burial grounds of sacred elephants; even ordinary elephants don't take too kindly to such disrespect. It is the general belief that the Missionary College would have prefered that Dr. Bernard and his colorful lifestyle had never existed. All traces of his existence have been obliterated, including the remains of his jumbo playmates.

It may be true, however, that an elephant never forgets. This would account for some of the rumors and stories that have circulated among students of the college. While visiting the Nyack library, former student Jim Murphy overheard me talking to the research librarian about the old estate. He quite unexpectedly turned and said, "That place is haunted like you wouldn't believe."

The librarian and I looked up at him, and I encouraged him to go on.

"I'd come home from class and find all my furniture tossed about the room. The bed would be turned over on its side, and the dresser turned over. Sometimes I'd find my things—books, chairs, nightstand, whatever—arranged in a circle nobody could explain. In the beginning I just figured it was some of the older students horsing around with me. But then one night I was alone and I felt this wind or force build up in my room, and all my papers started to fly off my desk. It was like a small tornado, but the windows were closed and the door was shut. Then I heard this banging coming from the other side of the wall, and when I looked up I saw a shadow on the wall. It looked like an elephant, but just its shadow. It just stood there at first, but then the walls began to tremble like there was an earthquake, and stopped again just as suddenly. My room was in a shambles; books, papers all over the floor. I've heard I wasn't alone. It happened to some of the other students who stayed there as well. You see, the walls are four feet thick in that building. I'm told it used to be used by the elephants. Can you imagine that? When the estate became a school, the building was gutted and redesigned for student housing. Some of us think those disturbances are because of the graves they dug up; they were right outside the building. I heard they just took the bones to the local dump. Maybe that wasn't such a good idea."

Mr. Murphy now lives in Greenwich Village in Manhattan, where he says things are more peaceful. According to a local news clip, the elephant bones were eventually retrieved and placed in a glass case for biology students at the Hillwood Elementary School.

At one point I drove up to the campus, but I could find nothing recognizable from the original photos I had seen. The dorm at Mosely Hall was a huge stucco building, surrounded by a football field and track, and looked like any other campus building.

Down by the river I stood for a while and watched the sun set. Looking north, I thought for a second I saw the shadow of a very large gray elephant looming in the distance. Then I realized it was Hook Mountain, fading in the dwindling light.

THE SHEPPARD ESTATE

No ghosts are known to haunt the former Sheppard estate in Scarborough Manor. The mansion is, however, one of the largest and most elegant buildings overlooking the river. In fact, at first glance it looks almost as though it were intended to be a public monument, not a private residence.

In 1892, Elliot F. Sheppard, a New York lawyer and founder of the New York State Bar Association, commissioned McKim, Mead, & White to build him a palatial Italian Renaissance mansion on a 338-acre estate. To enter and exit the grounds of this estate, one passes between two matching light-colored brick-and-terra-cotta porter's cottages, positioned to oversee a pair of huge wrought-iron gates. The south gate is used for entering and the north gate for leaving. The main house, very formal for its day, is set off by a rounded terrace and is bordered by tall stone Ionic pillars and balustrades on the river side. Large tubs of clipped topiary and marble urns surround the house. At one time, canvas awnings covered many of the windows in order to protect the fine wood furnishings inside from the rays of the sun. Today, the interior of the house is reminiscent of the grand hotels of Europe. The rooms on the main floor, which include a gilded French-style ballroom, are massive and decorated with many of the original furnishings.

In the entrance hall, above the sweeping circular staircase, there is a twelve-foot original stained-glass window by Louis Comfort Tiffany. The window rises up along the staircase wall to form an arch at the top, and is bejeweled with glass diamond-like stones set into medallions and surrounded by angels, birds, floral wreaths, and languid nymphs. Upstairs, the spacious bedrooms are filled with ornately carved beds, French-style furnishings, and carved fireplaces flanked by cozy chairs and couches. Charming brass sconces and paintings decorate the walls.

To the north of the property there is a massive stable-and-service complex and a Tudor-style carriage house, still used to this day. There is also a rustic log cabin with a stone fireplace hidden off in the woods. Inside, it is furnished with overstuffed couches, twig-art chairs, sporting prints and the occasional mounted stag head. It was built as a winter retreat from the formal main house.

Elliot Sheppard died in 1893, before the estate was completed, but his widow continued the building and fulfilled his dream. Mrs. Sheppard is said to have been overwhelmed by the size of her residence, and was often exhausted by chasing her many dogs around the eighty rooms and endless hallways. In 1910 she sold the house and furnishings to William Rockefeller and Frank Vanderlip, who owned Beechwood, the estate across the street.

Though the Sheppard estate had been functioning as a club for many years, it officially became the prestigious Sleepy Hollow Country Club in 1923, when Rockefeller and Vanderlip sold it. They became the club's first board of directors. Today the estate is maintained as it had been when it was first built, although a wing has been added to the northern end of the house that incorporates the columns from the former sunken garden. The new wing contains the locker and exercise rooms for the club. The estate is listed as a National Historic Site.

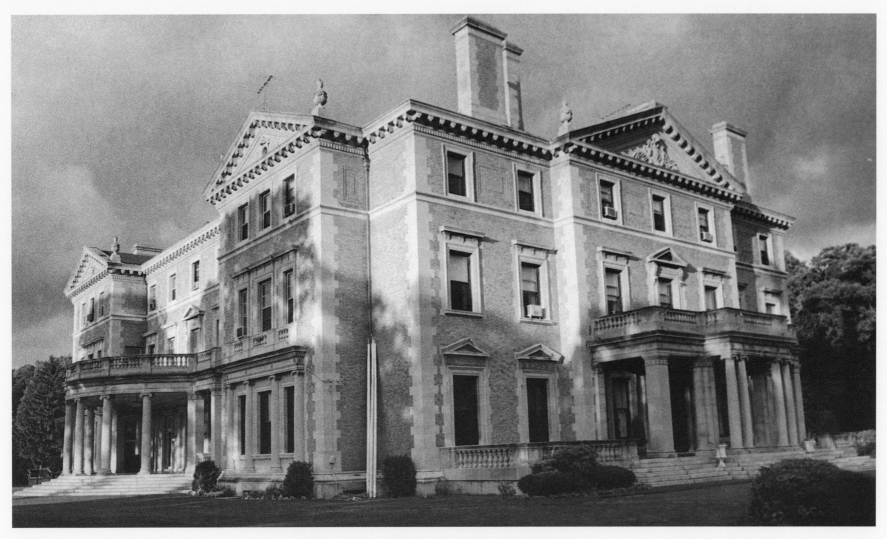

The main entrance at Sheppard Estate

LYNDHURST

At night, Lyndhurst rises up from the east side of the river in a blaze of light, like some phantom fairy-tale castle created by the whimsical mind of King Ludwig II. The illuminated fortress presents a breathtaking spectacle for the millions of drivers who cross the Tappan Zee bridge each year.

Originally built in 1838 by General William Paulding (mayor of New York City at the time), the Greek Revival castle and its battlements were an oddity. Alexander Jackson Davis designed the castle under the direction of Paulding, who asked for more towers, turrets, and odd-shaped stained-glass windows than Davis could give him. The overwrought architect is said to have nearly walked off the job when Paulding tried in vain to get him to surround the castle with a moat and drawbridge. Davis was finally able to talk him out of it by pointing out that the stagnant water would attract bugs and rodents. Even without the moat, the phantasmagoric pile was referred to by the locals as Paulding's Folly.

The pale-gray marble exterior, quarried from nearby Ossining, had open arcaded portals that surrounded much of the house and provided sweeping views of the river and the bridge. Inside the house were many unusual and innovative touches, dreamed up by Paulding. The most dazzling was a stained-glass window in the library with unusual magnifying glass panels that enlarged the view of yachts on the river. Above was an open-timbered, ornately carved and foliated ceiling, illuminated by a colorful gable lunette.

Despite the fantastic touches, many felt there was an ecclesiastical atmosphere about the place. There were dark, medieval Gothic rooms, heavy fabrics, and tall Tudor-style arched doors. A pipe organ stands to this day in the reception room, and the ceiling is adorned with angels from Raphael's *Hours*.

In 1864, the property changed hands and was bought by George Merritt, a wealthy New York merchant. He then commissioned Alexander Jackson Davis to add more pinnacles and towers, as well as a porte cochère. This time, the noted architect was challenged to build what was to become the largest privately owned greenhouse conservatory in the country. Seen from the vast rolling lawns, the massive transparent structure was reminiscent of Queen Victoria's Crystal Palace, with its soaring glass barrel-arched roof peaks. It was over six hundred feet long, with a hundred-foot-high bulbous dome at the center, which was used as an aviary for exotic birds. Andrew J. Downing designed magnificent parks and formal gardens

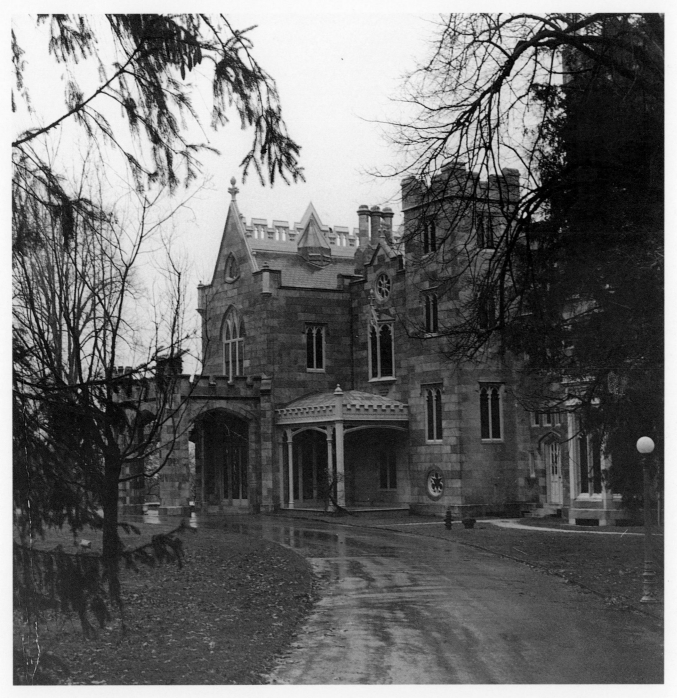

Lyndhurst is considered the crown jewel of all the castles on the Hudson.

with classical statuary, which surrounded the spectacular greenhouse. Nearby, a classical marble and wrought-iron lace-domed gazebo stands in the middle of one of the finest English rose gardens to be found anywhere. Various rare and exotic roses were trained to follow the arched trellises.

Also on the property is a vast complex of stables, a kennel that once housed seventy-five prized Saint Bernards, a carriage house, and a blacksmith's house. Close to the main house is a charming playhouse, known as the rose cottage, where the children once played.

At some point, a very large stucco laundry building was converted into an elegant cross-gabled Gothic-style château by the Archduke Franz Joseph, cousin of the pretender to the throne of the Austro-Hungarian Empire. It stands in ruins today on one of the highest points of the property, hidden away and covered in vines where no one can find it.

Jay Gould, whose name is most closely associated with Lyndhurst, purchased the 450-acre property in 1880. The infamous railroad magnate was known to many as the unscrupulous wizard of Wall Street. It was through his shrewd manipulations and questionable business practices that Gould gained control of Western Union Telegraph, the New York Erie Railroad, and the Union Pacific Railroad. The tracks of his arch-rival Vanderbilt's railroad ran along the river side of Gould's property, and he built a steel bridge so that he could avoid them on the way to his dock. He used his yacht, "The Atlanta," to commute between his Wall Street office and his Tarrytown estate.

Gould had no sooner moved into his fairy-tale castle than the fabulous greenhouse mysteriously burned to the ground. He had architects Lord & Burnham rebuild it, only this time it would be the first greenhouse with metal framing instead of wood. It was very modern with its fanciful embellishments and its towering Oriental aviary dome.

Gould, an orchid fancier, seemed to thrive in his country surroundings. He spent what little free time he had puttering around his greenhouse and reading classical literature in his ornate, many-volumed library. He and his wife entertained often and on a grand scale, but for all his well-documented extravagance, he had a little-known philanthropic side. During his lifetime, Gould gave millions to needy children and other noble causes. In his later years, he became crippled by tuberculosis. He died in 1892, leaving his beloved estate to his daughter Helen.

Helen Gould inherited her father's interest in charities. She was dynamic, energetic, compassionate, and dedicated to helping the less fortunate. At age forty-two she married Finley J. Sheppard, and together they adopted many children. On weekends she would open the gates of her father's estate to as many as three hundred impoverished city kids. She organized study groups for orphans and provided teachers for them. During the summer months, there were gala parties, magic shows, and theatrical programs under a big circus tent. Helen also cultivated a love for flowers and meticulously maintained the greenhouse; several rare orchids were named after her. Always generous and giving, Helen was known to send gaily wrapped boxes of orchids to anyone who pleased her. At the far end of the conservatory was a pale-blue latticed wall, cov-

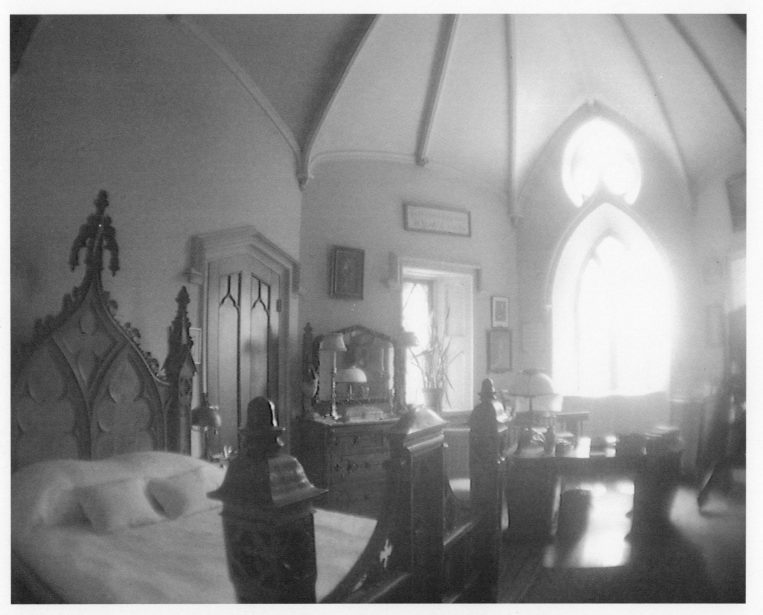

The master bedroom with its vaulted Gothic ceiling.

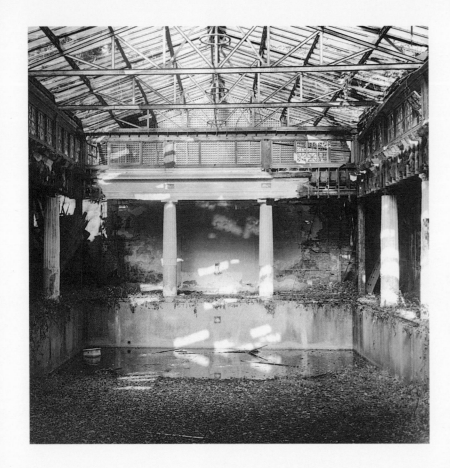

The abandoned pool was once the pride and joy of its builder Helen Gould.

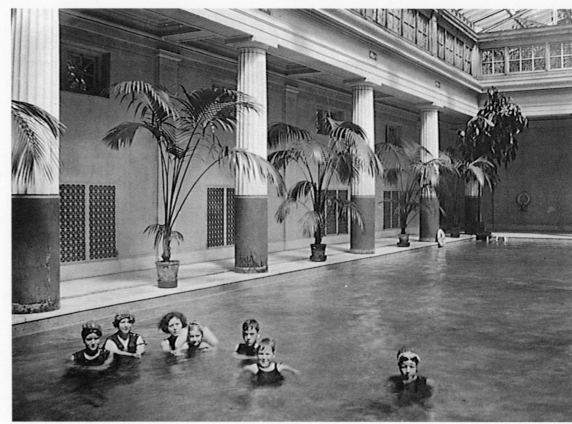

The indoor pool filled with frolicking guests in 1909.

ered with night-blooming cereus. Helen and her friends would stage all-night vigils to celebrate the blooming of these rare white flowers, which had a supernatural iridescence in the moonlight.

Watching flowers grow was an acceptable pastime in Helen's day; she lived in a time when women were considered reckless if they did anything more than take walks in the garden and crochet doilies. Exercise and sports were looked down upon, yet women were expected to maintain an eighteen-inch waistline, and so they resorted to tighter and tighter corsets. When Helen's older brother married the famous Broadway star Edith Kingdom, he made no secret of the fact that he had fallen in love with her hourglass figure.

In time, however, their rich lifestyle and their twelve-course dinners took their toll. Desperate to regain her figure, Edith took to wearing a rubber girdle, a device that proved fatal. Her death inspired Helen Gould to promote sports for women. First, she built a huge shingle-style Gothic sports casino and bowling alley. It contained two regulation lanes, a recreation area, and a stage with a piano. The walls rose to a steeply pitched roof with a carved vaulted ceiling. All kinds of theatrics and concerts were performed there for the visiting children.

THE POOL CASINO

The sports casino was extremely popular with all who used it, and this inspired Helen Gould's first attempt at a sports complex. In 1909, Helen commissioned architects Graw, Lewis & Wickenhoefer to build an indoor pool. The result was the largest indoor body of water in the United States. The building was 140 feet long, and its glass ceiling was 60 feet high. The building was hidden amid a grove of cedar trees on the northeast corner of the property. Guests could find it only by following a narrow gravel path dotted with little hand-painted signs pointing the way. One entered the massive red-brick, pillared, Georgian building through an elegant classical foyer filled with wicker furniture. The mens' and ladies' dressing rooms were reached by a pair of spiral staircases.

A pair of tall French doors led to the main atrium, with its breathtaking Roman pillars. Above, a clerestory with a plaster frieze was sculpted with scroll designs and set with blue-and-white tiled dolphins. At the far end of the massive room were hand-painted murals of animals, birds, and Roman figures in togas, executed in a Pompeian style.

Helen's pool casino was the talk of the town, and locals were desperate for invitations to the parties that were held there. She held many a costume gala, usually with a Roman theme; guests roamed the marble halls in white togas with laurel leaf garlands in their hair. As a precaution, a lifeguard paddled around the pool in a wooden lifeboat.

Despite the revelry, Helen was known to all as a deeply religious woman. She gave Bibles to all her guests. She

was also fanatical about the rules of the pool. Women had to wear long black stockings under their long-sleeved and skirt-ed bathing dresses, and rubber caps to cover their hair. These items were provided by Helen herself. She took these rules very seriously and was once overheard telling a friend that this practice was mentioned in Deuteronomy. On one occasion, Helen is said to have ordered a stockingless guest out of the pool. On another, Helen walked into the pool and found her handsome lifeguard throwing a ball to several playful dogs. The cavernous room echoed with Helen's cry of "My God!" and she ordered the pool drained and scrubbed with ammonia lest the dogs contaminate the water with fleas. It took a month to refill.

In 1938, Helen Gould Sheppard passed away. Her sister Anna, then the Duchess of Talleyrand-Périgord, returned from Paris to take over the estate. Anna did not share her sister's interest in sports, but she was something of a canine fanat-ic; at one point, she had as many as one hundred dogs running about the property. When one of her beloved pets died, she turned the children's playhouse into a mausoleum, placing a tiny metal coffin on the table that stood in the center of the small room. Other flower-draped coffins followed. In time, Anna turned a section of the garden into a pet cemetery, with mar-ble gravestones bearing the names of her furry loved ones.

The pool casino was last used during the Second World War, when recovering servicemen came to Lyndhurst at the Duchess's invitation. When the National Trust took over the property in 1966, plans were made to convert the pool house into a concert hall, but funding for the project fell through, and the building met with a sadder fate.

Today, what was once the country's most spectacular indoor pool has been reduced to a desert of rubble. Most of the plaster columns have dissolved in the rain that leaks through the badly damaged ceiling. The surrounding walls with their fanciful designs are eroding, and crumbling concrete and ceramic tiles lie in heaps on the marble floor. Even more dangerous are the glass ceiling panels that occasionally fall into the empty pool below, their haunting echo shattering the silence like a death toll bell. A medley of dense vegetation works its way into the cavernous room, and the vines' tendrils creep along the floor and cascade into the empty pool. The floor in the entrance hall has caved in, exposing the basement. The great arched windows next to the front door are softened by moldy silk curtains that hang in shreds.

The scene has the atmosphere of a Dali painting, a quality that has not gone unnoticed. In the sixties, the decaying pool house caught the eye of a director, who used the haunting ruin in the television series "Dark Shadows." Enhanced by fog machines, the scene played out as an ashen-faced woman, long dead, walked the length of the empty pool, surrounded by a swirling mist.

No one seems to know if Lyndhurst has any real ghosts, besides those created by Hollywood staging. But, Gary Lawrence, a talented Long Island architect who has had a long association with the estate, claims to have captured many strange images on film. He began photographing the property when he was a child and has taken thousands of pictures

94

over the years. In some photographs, a curious burst of blue light appears in rooms that are no longer used. In one photo, a lake appeared on the lawn with a castle standing in the background. Lawrence later discovered that about 150 years ago, a pond did exist in that spot; it had been filled in when Paulding began construction on his dream castle.

Can a camera travel back in time? Could an image from the past be captured on film? Such questions elude answers, yet cameras have been said to capture images of things and people that are long gone.

Lyndhurst today is one of the most popular tourist attractions on the Hudson River. It is open all year. Al fresco concerts are held on the grounds in summer and are attended by thousands of people.

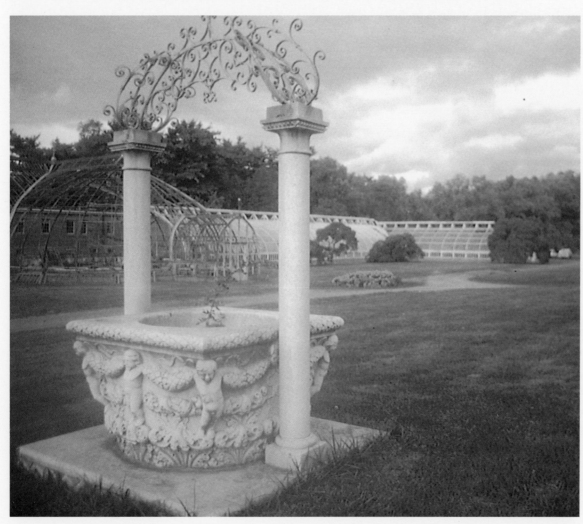

A marble wishing well stands in front of the greenhouse ruins.

95

DICK'S CASTLE

Dick's Castle, in Garrison, is one of the Hudson's most spectacular ruins. This sixty-room Moorish-style castle sits proudly on the Hudson River, with sweeping views of the Highlands and Constitution Island. Its soaring towers rise up from an ancient forest of trees over four hundred feet above the river, and its façade is nearly hidden by endless ivy tendrils that cascade along its cast-concrete walls and crenelated rooftops.

The house was built by Evans Richard Dick, co-owner of the New York brokerage house Dick Brothers & Co. He bought the land in the 1890s and embarked upon re-creating the eighth-century castle his wife had fallen in love with while traveling in Spain. More than one hundred workmen and artisans labored on the project for eight years while camping out on the 220-acre estate.

It was estimated that the main house would cost seven million dollars when completed, but Dick ran into financial problems, and the project was abandoned in 1911. Scaffolding stood rusting along its walls, while ladders, cement vats, and wagons lay amid the growing weeds. It stood empty for over thirty years, a tragic mausoleum of an unrealized dream.

In 1944, the deserted ruin caught the eye of Anton Chmela, an engineer and the president of General Quartz Laboratories. He bought the castle and turned its vaulted wine cellar into a laboratory, and from all accounts, the Chmela family seemed to enjoy living there. But it was Anton Chmela's enterprising daughter, Helen, who finally made the castle famous. She simply placed a large sign at the entrance gate off Route 9-D that read: "Come see the Castle: 25 cents."

With its towers visible for miles around, it soon became the biggest tourist attraction in the area, competing with nearby Bear Mountain. Helen warned visitors of the sagging floors while she conducted tours of the romantic castle, and she and her father built gangplanks and bridges in the hallways where the floors had given way. Tales of a workman who had toppled to his death from a four-hundred-foot cliff during the house's construction, and who had since "revisited" the site, added to the drama of these precarious walks.

After Mrs. Chmela died in 1979, the Dia Art Foundation took over the property, with plans of turning the estate into a museum for Hudson Valley artists. These plans were never realized. Instead, the windows in the ballroom were boarded up, and the unused balcony, originally built for an orchestra, began to sag. The cloistered courtyard, with its thirty-six pairs of imported columns, crumbled, and leaks caused the house's walls to dissolve and shatter. Most of the twenty-

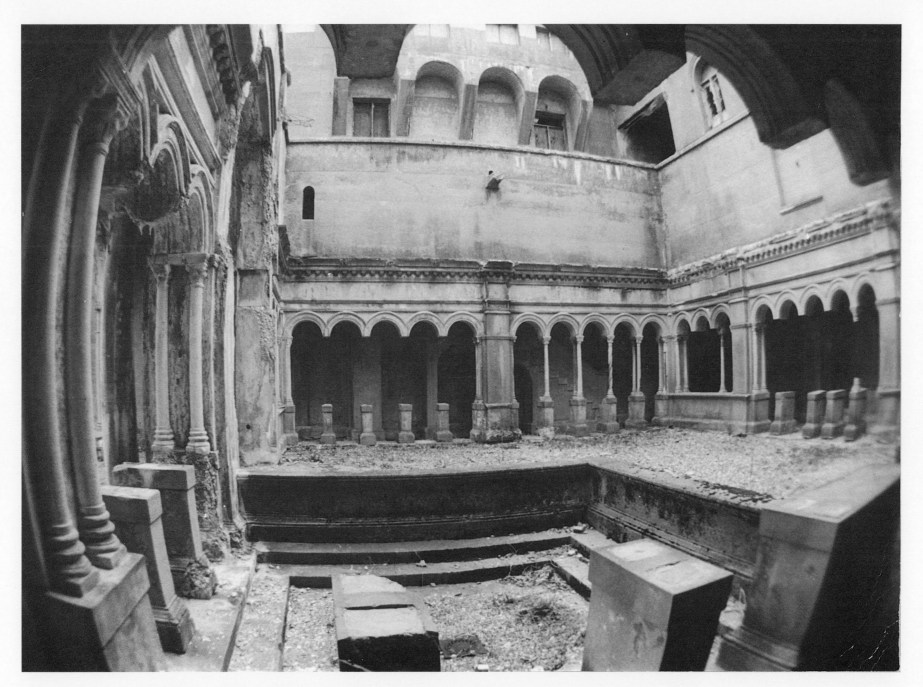

The center courtyard with its Moorish arches awaits restoration.

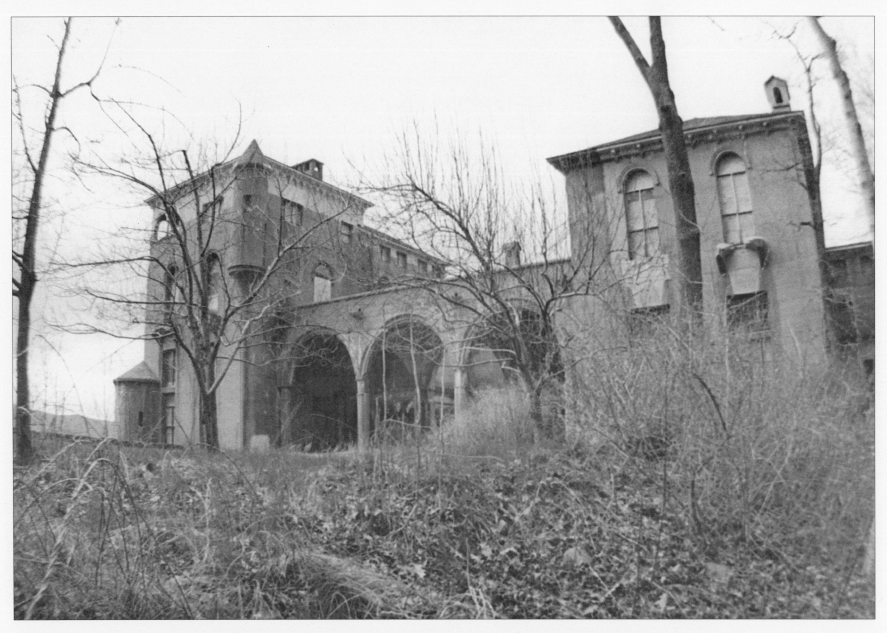

Dick's Castle is one of the most spectacular ruins along the Hudson River.

three imported fireplaces were smashed by vandals or stolen, and forty-eight of the carved lion's heads set into the stone promenade walls fell prey to souvenir hunters. A giant marble fountain in the shape of a toadstool has survived over the years, but it is no longer visible beneath layers of meandering vines.

Sometime in the late 1980s, the castle was bought by a contractor and was almost completely renovated and modernized. The exterior walls were painted a gleaming white. Several TV commercials were shot there in the fall of 1992, and a wedding was held in the restored ballroom.

But, alas, history seems to be repeating itself. All work on the building has come to a halt, and ladders stand unused against the interior walls of rooms yet unfinished. Forsaken at the end of its mile-long driveway, the castle stands empty once again.

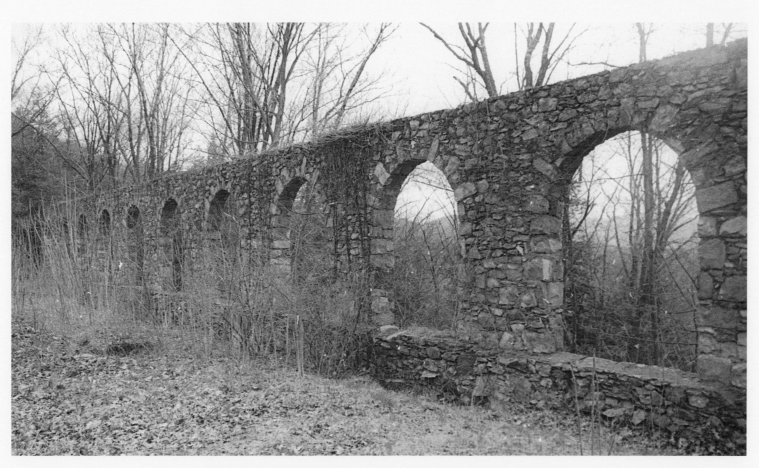

A long series of stone arches stands along the river.

CASTLEROCK

Perhaps the most picturesque castle on the Hudson is Castlerock in Garrison. Its dizzying towers and spires stand perched on one of the highest mountains overlooking the river. Like many of the river fortresses, it is easily spotted from Route 9. A Gothic vision with its austere, defensive architecture, Castlerock's steeply pitched roofs stand against the fast-moving clouds which often engulf it. The castle is surrounded by precipitous, rocky, vine-entangled woods, which are full of red foxes and black squirrels, and which echo with the mellow fluting of gray doves.

Built in 1860 by William H. Osborn, it was originally designed as a lookout post for spotting forest fires. As Osborn grew fond of the location, he added wings, gables, and towers, and it eventually became his thirty-six-room summer home.

The entrance to the property is carefully hidden. One must travel quite a distance before coming to the gate-keeper's stone cottage, with its diamond-shaped Dutch windows. The steep, winding driveway is many miles long, and it can be treacherous, if not impossible, to climb during the winter months.

The estate has over thirty-five miles of carriage roads that twist and turn at dangerously sharp angles. There are no markings along the way, making it easy to get lost. One road leads to a beautiful forest lake, where herons and ospreys roost on giant black branches that jut out from the emerald green water. Another road leads to a hunters' lodge with a huge stone fireplace. And yet another road winds its way over and around a massive feudal-style bridge with dungeon-like towers on each side. Rusting iron bars cover the tiny windows.

Just before reaching the entrance circle at the top of the mountain, there is a massive twenty foot rock that rises up along the road. Mr. Douglas Banker, one of the castle's present owners, believes it was once used by an Indian tribe for sacred rituals.

At the top of the mountain, one must pass through a centuries-old stone ivy-covered bridge to approach the house. At one time there were formal gardens, with ancient statues, decorative urns filled with flowers, rose arbors, and a marble lion's-head fountain. Though these gardens are in ruins today, they are hauntingly beautiful. At this level, the castle appears much smaller than it does from the road, for much of it was built into the rocky side of the mountain on which it stands. To the left of the entrance is a stone veranda with a spectacular view of the Highlands. Bannerman's Island with its Scottish castle looms in the distance.

Today there is very little furniture inside the castle, but at one time fine Oriental rugs overlapped one another every-where. Heavy carved-oak furnishings decorated the massive rooms. There were mounted heads of giant elk, deer, and moose

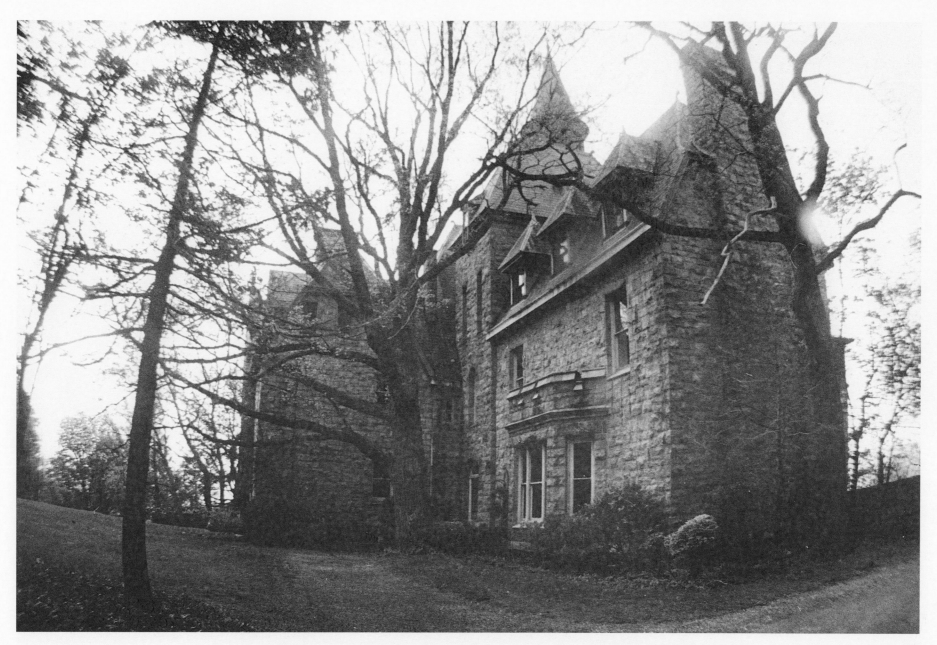

Castlerock is perched at the highest point overlooking the river.

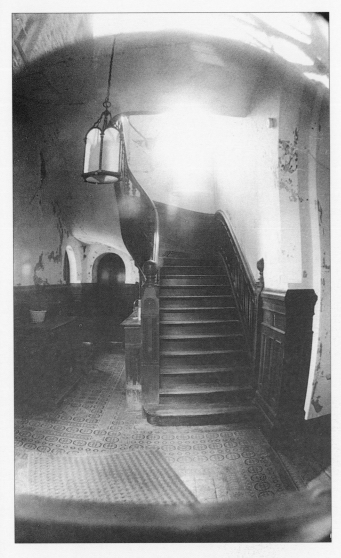

The main entrance hall to the house.

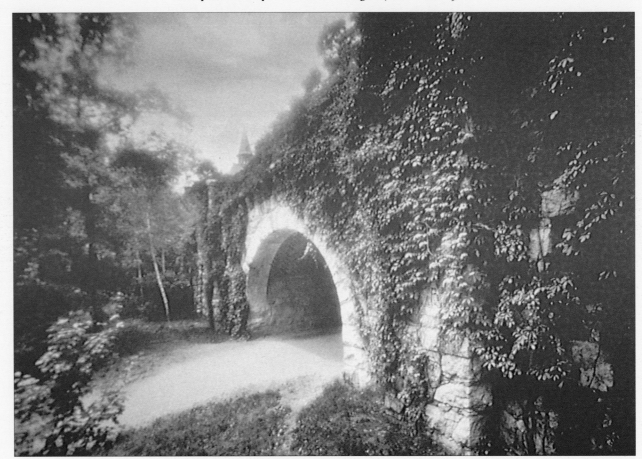

hanging from the paneled walls and over the large stone fireplaces. In the gallery and the main hall, dozens of ancestral portraits hung proudly on the walls, and a valuable collection of marble busts stood on fluted pedestals. In one corner of the room, a tall mahogany grandfather clock stood ticking away the hours. The house was also one of the first to have a private elevator.

William Osborn was related to the three famous Perry brothers: Commodore Matthew Perry, who opened Japan to trade in the nineteenth century, Commodore Oliver Perry, who launched a victory over the British during the War of 1812, and Captain Nathaniel Hazard Perry, a distinguished naval officer.

Castlerock remained in the family for over a hundred years, though maintaining the building grew progressively more difficult. Eventually Mrs. Perry Osborn Jr., unable to meet the costs of fuel and repair, was forced to sell the remaining eighty-eight acres of the property. The ensuing auction was attended by thousands who bid on the prized family heirlooms, which included a Chippendale four-poster canopy bed and an outstanding collection of Empire furniture. Mrs. Osborn was emotionally devastated by the sale.

Today, the walls of Castlerock are faded and bare. There is a warning sign posted on the front door. It reads: "To our guests—Please take note that we keep rattlesnakes as pets. Do not feed or pet them as they have been known to bite."

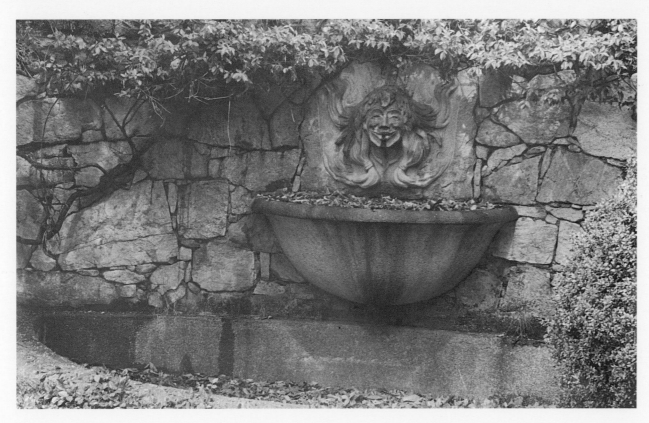

The marble face of an old Indian woman graces a massive fountain.

BANNERMAN'S CASTLE

Bannerman's Castle is perhaps the best known and largest of all the haunted ruins on the Hudson. As far back as four hundred years ago, the Indians began circulating rumors that the island on which the castle stands was crawling with ghosts. Not wanting to go there alone, I called my lifelong friend Robert King, who also writes on great estates and had done extensive research on the castle. Together we drove to Fishkill.

As one drives along Route 9, the ruin suddenly appears after a bend in the road. The sight of it takes one's breath away. Perched on a tiny island just five hundred feet off the mainland, the castle rises like a ghostly fortress; gloomy, forbidding, almost frightening. Its derelict towers jut from the black water, crumbling and secret.

We searched the area until we found a small space in a thicket of swamp grass and cattails about a half mile from the castle, and we parked the car. We then set out along the train tracks, hoping an Amtrak express wouldn't come along and squash us. As we were walking, we spotted two hunters in bright orange jackets in the distance, shooting at something. We waved to them and they waved back, then lowered their guns and began walking in our direction.

"What were you shooting at?" I asked when we caught up with them.

"Moose," the hunter said.

"I thought you had to go further North for moose," my friend Robert said.

"Well . . . I just shot at something big and furry," the hunter said staring at my fake fur coat and matching hat.

"You folks are taking a chance being out here dressed like that. It's hunting season you know . . . you should be wearing an orange vest. You got a lot of crazy people up here who'll shoot at anything that moves."

"I take it you're from the area?" I asked.

"Born and raised, I'm Smokey and this is my friend Joe," he said in an obscure accent.

"Perhaps you can help us, we'd like to get out there," I pointed to the castle.

"Oh hell you can't go out there, too dangerous," Smokey said reaching up to remove his red and black hunter's cap. "You can't swim out, the current is fierce, and if you take a boat there are land mines and steel spikes that will wreck the hull. At low tide you can sometimes see them, but you got to know where they are."

Robert and I exchanged knowing glances, we always thought alike and in that moment we knew that nothing was going to keep up from getting onto that island. "Do you know where we can charter a boat?" Robert asked.

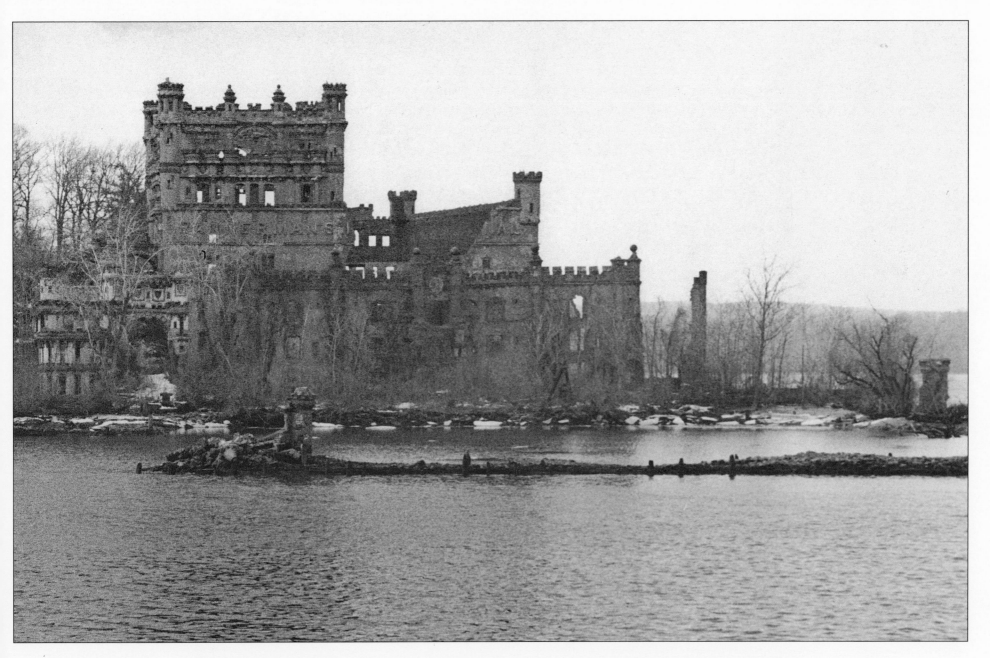

Bannerman's Castle rises up dark and secret overpowering the tiny haunted island.

"Not this time of year, they're all in for the winter," Smokey said.

"How about a submarine, know anyone with a sub?" I asked not expecting to be taken seriously.

Joe thought for a moment, then added "You know, I hear they have one over at West Point, maybe you could borrow . . ."

His partner cut him off. "Lady, even if you got out there, you can't go unarmed. There are wild packs of wolves who feed off humans, and even if they don't getcha there are weird things living in those ruins."

Accepting all this on faith I asked, "How did the wolves get out there?"

"They walked. This here river freezes solid in winter, you could drive a bus out there."

Robert and I looked at each other again knowing we'd be back with snow shoes. We gazed down at the black swirling water and wondered how it could freeze with the current as strong as it was.

Smokey then added solemnly, "My best friend drowned here, since that time I've never gone back out there."

"How did your friend drown?" I asked.

"That was a while back, maybe ten years ago. I had an old fishing boat, and my buddy and I went out to the island to steal old cannonballs. There were thousands of them back then. That place used to be an arsenal, and everyone used to go out there and steal cannonballs.

"Well, we really filled the boat that time, 'cause we were really too low in the water. As we were heading back, suddenly we saw this shadow. It looked like some kind of soldier because he was wearing this uniform with a military hat. Whatever it was, it just sat there on top of those cannon balls.

"I don't believe in ghosts, but I have never seen anything like this. My buddy panicked and jumped overboard. He was swept away by the strong current and drowned. It was three days before they found his body; it was miles down the river. It was a horrible thing. I was lucky. The boat tipped over and sank when he jumped, but I made it across to where we're standing now."

We talked a while longer, then stood there and watched as the sun set behind the Highlands in a fanfare of light. We thanked the hunters, then made our way back to the car.

The river didn't freeze over that winter, nor the next. Eventually, some friends from Long Island took us out to the island on their yacht. There were no wild packs of wolves, nor did we see any ghosts. But the castle ruin, with its great curtain of charred walls, was spectacular.

The man whose imagination and energy are solely responsible for the building of this fairy tale castle was Francis Bannerman, who bought Pollepel Island in 1900 for $1,500. Born in Dundee, Scotland, in 1851, Francis Bannerman was only three years old when he came to this country. His father, Frank Bannerman, established a business selling surplus military equipment he acquired at auctions after the Civil War.

106

Young Francis Bannerman was both fascinated by and obsessed with every implement of war. After he inherited his father's business, he married a woman who believed she had been the Queen of England in a previous life. Both Francis and his wife shared a love for Old World castles.

Around the turn of the century, the European elite regarded America as a greedy nation, devoid of grace and culture. They found the Hudson River attractive but lacking in distinguishing architectural features. Francis Bannerman set out to change their minds. Without an architect, he designed and built what appeared to be an ancient Scottish castle. It was of monumental proportions, and was complete with a moat and a drawbridge.

Francis himself was a Scottish patriot, and his castle was a reminder of his beloved homeland. He had several stone fireplaces, with carvings of biblical scenes and Scriptures, brought over from Scotland. The castle had bold stone corbeling along the walls, as well as parapets and embrasures. There was also a lookout tower. Huge iron baskets, suspended from the corner castle turrets, held gas lamps that burned through the night like ancient torches. Inside the castle were hidden passageways and even a dungeon.

Once Bannerman's castle was complete, his wife was able to live out her past-life fantasies, and he had a place to store his vast collection of weaponry. He collected and sold everything: crude stone weapons, blowguns, crossbows, suits of armor, even medieval torture devices. He was respected as a shrewd and innovative businessman and an expert on firearms. Even Buffalo Bill came to Bannerman for his guns, and for help with costumes for his shows and historic reenactments.

Bannerman's Castle was the most spectacular fortress in the country; thousands of people drove down Route 9 just to catch a glimpse of it. Then, in the 1920s, a great explosion blew the northeast wing into the river. One of the corner turrets shattered, and landed in fragments five hundred feet away on the railroad tracks. A cloud of smoke prevented help from reaching the island, and an enormous wave nearly wiped out part of the railroad tracks. Hundreds of windows were shattered in the area.

Bannerman, undaunted by the catastrophe, continued to add to his collection. Barges of arms and surplus bombs still found their way to his island. He was widely criticized by the press, and reporters began to call him the Merchant of Death.

Sea captains have always believed there was something strange about the island, that it seemed possessed by disgruntled spirits who evoked curious and inexplicable weather changes. They describe sudden strong winds and rainstorms as they approach the shores of the island, when all on the river had been calm only moments before. Hundreds of boats have crashed upon the island's rocks and sunk, including Bannerman's own *Pollepel*, his freight and passenger boat that provided transportation to the island for over half a century. Old rivermen immunized young recruits against the phantoms by throwing them into the river as the vessel passed the island. They claimed that during the black squalls in spring, they could sometimes hear the captain of *The Flying Dutchman* shouting orders. *The Flying Dutchman* struck a rock and sank off the island in the early eighteenth century, and the spars of her hull are still visible beneath the surface of the water.

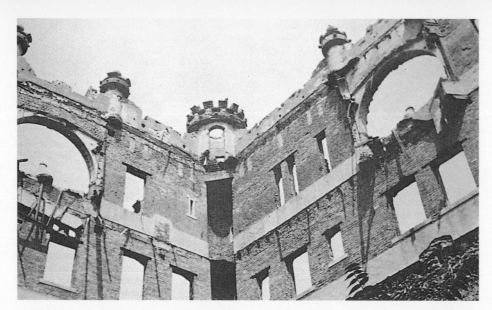

The interior was gutted by an explosion during the 1960s.

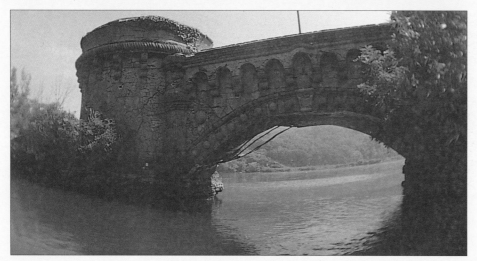

The feudal entrance as seen in its heyday.

One of several bridges that surround the castle.

Indians are said to have brought criminals and misfits to the island, where they would be dealt with by the evil spirits. Most often, however, they died of starvation. During the Revolutionary War, prisoners were chained there in dark cells, and it is said that many died from the severe winter cold.

 With all of these superstitions, negative energies and tragic deaths, as well as Bannerman's two-hundred-room castle full of war relics, it is no wonder that rumors of ghostly sightings continue to this day. Within the realm of parapsychology, there is a belief that for every unnatural or violent death, there is potentially a lost spirit left lingering. One view

holds that a ghost may be nothing more than an ethereal body of electromagnetic energy that remains fixed at the place of death, or to the object that caused its death. The hunter who lost his friend could very well have seen a ghost. Perhaps it was a soldier who had been killed by one of the cannonballs they had loaded onto their boat.

During Bannerman's day, stories of workmen seeing headless soldiers were rampant. Records show that there were countless mishaps and explosions, which killed many of his workmen. In one case, a cannon that had been used during the Civil War was being tested on the highest point of the island. When fired, it suddenly jumped from its casing mount and tossed one of its shells over the mountain and through the roof of one of Bannerman's factories. Several workers who were inside melting scrap metal unwittingly added the live ammunition into the melting pot. They were killed and the building was destroyed. They are said to be among the ghosts that haunt the castle.

When Bannerman died, in 1918, at age sixty-eight, he had long been recognized as having created the most famous military-surplus business in history. According to his *New York Times* obituary, he died from overwork while collecting and shipping clothes for the Belgian relief effort. Despite the fact that he was criticized as a warmonger, he often wrote of his wish for peace, and his great hope was that his castle of destruction would one day be a museum of a lost art.

His business was carried on by his sons, Frank and David. Locals recall seeing the castle ablaze with searchlights in the 1920s. Armed guards and attack dogs warned would-be trespassers to stay away. But perhaps the most effective guard was an acoustic quirk of nature called Lady of the Rocks. In northerly winds, a slate wall that rises a hundred feet over the river emits an eerie, human-sounding scream. This natural phenomenon often proved more effective than guards and dogs in keeping intruders away.

By the 1960s, the island's electricity had long been cut off and the castle had fallen into ruin. Its massive walls were almost completely swallowed up by creeping vegetation, and cascades of ivy and other vines descended from the haunted fortress.

In 1967 Bannerman's descendants sold the island castle to the New York State Office of Parks, Recreation, and Historic Preservation. Park officials set out to remove most of the ammunition and gunpowder, but they didn't get it all in time. On a very hot night in August 1969, some vandals made it out to the lonely outpost by boat and set fire to one of the castle towers. They escaped just as some gunpowder exploded. A black snowstorm of swirling ashes made it impossible for firefighters to get within reach of the castle. As the flames rose, filling the night sky, the river mirrored the hellish sight of the castle being enveloped in a great blaze.

Today, one can view the final episode in the history of the castle. Bannerman's name can still be seen in block letters along the deteriorating façade of the east wall. Even as its brooding walls and towers crumble, littering the shoreline below, the castle still evokes a sense of its former glory. It is a breathtaking sight to behold, as the dark and deadly river presses ever closer.

THE FREDERICK W. VANDERBILT MANSION

Frederick Vanderbilt, known for his prudence, conservatism, and scholarly ways, was regarded as the most morally upright of the four Vanderbilt sons. So it came as a shock when work crews who were cleaning the ceiling of his former mansion discovered a thirty-foot mural of nude nymphs. One of the bare-breasted ladies was pictured riding a gold chariot pulled by white horses. Several other nudes danced provocatively around an old gray-haired man who sat crouched with his head in his hands. Some observers claim the old man bore a striking resemblance to Vanderbilt himself. The mural had been buried under layers of white paint for years. It was discovered in 1962, shortly after the estate was taken over by the National Parks Commission. It is believed to be the work of an American artist, Edward Simmons.

The Hyde Park estate commands a spectacular view from one of the highest points on the river. The Italian Renaissance-style palace, built of Indiana limestone, can be seen from both sides of the river; sixty-foot pillars rise from the west loggia and set off the dramatic architecture. The stately Beaux-Arts palace, with its sweeping lawns and gardens, was designed in 1898 by McKim, Mead & White. Stanford White also helped design some of the interiors, in what was to become the most lavish of all the river estates. Shortly thereafter, White was shot and killed by a madman while watching a vaudeville show. White was at the roof theater of a building he designed at Madison Square Garden, and it is alleged that he was shot after failing to remove a nude statue of Evelyn Nesbit from the roof of that popular building.

Frederick Vanderbilt was one of four grandsons of Commodore Cornelius Vanderbilt, who had amassed one of the greatest fortunes of the nineteenth century. Frederick and his extravagant brothers competed in building the grandest homes ever seen in the country. The largest is Biltmore, located in North Carolina, with approximately 250 rooms. Other monumental structures can be found in Newport, Asheville, and Hyde Park and on Long Island's Gold Coast

Frederick's siblings were known for their glittering parties, but Frederick showed little interest in such frippery. He was content instead to sit by the fire and read a book from among the thousand or so in his magnificent library. He and his wife, Louise, had no children. They shared a love for gardening and raised orchids together.

Vanderbilt bought the 211-acre estate in 1895 from Walter Langdon Jr., because of its proximity to the city, its scenic

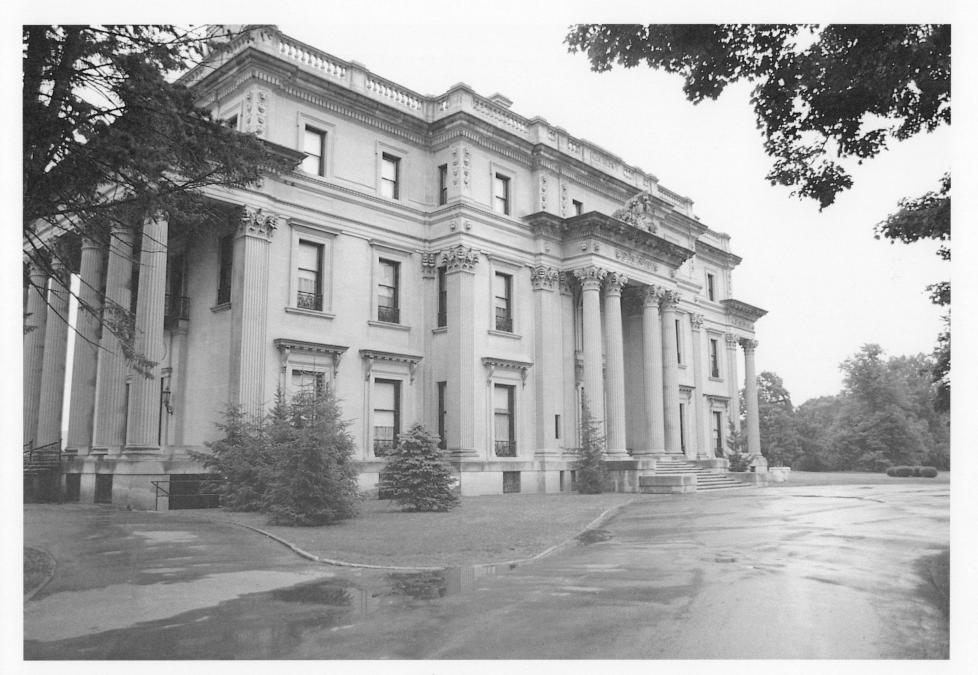

The main entrance.

A charming garden folly stands in the south end of the estate.

charm, and its notable neighbors: the Roosevelts to the south and the Ogden Millses and Astors to the north. John Jacob Astor had, in fact, owned the property at one time. He then gave it to his daughter, Mrs. Dorothea Astor Langdon, in 1840.

Vanderbilt loved his new home and took meticulous care in maintaining the gardens and grounds of the estate. Beautiful old beech trees, English elms, Japanese maples, and Norway spruce thrived on the riverbank. He also took to raising purebred livestock, and he became active in the Dutchess County Horticultural Society, winning prizes for his rare and unusual roses and orchids. At some point, he added a man-made lake. It was filled with swans and traversed by a splendid stone bridge graced with flower-filled urns. There was also a carriage house, a greenhouse, a gatehouse, and very elaborate formal gardens set off by marble fountains. Footmen served tea in the charming teahouse pavilion when the roses were in bloom. The teahouse is set off by stone Mediterranean arches and a terra-cotta roof. It overlooks a round marble reflecting pool.

During the cold winter months, the Vanderbilts closed up the big house and took up residence in what was known as the pavilion, a spacious neoclassical structure just off to the north of the main house. At Christmas, a twenty-foot tree trimmed with rare glass ornaments stood in the main hall. With the first snowfall, sleigh riding along the countryside became the event of the winter season. Even the help were invited to all-night rides through the glistening snow.

The interior of the house was much like those one might find in the Newport palaces along the sea, or at Versailles. Mrs. Vanderbilt's bedroom, designed by Ogden Codman, was a near replica of Empress Josephine's room at Malmaison, just outside Paris. The gilt canopied bed stood thronelike on a raised platform, surrounded by a gilt balustrade. Servants would gather here in the morning to await the day's instructions. This kind of behavior seemed excessive, for most of the other river estates were vast and self-sustaining farms; even the Astors were up and out at dawn to oversee the milking of their cows.

The dining room had two marble mantels that came from a palace of Napoleon III. There was also a three-hundred-year-old forty-foot Isfahan rug. In one of the marble halls, Vanderbilt displayed several models of his yachts, and on the grand staircase landing were several arched niches with more nude nymphs. Vanderbilt was also an avid collector of Venetian torchieres and château guns.

When Frederick Vanderbilt died, in 1938, the mansion and grounds were left to Louise Vanderbilt's niece, Margaret van Allen. She in turn gave the property and furnishings to the National Park Service to be maintained and preserved. The Vanderbilt Mansion was designated a National Historic Site in 1940, and it is open to the public all year long. The grounds and plantings look very much as they did in their heyday. But without the large staff of gardeners, the greenhouses have deteriorated, as have some of the formal cutting gardens and the massive brick loggia to the south. Above the arched stone centerpiece hangs a curious sign: "Beware of slithering snakes." One cannot be sure if there are any such creatures lurking amid the crumbling stonework of these abandoned gardens. Perhaps the sign is just a way of keeping the curious from falling into the now-empty pool.

THE PAYNE-WHITNEY ESTATE

This magnificent Mediterranean villa, set on a sweeping bluff overlooking the Hudson River, was built by Colonel Oliver Hazard Payne when he was seventy years old. Just after the turn of the century, Payne bought the former Astor estate and a neighboring property (a total of 645 acres) and commissioned society architects Carrère & Hastings to build him a massive *palazzo*. Nothing like it had ever been seen in the area before. West Park, located on Route 9W in Ulster County, is considered one of the grandest homes on the west bank of the Hudson.

The Colonel (as he was often called) was treasurer of Standard Oil, and his holdings in the company were exceeded only by those of John D. Rockefeller. Payne came from a very close-knit Ohio family; his father had been a senator, and his cousin had written the song "Home Sweet Home." Payne attended Yale, then left to fight for the Union Army during the Civil War.

Young Payne's life was changed dramatically when he was shot from his horse during the Battle of Chickamauga. It was rumored that he was shot in the groin, though he would never discuss the matter. He was shy by nature, and would not even allow himself to be photographed. He once stated that he had chosen "an old bachelor's life." Payne was known to be methodical, scrupulous, determined, and generous.

During the age of the robber barons, Payne got involved in iron manufacturing and oil refining, and later founded U.S. Steel. When he finally built his dream house at West Park, there were over fifty rooms, and the main floor had walls of rich Circassian walnut paneling, with leather insets and ebony and gold tracery. While the villa was being built, Payne collected paintings by Rubens and Turner, as well as dozens of Ming porcelains, which he displayed in the vast halls. He also imported tapestries, bronzes, and marble statuary. Outside the villa were breathtaking formal gardens, a long bank of balustrades topped with huge marble urns, and several greenhouses. To the north were barns and outbuildings, and a servants' wing with an ivy-covered clock tower. At the water's edge was a large stone boathouse secured by an unusual iron gate with a wrought-iron peacock grate. The boathouse was designed by Payne's superintendent, Julian Burroughs.

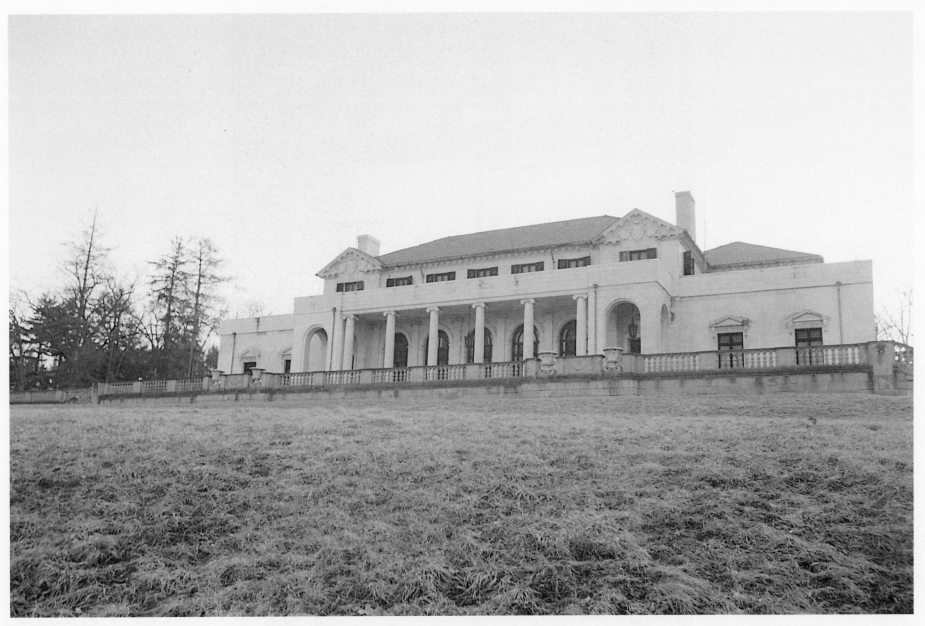

The main house stands on the west side of the river.

The entrance door of the house.

116

Payne's yacht, *Aphrodite*, exceeded 300 feet. It was moored at his dock and was considered the largest yacht in America.

Payne had hired Julian Burroughs after his previous superintendent, Andrew Mason, had passed away. Payne was so impressed by Burroughs's innovative designs for outbuildings that he bade Burroughs build them at any cost. When Payne's original architects, Carrère & Hastings, heard about this, they were none too pleased, but Payne had already become disenchanted with their work. The exterior of the main house, faced with imported French limestone, had not stood up well to the brutal winters. Burroughs had the insight to replace the limestone with local stone, which has held up to this day. Payne was so pleased that he presented Elizabeth Burroughs with a diamond pin from Tiffany, so she could wear it to the opera with her husband.

Payne's days at West Park were all too short; he lived in his fantasy villa for only eight years. Fortunately, it appears by all accounts that he enjoyed every minute of those years. Colonel Payne died on June 27, 1917. He was seventy-eight.

Most of Payne's estate was passed down to his favorite nephew, Payne Whitney; however, this legacy did not include his prized Hudson River villa, which went to his other sister's son, Harry Payne Bingham, of Cleveland. Bingham's first wife, Harriet Gawn Bingham, was regarded as something of a bull in a china shop by the old workers who remained on the estate. Julian Burroughs and his wife, before leaving the estate, saw the ebony and gold tracery walls of the main floor painted a dreary gray. Later, after Bingham divorced his first wife, the estate was taken over by the Episcopalians, who turned it into a home for mental patients.

In the 1940s, the property was sold to the Marist Brothers, and it became a religious retreat and training center. The main house suffered further abuse when the brothers painted over the precious frescoes that lined the large center courtyard. Soon after the damage was done, they realized they could not afford to maintain the estate, and so they moved into the old barns and outbuildings surrounding the villa—sadly, too late for the frescoes.

In the 1980s, the house once again came into the possession of a reclusive millionaire. He has not yet moved into the house, and nobody seems to know his whereabouts. The Whitney family, however, remains prosperous and in the public eye, thanks largely to Colonel Payne's shrewd investments. Colonel Payne's art collection has broken many auction records over the years; one of his Turners sold for $6.5 million in 1980, at the time the most ever paid for a work by that artist.

Payne's yacht, however, did not fare so well. Just before the Colonel died, he offered *Aphrodite* to the navy for wartime use. It was painted battleship gray, and the Stanford White-designed interior furnishings were stored in a Long Island warehouse, which burned to the ground while *Aphrodite* was at sea.

All seems quiet these days up at the big house, and if there are any ghosts brooding in its vast halls, nobody has reported seeing any.

THE OGDEN MILLS MANSION

The Ogden Mills mansion stands as a mute testimony to the great wealth and power that came to the Hudson Valley during the last century. It is a classical, pillared palace that looks very much like the White House. The mansion's drama is largely due to the beauty of its natural setting; the well-planned entrance drive has a stone bridge that takes the visitor past a lush green hillside and rows of stately trees. All about the park lie huge statues of mythological figures—Apollo, Diana the Huntress—punctuated by garlanded stone urns. At the base of the curving twin staircases at the rear of the house is a curious stone bathtub that once belonged to David Garrick, the famous British actor.

The Mills land was originally purchased in 1792 by Morgan Lewis, a Revolutionary colonel who went on to become New York's third governor. In 1832, Lewis built a stately Greek Revival home on the site for his wife, Gertrude. She was the sister of Robert R. Livingston, Jr., of Clermont, who was Chancellor of New York and also became Minister to France under Jefferson, negotiating the Louisiana Purchase. The property was eventually passed down to great-granddaughter Ruth Livingston Mills, wife of energetic financier and philanthropist Ogden Mills.

In 1896, Mills hired Stanford White to redesign the house, transforming it into one of the grandest homes in America. Two wings were added to the north and south, along with massive stone pillars and a central pediment. The exterior has classical embellishments, with balustrades, pilasters, and floral swags.

Inside, the rooms were built to impress, filled with sumptuous treasures from all over the world. Richly carved marble fireplaces and marvelously fine furniture in the style of Louis XV and Louis XVI adorn all the rooms. Above a sixty-foot grand staircase, the ceiling is painted with cherubs transporting mortals to the heavens. The surrounding walls are of quartered oak. At the entrance door, a long gallery is lined with the gilt-framed portraits of generations of Livingston family members. Rare Gobelin tapestries in delicate colors adorn the walls; one of the most valuable depicts the story of Antony and Cleopatra enticing Julius Caesar. Hanging over the fireplace in one room is a self-portrait by Joshua Reynolds.

The library takes up most of the south wing. The carved oak walls glitter with gilt rococo details; sun gods and

118

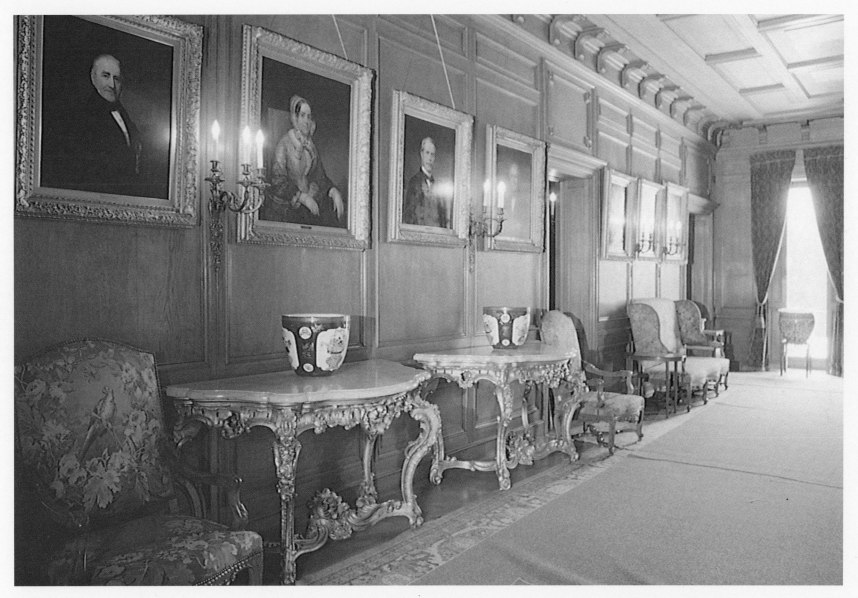

The main entrance hall is decorated with gilt portraits of Livingston descendants.

Rows of French chairs (above) and abandoned furniture forgotten in the attic.

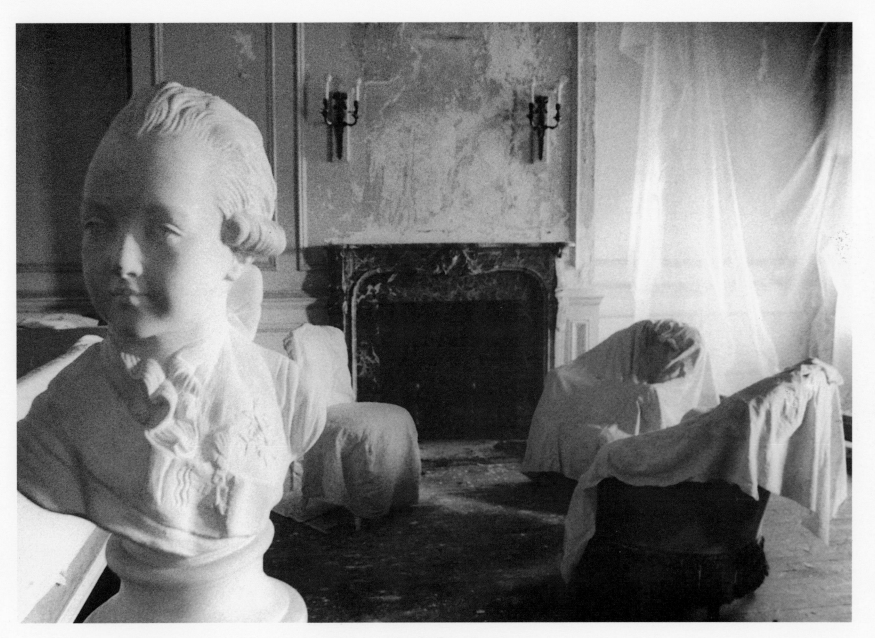

Statues in shadowed corners.

121

medallions adorn the many mirrored French doorways. Glass cases of rare leather-bound books dominate one wall. The many gilt chairs and settees are upholstered with lush velvets, brocades, and fine tapestries.

Although the Mills family only used the house during the autumn months, all the rooms were kept filled with fresh flowers from the extensive greenhouses. The greenhouses also produced ripe cantaloupes throughout the winter.

On the other side of the mansion is the dining room, perhaps the grandest room in the house. It stretches fifty feet in length, and its walls are of blue-gray Italian marble. Brass dragons stand in front of a classical marble hearth. The room is one of the most ornate ever built in a private home, with gilt embellishments on the walls and rare tapestries set into ornamental moldings. Candelabras with brass floral-leaf designs cast a delicate glow about the room. On one of the gilt tables rests a huge bronze libation bowl, which holds enough wine to serve five hundred guests.

Mrs. Mills's bedroom, located on the main floor, is a near duplicate of one designed for Marie Antoinette. Set on a thronelike platform is a dramatic canopy bed, with rose-colored silk-damask drapes. The gilt furnishings are of the Louis XV period. Sometime during the 1940s, M.G.M. was making a film of Marie Antoinette's life. The set designers, in search of authentic inspiration, came to the Mills mansion, took notes, and built a duplicate of the bedroom back in Hollywood.

Despite all this grandeur, a 1902 issue of *Town & Country* magazine featured photographs of the sprawling mansion and made the following comment: "Yet for all the millions spent on renovations recently, there is not the slightest suggestion or heedless display of lavish wealth." The article goes on to describe how modest and comfortable each of the ninety-eight rooms is. One wonders by what standards these rooms could possibly be considered modest.

One of the most celebrated and extravagant weddings of this century was the wedding of Gladys Mills to Henry Carnegie Phipps. Most of high society presented their formal white invitations at Gate 19 in Grand Central Terminal, where a private train took them up to the estate in Staatsburg. At 10:15, the conductor gave the final "All Aboard!," steam spewed out onto the platform, and the doors closed. At that moment, Mrs. McKay, of Long Island's fabled Harbor Hill, arrived at the closing iron gate in a great flurry of near hysteria. She was wearing an oversized hat draped with long black plumes, and she was holding up the six-foot train of her gown. As the train chugged out of the station, she was surrounded by frantic newspaper reporters who fought to get photos of her. It was only after she collapsed from exhaustion that the train stopped to pick her up.

The much-publicized wedding celebration went on for several days. Every guest room in the main house was filled, as were all the neighboring estates and guest cottages, which included the Vanderbilts', the Astors', and nearby Dinsmore. At the bride's home, each room was filled with thousands of white roses and lilies-of-the-valley. Even outside, in the garden, the clipped topiary trees were trimmed with white camellias. Hundreds of feet of white rose garland hung from the terraces and balustrades of the house. The bride and groom arrived at nearby St. Margaret's church in a vintage nineteenth-

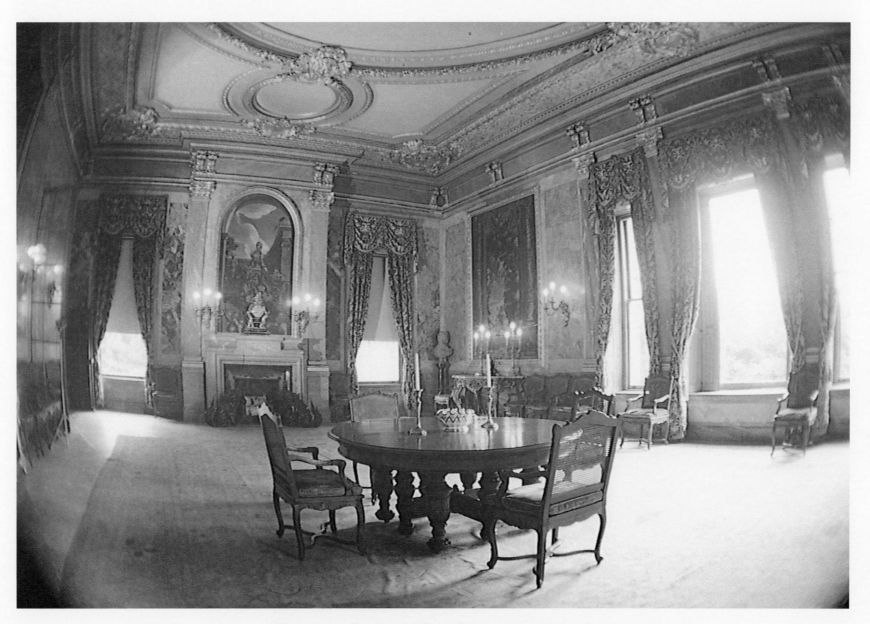

The main dining hall with its ornate details.

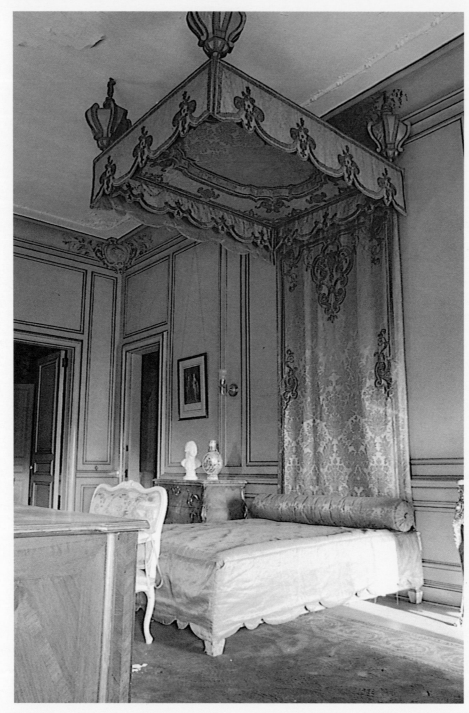

Set on a thronelike platform is a dramatic canopy bed.

century horse-drawn carriage, complete with coachmen in livery and a nervous footman, who scurried about trying to keep the floral bowers from falling off.

When not dining, dancing, or making merry, guests were entertained with carriage rides on the estate. They also toured the famous Mills stables, where silver trophies and blue ribbons won at Madison Square Garden horse shows lined the walls. At the coach house, on the north side of the property, the servants hosted their own bash after the three-day event was finally over.

Many more glittering parties followed. Then, in 1920, Mrs. Ruth Livingston Mills passed away, leaving her husband to ramble around the hundred-room domicile alone, until his own death in 1929. In 1937, their only son, Ogden L. Mills (who was secretary of the Treasury under President Hoover), left the mansion and grounds to New York State, so they might be preserved in memory of his parents.

Today, the splendor of the Mills mansion lives on, and the main floor and grounds are open to the public. But it is on the upper floors that the secret life of the house is truly revealed. The second and third floors have been closed up for decades. The electricity is turned off, and the shuttered rooms are a confusion of light and shadow. Sheets of dust take on the appearance of grimy phantoms, and endless rows of French chairs stand as if waiting to be used again. An old fan lies on a vanity table; next to it, a broken strand of pearls. In one of the rooms a window remains open, and leaves drift in and collect in the corners. Tiny gray feathers of lost doves alight on threadbare rugs.

At the far end of the hall, the door to Mr. Mills's bed chamber opens into a room lost in time. Its king-sized canopy bed rises like an apparition to the ceiling, where two huge damask, braided finials act as sentinels. A French armoire stands in one corner, its doors open to reveal delicate paintings of cupids and angels hovering amid pastel clouds. Giant tassels hang in tatters from draperies, laden with a century of dust. Yet for all its disturbing melancholy, there is an aura of dignity about the former master's room. It speaks with a graciousness and charm we have long since lost.

THE LOCUSTS

This beautiful Staatsburg estate has survived two incarnations. Built in 1873, it was originally called Dinsmore, after its builder. William B. Dinsmore had a reputation for gracious entertaining, and he gave very elegant garden parties on summer weekends. Usually these events centered on the blooming of the rare and exotic plants that were raised in the vast greenhouse complex. On any given Sunday, ladies were seen walking the fragrant gardens with their delicate parasols, while men in their morning coats and top hats played croquet on the gently rolling lawns.

Perched on the highest point of the two-thousand-acre estate was a massive four-story manor house, complete with gingerbread towers, gables, and a wraparound porch. In the house's heyday, friends and neighbors came from miles around to enjoy the famous rose gardens. Here, old-fashioned damask, Edwardian, and cottage roses bloomed in great profusion and were trained to follow the lines of the garden's decorative arbors.

Massive rows of greenhouses, some as large as those found at the New York Botanical Gardens, were Dinsmore's passion, for he cultivated thousands of exotic orchids. Huge tubs of Boston ferns and geraniums lay in every corner of the all-glass conservatories. Water was piped in from nearby streams, and nine huge boilers kept each plant at its ideal temperature.

Dinsmore, the president of the Adams Express Co., in New York City, took up horticulture as a way to relax from the stress of running a city business, but it became the great love of his life. Dinsmore decided to devote each one of his conservatories to the raising of a specific plant or tree. In the grapery, there were 140 feet of arbored vines, with every kind of grape. Tea roses were cultivated in another wing. There were over 200 feet of rare orchids.

Outside, during the spring and summer months, bedding plants were arranged in intricate designs to keep the gardens fragrant and colorful. To this day, tens of thousands of the daffodils that were planted bloom each spring in a yellow blaze along the rolling lawns by the river. Dinsmore preferred to leave the doors of the main house open, in order to feel the soft river breezes. He took delight in watching flower blossoms flutter onto the porch and into the house.

On the north side of the house, Dinsmore planted masses of rare and unusual lilacs. At one time, classical marble statues and giant flower-filled urns stood at the intersections of the garden paths. The towering corkscrew-shaped topiary trees remain even today.

Dinsmore, who was also a gentleman farmer, took great pride in running what was considered one of the largest

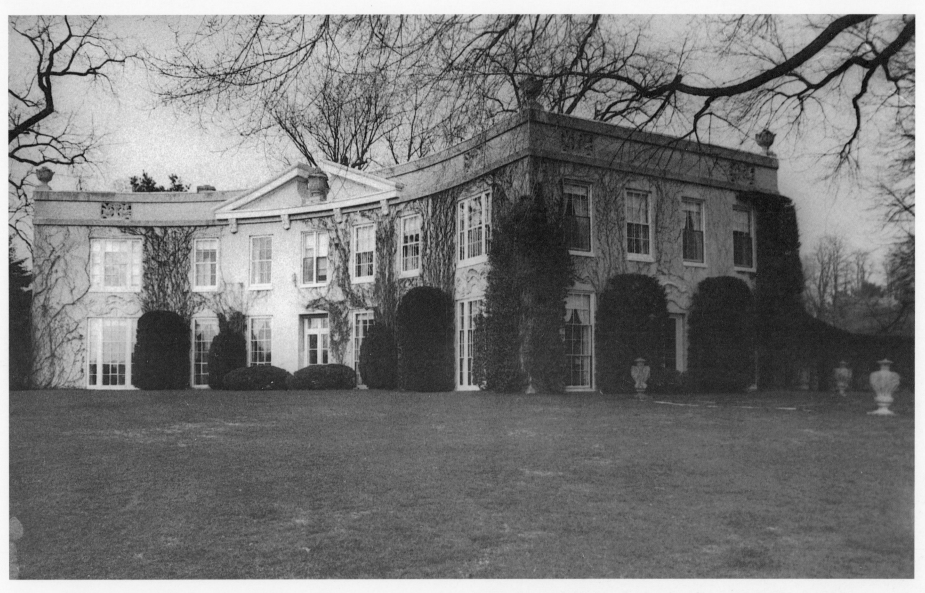

The original dark and rambling Dinsmore was replaced by the graceful and classically styled The Locusts.

The long-abandoned greenhouses give mute testimony of the owner's love of gardening.

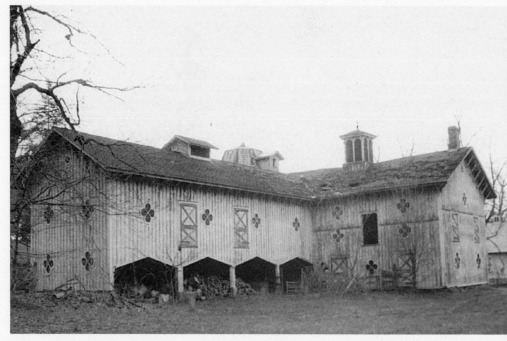

The massive complex of stables is unique with its cloverleaf-shaped windows.

farmhouse complexes in the area. Distinctive cloverleaf-shaped windows decorated the barns, stables, and carriage houses in which hundreds of prize-winning Jersey cattle and pigs were raised. The pigs' barn was so elegantly designed that it was later used as a hunting lodge for a men's sporting club. The farm's butter was sought by the best hotels in New York; it sold for twice the price of regular butter.

After Dinsmore's death, his aunt, Madeleine Dinsmore, inherited the vast estate. In 1941, it was passed down to her niece, Helen Huntington Hull. Helen was an attractive, gracious, and distinguished woman who had been married to Vincent Astor for twenty-six years. She later divorced him to marry a handsome Southerner, Lytle Hull.

Determined to express her own style, Helen shocked everyone by dismantling her great-uncle's unique mansion, numbering every piece, and loading it into one of the barns, where it lies moldering to this day. She then commissioned the noted architect John Churchill to build her a neobaroque stucco manor on the site where Dinsmore had stood. Her dream house, named The Locusts, was unique, with lush 1930s plaster scrollwork above the doors and windows.

Helen Hull's impeccable taste was reflected in the beautiful art treasures she had obtained in her world travels. Dozens of fine paintings graced the walls. In the living room a precious eglomise mirror hung over the formal carved wood mantel. In one corner of the room stood an eighteenth-century German chinoiserie cabinet, filled with Chinese armorial platters, as well as a Cantonese enamel platter. Guests dined on a George III-style mahogany table graced with rare nineteenth-century porcelain.

Helen Hull was regarded as one of the best hostesses of her day. Her home was always filled with music, and quite often the greatest artists of her time stayed at The Locusts. Among them were Arthur Rubinstein, Nathan Milstein, Leonard Bernstein, and Cole Porter. As a patron of the arts, Helen Hull was the founder of the New York City Opera Company and the New York City Center. She was also on the Board of Directors of the Metropolitan Opera, the New York City Ballet, and the Lincoln Center for the Performing Arts.

Helen had also inherited her great-uncle's passion for cultivating exotic plants, and she maintained his vast greenhouses. She was fond of giving her prized specimens as gifts to her friends and staff.

One of the most celebrated events held on the estate was the gala garden party she hosted each summer for the New York Philharmonic Society. Huge pink and white tents were set up on the lawns. Inside the house, every kind of delicacy was served on gleaming silver trays by her devoted staff. Hundreds of vases and baskets were filled with flowers cut from her gardens.

Until recently, this tradition was maintained by businessman Justin Colin, when the estate became his country retreat. Today, the estate is still in private hands, and the towering two-hundred-year-old elm tree still shades the south terrace that overlooks the river.

WYNDCLIFF

Wyndcliff is everything its name implies. It is the stuff of Gothic novels; it is Wuthering Heights come to life, and one half-expects Heathcliff to come thundering up to the front door at any moment. A warning sign is posted outside the rusting gates, cautioning trespassers to stay away.

Abandoned now for over forty years, Wyndcliff is a very dangerous place. It rises majestically from its deserted park of briers, fallen trees, and weed-ridden gardens. A deathlike stillness lingers as one beholds the savage wilderness of decay.

Wyndcliff's roof is now gone, and the crumbling red-brick walls are all that remain of what was once the grandest manor home in the area. The interior rooms have caved in on themselves; beams and rafters form a chaotic mass at the basement level. The remaining walls turn various shades of moldy green as they slowly dissolve with each rain. Amid the catastrophic wreckage, what was once the main staircase now hangs suspended. Shattered piles of fallen stones are everywhere, and a jungle of vines pulls the weakened points of the house farther apart. Faded gossamer curtains cling like cobwebs to rotted window frames. The chandeliers and carved marble mantels are long gone. A rotting piano sinks precariously into the sagging floor. And everywhere, windblown leaves settle in shadowy corners.

Wyndcliff's gloomy state reflects the character of the woman who built the house in 1852. Elizabeth Schermerhorn Jones, a cousin of Mrs. William B. Astor, bought the eighty-acre property, then known as Linden Grove, and hired architect George Veitch from Boston to construct what was then considered the most extravagant house ever built on the east side of the Hudson. The house was so costly and imposing that it engendered the expression "keeping up with the Joneses."

The celebrated nineteenth-century writer Edith Wharton was a relative of Jones's and would frequently spend weekends at Wyndcliff, though it was reputed that she found the house gloomy and oppressive. She wrote of the Victorian villa often in her novels.

Elizabeth Jones is said to have fallen in love only once; after her betrothed died, she wore black for the rest of her life. She never married, and apparently she disliked children. And for all the finery, costly furnishings, and servants, she rarely entertained or received guests. But she was headstrong and unconventional; in an era when women rarely indulged in sports, Jones installed a tennis court on the property. Furthermore, unlike the ladies of her day, she rode while straddling a horse instead of sidesaddle.

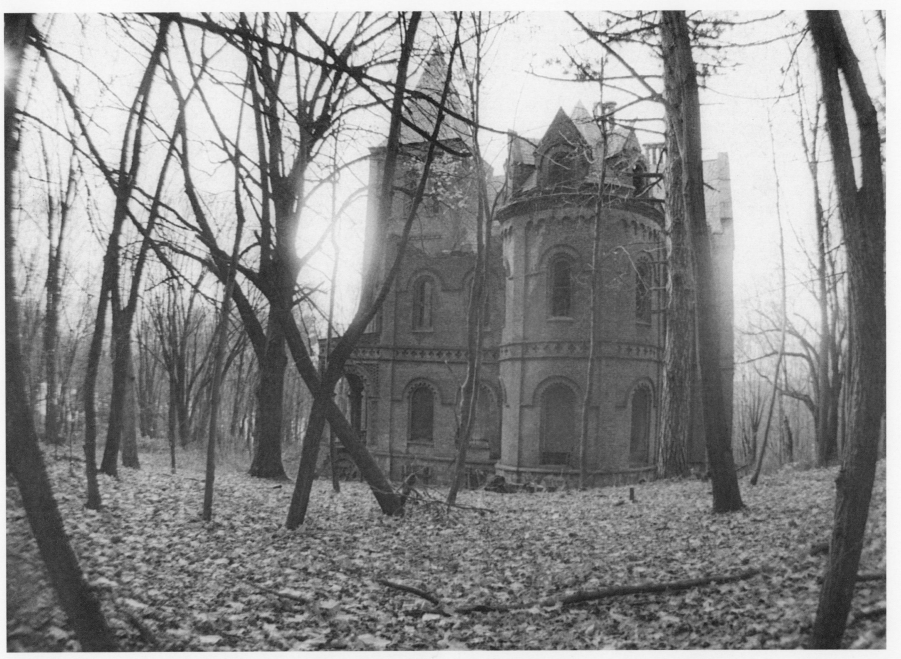

Though abandoned for nearly half a century Wyndcliff remains one of the most captivating ruins on the Hudson.

131

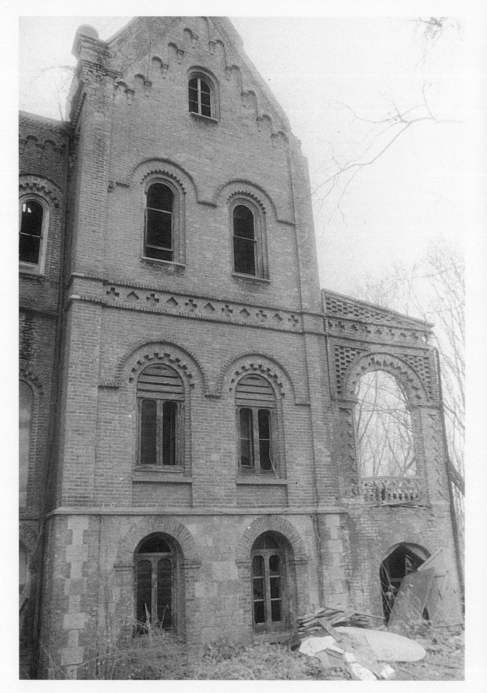

Far left, northside view. Left, with its damp and moldering walls, Wyndcliff appears to be devouring itself from within. Below, what remains of the house, buried in vegetation that has worked its way into the crumbling stone work.

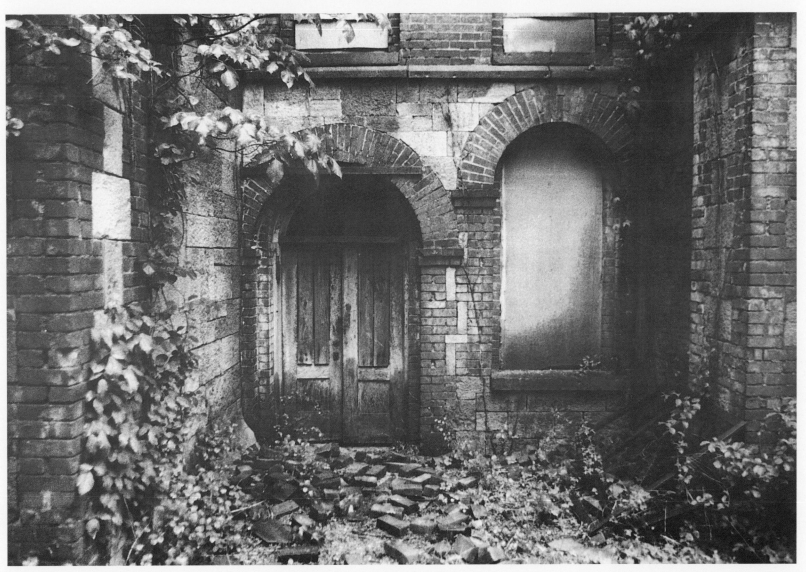

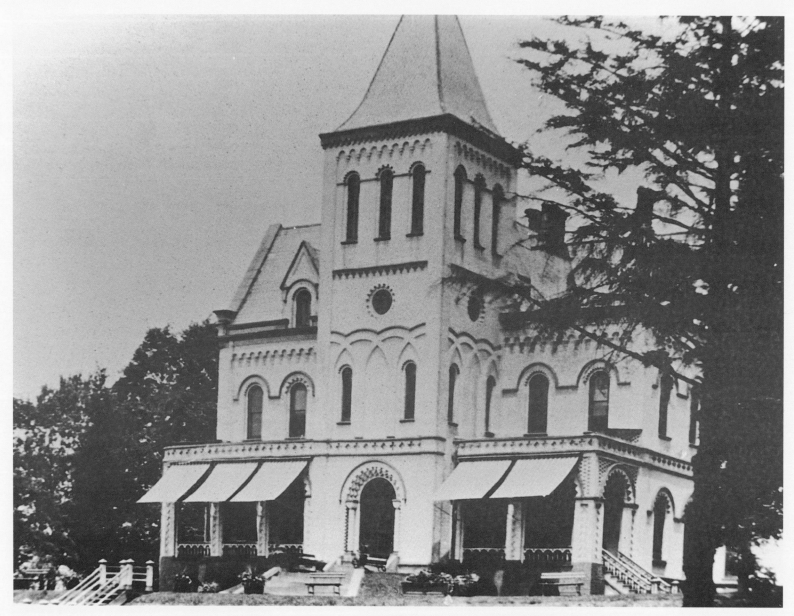

Wyndcliff as it appeared when it was first built in 1853.

When Jones passed away in 1876, the estate was sold to Andrew Finck, a brewer from New York. He installed an elaborate pipe system from the main house to the tennis court, so that his guests could have cold-running beer after a match. The house was well maintained, complete with all its original furnishings, until 1936. For fourteen years it sat empty, until it was sold again in 1950 and became a Hungarian nudist colony.

In the conservative community of Rhinebeck, such goings-on did not sit too well with the locals. The nudists were asked to leave, and the mansion was boarded up and abandoned. Left unheated, the house began to deteriorate because of the bitter-cold river winters. It barely escaped being demolished in 1961 and was rescued just in time by two preservationists—Charles and Betty Eggert—who bought the mansion and the surrounding property. They never moved into the main house; instead, they set about restoring the charming carriage house nearby. Soon, however, they were beset by some strange experiences.

While the massive Gothic-style villa looks like a perfect setting for a ghost convention, apparently the unimposing carriage house is the one with the ghosts. According to one account, around the time the structure was first built, a stable hand hanged himself from a beam inside. He is said to reappear on occasion.

More recently, someone staying there reported having seen a vision of a child in a white lace dress, rolling a hoop with a stick where the old cutting garden used to be. She vanished after a few moments but was seen again the following spring.

On yet another occasion, the Eggerts described hearing what sounded like a fox hunt sweeping through the now densely brambled woods. They could hear the hounds baying and the horses thundering past, heading in the direction of the river, but when they looked out the window there was nothing there. They gazed outside, seeing nothing, until the echo of galloping feet grew faint and finally faded away.

Some effort was made to restore the main house, but work seems to have come to a standstill. The villa's future is uncertain, as the property surrounding it has been sold. The Victorian boathouse that once stood on the water's edge has long since fallen into the river. All the meandering paths and garden walls have crumbled and been reclaimed by the earth.

On foggy days, a dreamlike mist floats up from the river, diffusing the derelict building's flaws. Today, the immense house stands silhouetted against the sky, evoking the awe and sympathy of those who behold it.

FERNCLIFF

When John Jacob Astor, then the richest man in America, asked Stanford White to draw up some sketches for a modest Ping-Pong court, White saw an opportunity to go out on a limb. With visions of the Grand Trianon of Versailles and the World's Fair Crystal Palace dancing in his head, he designed a sports casino the likes of which had never been seen before. Astor took one look at the plans and said, "Build it!"

The structure was completed in 1904. It lay at the end of a long drive, which passed through an apple orchard and fields of pheasants and grazing deer. It is still standing and is considered one of the best examples of Stanford White's work. One enters the sprawling stucco building through a great hall with a high, vaulted ceiling. To the left, down several marble steps, a neoclassical marble pool with white tiles runs the length of the building. One of the building's most innovative features is a wall made entirely of plate glass, which affords an unimpeded view of the gardens and the woods. In the men's dressing room is a marble table, where the resident trainer would administer rubdowns.

The main attraction of this Palladian structure was its two-hundred-foot tennis court. A glass ceiling is supported by sixty-foot parabolic steel arches. At one time, canvas panels could be rolled back and forth across the ceiling to provide shade for the players. The terra-cotta brick walls were laid out in a herringbone design, and at one end of the room is an observation balcony, where guests would sip mint tea and watch the games.

There is also a Ping-Pong court, two squash courts, a paneled library, five bedrooms, three baths, a steam room, a full kitchen, servants' quarters, and a baronial living room reminiscent of the New York Athletic Club. The rooms were furnished in the grand Astor style, with eight-foot fireplaces, Persian rugs, oil paintings, and fine Oriental vases and sculptures. During the spring and summer months, the handsome outdoor clay tennis court was used. Spectators sat along the promenade, which was lined with gleaming white Ionic pillars and surrounded by clipped boxwood and evergreens.

As resplendent as the casino was, it was only one small part of Ferncliff. Fifteen farms, comprising fifteen hundred acres, had been purchased by John Jacob's father, William Astor, in the 1850s. A charming Gothic Revival cottage guarded the entrance to the vast estate, and one entered the grounds through a wrought-iron gate. A gravel drive flanked by dozens of marble statues of goddesses led to the house. Flower beds, filled with well-maintained exotic blossoms, set off the imposing Italianate manor.

The gatekeeper's lodge is all that remains of Ferncliff.

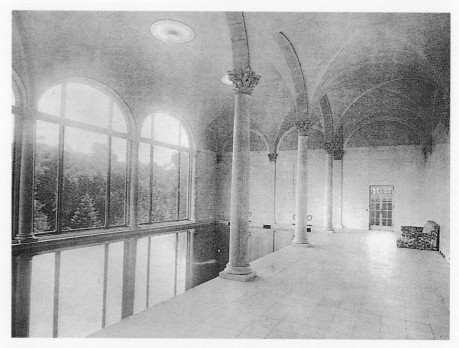

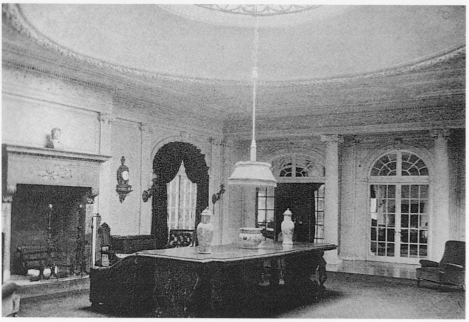

Top left, the indoor tennis court, 1912.

Above. the classic marble indoor pool.

Left, the billiard room.

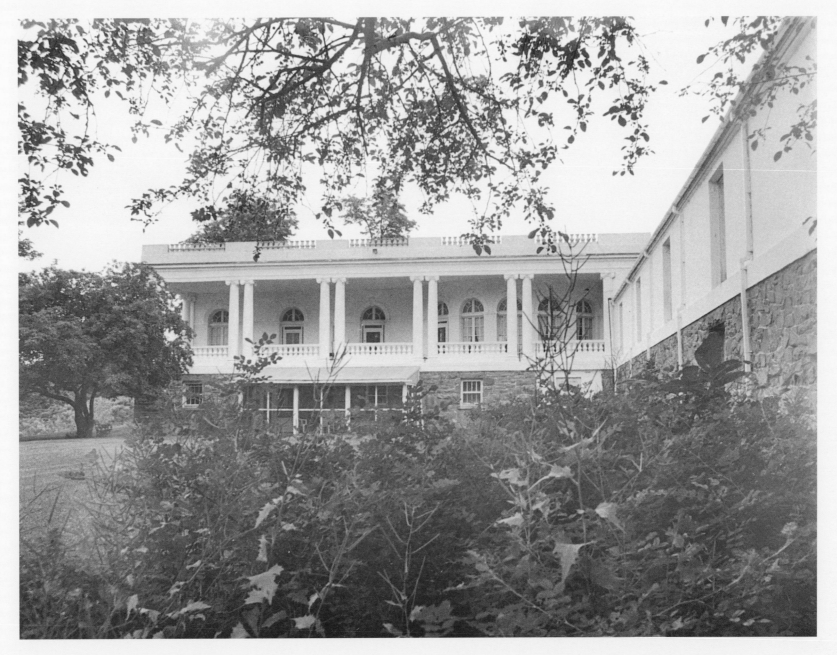

Stanford White designed a magnificent verandah that stretches out from the casino.

The stable ruins are swallowed up in vegetation.

One entered the house beneath a massive brownstone portico supported by Corinthian columns. Inside, the entrance hall extended sixty feet to the rear of the house. The interior was richly decorated with Persian rugs and ancient tapestries. There were mounted stag heads and other hunting spoils. Fine hand-carved moldings adorned the house, along with hundreds of paintings by noted artists, many of which depicted Astor's race horses. On the river side was a five-story Gothic tower that provided a perfect view of a nearby creek and the distant Shawangunk Mountains.

From the veranda, a long path stretched down to the river, where the Astors' yacht, the *Ambassadress*, was moored. A charming stone boathouse once stood on the water's edge.

To the north of the property, dozens of splendid Tudor-style farm buildings and barns were clustered, dominated by a huge dairy with a seventy-foot steeple. The charming Old World buildings were reflected in a man-made lake filled with water lilies. There was also a foundry, a blacksmith shop, assorted corncribs, silos, and a poultry yard. Astor's breeding and racing stables had housed as many as fifty horses. There was even a covered all-weather racetrack that was about a tenth of a mile in length.

Astor saw his beloved Ferncliff for the last time in 1912. That April, he was one of the thousands who died in the *Titanic* disaster. By all accounts, he died bravely. Having resigned himself to fate, Astor went down to his stateroom, put on his tuxedo, and walked out onto the bow of the sinking ship. He was killed by a falling mast moments before the *Titanic* slipped beneath the sea forever.

Ferncliff was demolished in the 1940s, but the casino still stands, as does the charming Gothic gatekeeper's cottage. The greenhouses have rusted and been engulfed by vines. The many outbuildings and barns to the north have fallen into ruin and are reflected in the nearby lake.

Astor bequeathed one hundred acres of Ferncliff land to his daughter Alice. In 1926, Alice married Prince Serge Obolensky, a descendant of the czars of Russia. Together they built an elegant thirty-room manor house, called Valeur, on the site of her father's old home. She was known to stage glittering weekend parties at the house. Her guests included Tennessee Williams, Aldous Huxley, Edith and Oscar Sitwell, and Gore Vidal. The house is now used as a conference center.

EDGEWATER

Edgewater is a neoclassical house that was built around 1820. It stands at the tip of a peninsula, on a grassy knoll surrounded by weeping willows. The property originally belonged to John Robert Livingston, great-nephew of Chancellor Robert R. Livingston. John Livingston built the house as a wedding present for his daughter, Margaret Mary, who married Lowndes Brown of Charleston, South Carolina. Brown was a Yale graduate and had gallantly fought in the War of 1812.

The original architect is unknown, though some believe Robert Mills may have influenced the design of the house. Mills had worked on the designs of Thomas Jefferson's Monticello, and he had created several Greek Revival homes along with architect Benjamin Henry Latrobe. Architect Alexander Jackson Davis later added an innovative octagonal library to the north wing of the stately Southern-style pillared home.

The massive classical portico, its wide entablature supported by six Doric columns, can be seen through the swaying willows at the edge of the property. At one time, an enchanting garden lay at the far end of the estate, with stone steps that led to the water. From there, guests could board a gondola and explore the quiet cove. Marble urns filled with exotic plants stood on pedestals along the garden paths.

The wide terrace at the rear of the house is set off by long arched windows. Piers beneath the portico, which serve as arcades, a design typical of Southern plantations, are now buried and hidden from view. Inside, a narrow entrance hall of a sophisticated design leads to an elliptical staircase, enhanced by curved doors and a domed ceiling.

Margaret Brown, who had been the lady of the house for over thirty years, staged many memorable balls, teas, garden picnics, and amateur theatrics at Edgewater. Decorative lattices supported the tentlike structures that were set up on the sweeping lawns. To the north, a handsome complex of boathouses stood, along with several barns and an icehouse.

Life at Edgewater was idyllic in all respects until 1851, when both Margaret's husband and her father died. These misfortunes were closely followed by the arrival of the Hudson River Rail Road, which roared along the Edgewater property and came within fifty yards of the house. Unable to bear the noise and soot of the great iron beast, Margaret sold the property to Robert Donaldson.

Donaldson, also a Southerner, was a retired merchant and a patron of the arts. He possessed a vivid and creative imagination, and he was regarded as a distinguished man of great taste. He set many a new trend, and he influenced nine-

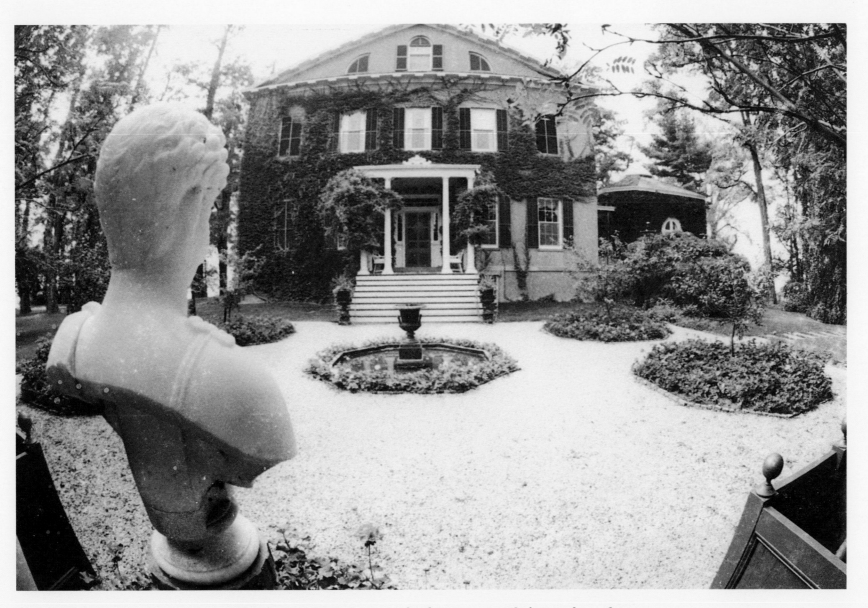

The front entrance overlooks a restored formal garden.

143

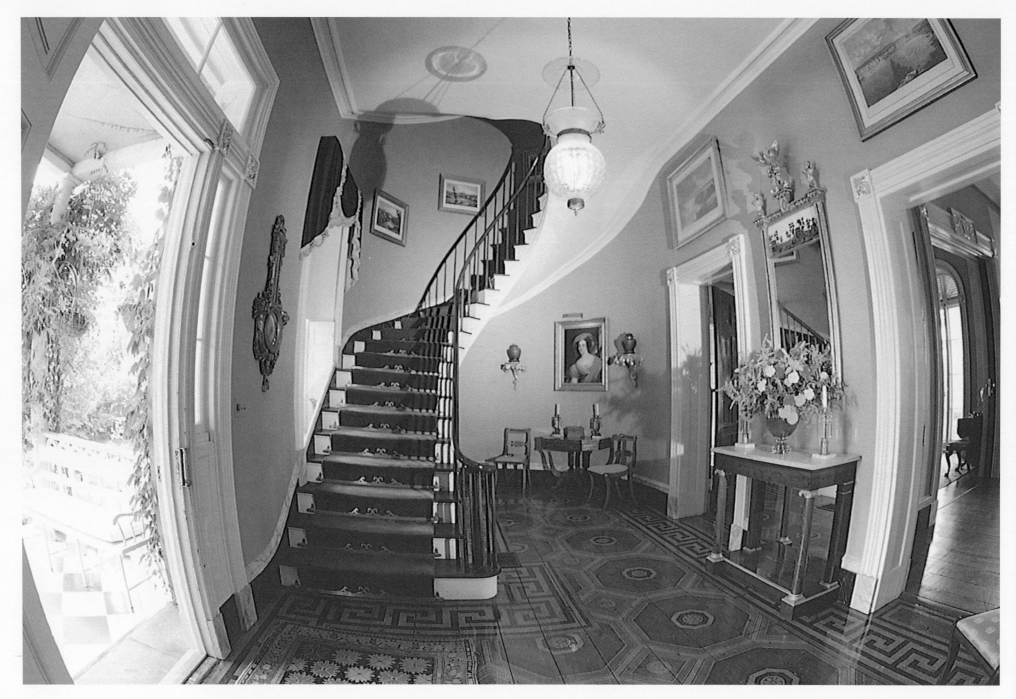

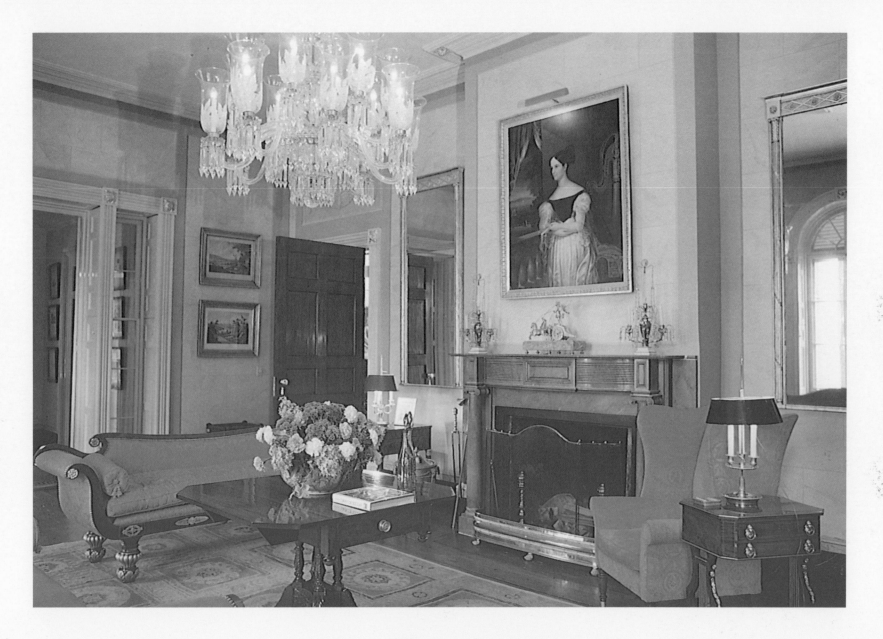

The main drawing room.

Left, the main staircase.

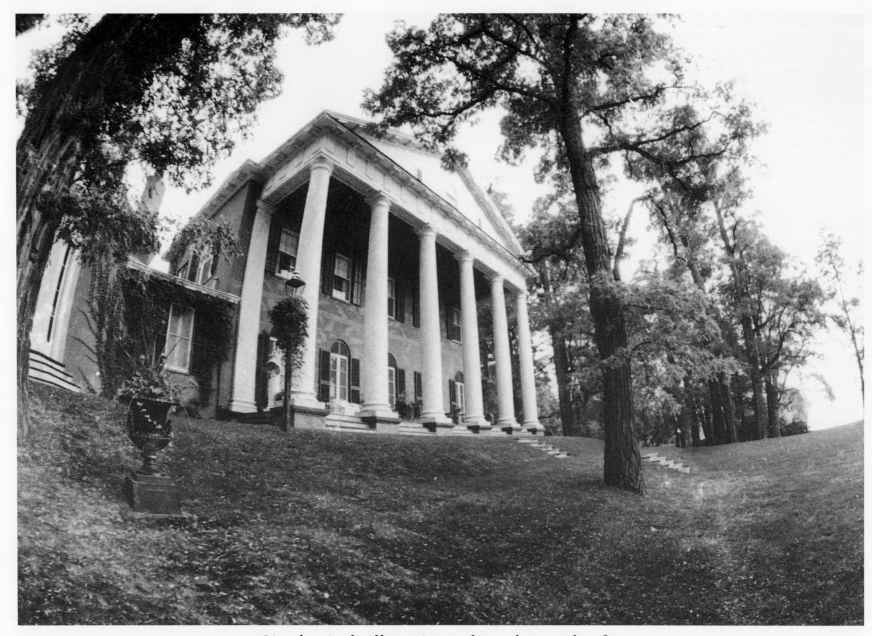

Six classical pillars rise up from the west facade.

teenth-century architecture and landscape design. Undaunted by the railroad, Donaldson entertained many noted artists and writers of the day at his home. Many found inspiration in Edgewater's quiet opulence and informal beauty.

Donaldson had fallen in love with the Hudson River at age eighteen, after a moonlit boat ride from Albany to New York. He described the Hudson as the "consummation of earthly bliss." At one time, Donaldson had owned Blithwood, but he was captivated by Edgewood's beauty, and after moving he told friends that he wished to live and die only in his Greek temple. He asked architect Alexander Jackson Davis, a friend of his, to add an octagonal library, a greenhouse, and a prospect tower, as well as an observatory, an entrance-gate cottage, and a Sabbath schoolhouse. The new library closely resembled the gate lodge at the entrance to Blithwood. Inside, rows of floor-to-ceiling bookshelves alternated with portraits. There were two doors with stained-glass panels. The roof was crowned with a weather vane shaped like a bird of paradise.

Today, Edgewater is perhaps even more spectacular than it was in its heyday, largely because of the painstaking efforts of financier Richard Jenrette, who, like Donaldson, is a native of North Carolina. Jenrette bought the house from writer Gore Vidal in 1969 and has spent the past eighteen years researching its history and restoring every last interior detail. Many of the original paintings were sought out and rehung, including a portraits of Robert and Susan Donaldson. Other pieces were gathered from several continents, including the original family silver and an 1822 set of Duncan Phyfe furniture. (The latter was almost lost when the boat carrying it sank in the Cape Fear River. The furniture was reclaimed from the water intact, however, attesting to the durability of Duncan Phyfe craftsmanship.) In the opulent red sitting room off the main hall is the nineteenth-century harp that Mrs. Donaldson played at Blithwood. It is also pictured in Mr. Donaldson's portrait, which hangs in the same room.

Mr. Jenrette referred to an 1872 inventory guide in order to recreate Edgewood's interior. In his never-ending search, he has found several pieces in a warehouse in Brooklyn, others in an antique shop in Spain. The master bedroom is a showplace of elegant French Empire pieces, including a massive mahogany secretary embellished with gilt and stenciling. A cheval glass stands in one corner of the room.

Edgewater is listed in the National Register of Historic Places. It is an ideal representation of the grand river homes of the last century. At sunset, the great portico is dazzling in the warm, glowing light—a haunting reminder of the Southern plantations that once lined the Mississippi.

WILDERSTEIN

No existing house on the Hudson preserves more of the area's original flavor than Wilderstein, a Queen Anne-style house that remains steeped in the authentic aura of the lost Hudson River culture. A mass of towering pine trees hides the house from view until one is almost upon it; then a Gothic fantasy springs into view, resplendent in its gloominess.

Wilderstein was built in 1852 by Thomas H. Suckley, a hardware merchant who married into the Livingston family. The manorial house blends in beautifully with its surroundings, and its windows catch reflections of swaying trees and the nearby river. A five-story tower with Victorian embellishments rises almost into the clouds. On the north side of the house, green moss has seeped into the dark wood of the now paintless shingles. Birds nest in the rotting timbers of the gables.

One enters the house from a massive, wooden, gingerbreaded porte cochère. A wide, high-ceilinged porch with cyclopean pillars and carved balustrades rims the river side of the house. Scattered about the porch is a rare collection of Victorian wicker furniture with faded floral chintz cushions. At the far side of the house is a glassed-in conservatory or winter garden, filled with colorful majolica pots containing exotic creepers, jasmines, and Boston ferns. Wooden tubs of gardenias and orange trees perch on rusting wrought-iron stands.

Once inside Wilderstein's double oak doors, one finds one's perception of time is somehow altered, and one becomes lost in a haze of antiquity. Inside the main hall, there is dark woodwork everywhere, and the craftsmanship of the carvings is of the highest quality. Above the woodwork, the walls are covered in hand-tooled leather, which has begun to buckle and peel away from the plaster surface. Off to the right, a Victorian marble mantel is reflected in a huge looking glass on the opposite wall. The room's eerie quality is enhanced by a grand staircase; the landing is graced with a bronze dragon finial, and it is set off by a massive stained-glass window with jewel-like sapphire panes.

Off to the left of the main hall is an enchanting parlor, glittering with the stately excess of gilt detail and elegant gold silk-damask walls. Delicate lace curtains hang from the tall windows, casting a filigreed light on the marble statues and fine porcelain vases scattered about the room. The furnishings, designed for the house when it was built, are by J. B. Tiffany, a cousin of the celebrated Louis Comfort Tiffany. Exquisite plasterwork on the ceiling sets off a huge round mural of fanciful cherubs dancing in a cloud-filled sky. Jewel-like crystal pendants catch the light from wall sconces with rose-tinted shades worn thin as gossamer.

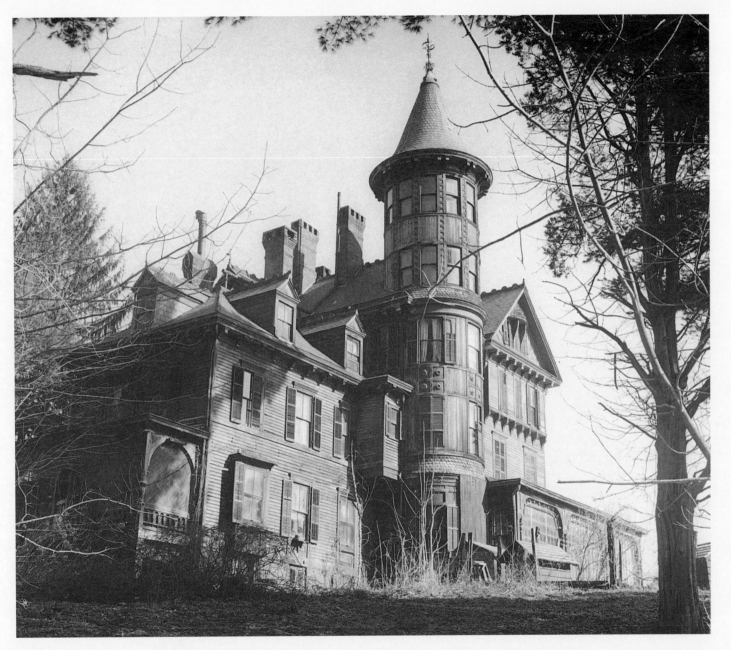

Wilderstein rises up from a river bank in haunted majesty.

149

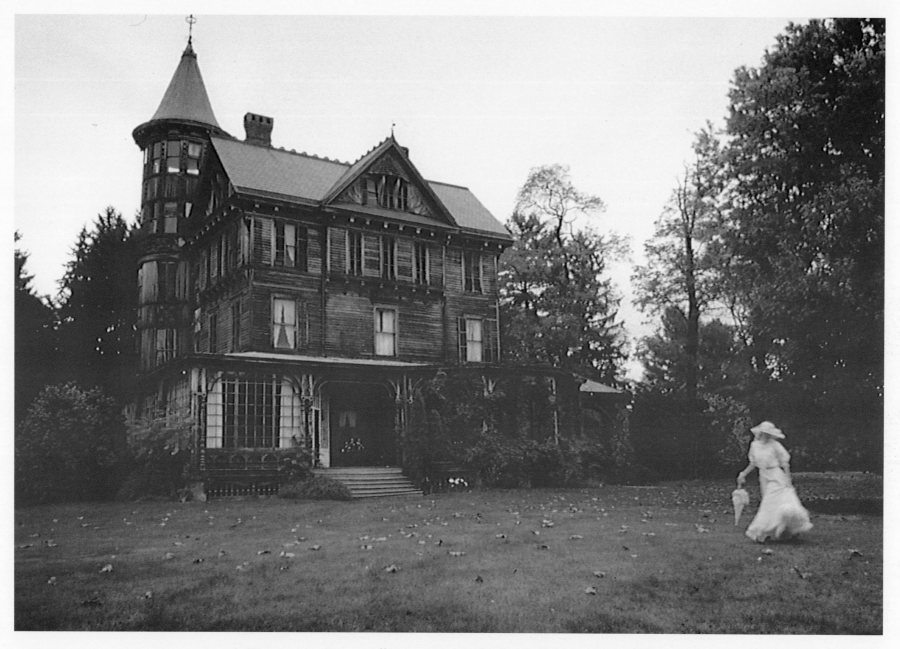

A Victorian woman floats across the lawn like a time phantasm.

150

Today at Wilderstein, most of the entertaining takes place in the dining room at the end of the main entrance hall. The walls are rich, dark mahogany, and antique china rests on a narrow shelf above the wall paneling. The room is dominated by an oversized mantel flanked by pillars and carved with fruit and acanthus leaves. Colorful ceramic tiles are set above and around the hearth. Throughout the room, layers of tiny niches hold collections of porcelain knickknacks.

It was in this room that I was to have tea with the remarkable lady of the house, then nearing her one hundredth birthday. I had first met Miss Margaret Lynch Suckley, known to her friends as Daisy, in 1979. It was she who, after showing me around her Charles Addams-esque manor, inspired the undertaking of this book. She was the last in her line, a descendent of the Livingstons of Clermont and the Beekmans of Rhinebeck, who obtained their land from the Indians, the Dutch, and the British in the seventeenth century. Miss Suckley lived all her life in the house her grandfather built. She never married.

It was a cold gray day in November when I pulled through the stone gateposts and up the long drive. The landscape was barely cultivated, as meadows of tall grass gave way to fields of dried September weed. A crumbling gazebo stood in the distance. I was late, and I found Miss Suckley standing at the entrance holding a watering can.

"I was just watering my plants in the winter garden," she said as I followed her into the darkened hall, then down the long corridor into the dining room.

"Let me check to see if my girl has our tea ready," said Daisy, then disappeared into the kitchen.

I gazed about the room. It was drenched with opulent details and furnishings now musty and moldering, like the setting for a Gothic suspense tale. At the west end, the room ballooned out in a wide half circle, comprising the first floor of the five-story tower. Encircling the room were more multi-colored jewel-like stained-glass windows decorated with armorial designs of deer, stags and sheep. Dominating the room was a large mahogany table that could easily seat twenty for dinner. It was cluttered with stacks of old journals, memorabilia, folders of newsclips and old letters tied with faded ribbons. On the floor were several old suitcases.

Miss Suckley returned a few minutes later, followed by a young woman who carried a silver tray and a steaming pot into another room. Miss Suckley looked down at the cluttered table and shook her head.

"I'm sorting things out these days, trying to decide what's important and what would be of no interest to anyone. It's been a family trait, I guess, never to throw anything out. We were all pack rats around here," she said smiling, then turned away as if overwhelmed by it all.

I followed her into the parlor where she sat down on a fraying Renaissance Revival chair. Her two tiger-striped cats followed her as well, and took their places beside her.

I watched as she poured the tea into a pair of delicate blue- and rose-colored Limoges cups. She seemed poised and in perfect harmony with the room. Miss Suckley was slender, with high, aristocratic cheekbones. Her powdery gray hair was held in place by an almost invisible hairnet. She possessed great personal charm, and behind the glare of her spectacles her pale-blue eyes overflowed with amusement, compassion, and warmth. She was a romantic figure who had somehow survived into the twentieth century.

"Has the house changed much since you were a child?"

"Well, not very much. We never had very many servants. We always did for ourselves. My mother had a cook, a laundress, and a chambermaid. There were more gardeners working outside, and now there is only one caretaker. I do miss the gardens we used to have. They were designed by Calvert Vaux, who helped design Central Park. We had two tennis courts—we were big on tennis then. It kept you in shape.

"They're all gone now, the gardens and all. They were glorious. We grew everything: primroses, pennyroyal, fennel, japonica in August. There were colorful hollyhocks, and English roses that grew on wire arched arbors. It was a real haven for honeybees and butterflies. In spring there were cherry trees with petals that fell like confetti. On windy days the blossoms would fly up against the windows of the house. My sisters and I used to say it was the fairies calling us out to play.

"We grew all our own vegetables and could live off them all winter. I used to love to watch the cook put them up in September; it took days and days. She had to peel them first; then they were steamed, then put in hundreds of glass jars. The shelves in the basement are still full of them; some have been there since the war. The really old ones tend to blow up from time to time and make a terrible mess."

"Did your parents entertain a lot when you were growing up?" I asked.

"There were lots of parties out there on the lawn and in the gazebo, which is now falling apart. My parents loved to play croquet in summer, and everyone came. It seemed there was always something to celebrate: a wedding, a christening. Mother gave teas on the porch for any reason at all.

"I remember my sister had her wedding here. It was during the war. We had a huge wedding bell made of all white chrysanthemums, hundreds of them all tied to a big wire frame. It's still in the house somewhere up in the attic," she concluded, waving her hand in no particular direction.

"Do you miss anything about the past?" I asked. She gazed up at the mantel, where several ornate silver frames contained photographs of beautifully dressed women.

"Style," said Daisy. "There was an aesthetic order to things that was inbred. I think there is a hunger for that today, a hunger for beauty and order."

152

"Yes, there is a ghost, but she has her wing and I have mine." —*Daisy Suckley*

"Didn't the women dress for the men?" I asked.

"We dressed because we were ladies, and ladies wore gloves and hats and proper underpinnings. We loved to wear hats, but we only wore the big fancy ones to go to church and for teas and social affairs. Hats were an art then, and they were exciting, with all those frills, froths of ribbons, birds, and aigrettes and ostrich plumes."

"What about those tight corsets? Weren't they uncomfortable?"

"Oh, yes, but you were trained to wear them. You were started as a young girl. It was all a matter of style, and nobody thought to question it.

"Of course, in summer, when it got unbearably hot, we would sneak back into our rooms and take the fool thing off; no one would know the difference."

"Did the corsets cause problems? I mean, with having babies later on?"

"My dear, you didn't wear those things when you were having babies. Women stayed home during those times. You must realize that things changed drastically with the First World War. The world turned upside-down, and women had to change with it. All those fripperies became a thing of the past."

"You never married," I said.

"No. I never felt the need. Not every woman is destined to marry. There was so much I wanted to do, so much I wanted to learn. I was always so busy doing the things I wanted to do that I never even thought about it.

"It was my dad, Robert Bowne Suckley, who wanted me to go to college. It was very unusual in those days for a young lady. My mother was opposed to the idea; she feared no man would want me if I cultivated my mind or knew too much. But I loved the arts and languages. I had learned to speak German and French when I was abroad. My father was a remarkable man and very wise for his day; he felt you could enjoy life more with an education, so I went to Bryn Mawr and loved it. It was the best school for girls then. None of my girlfriends went to college, though, so I was something of an odd duck. When I came back, all my friends were married and were having babies one after the other," she said without a hint of regret.

"Did you ever fall in love?" I asked.

"I believe I might have. There have been men I've admired greatly, and perhaps loved in my own way," she said, stirring her tea.

"How did you come to work for Franklin Roosevelt?" I asked.

"We were distant cousins. I worked as an aide during his twelve years in office and became his archivist at the nation's first presidential library at Hyde Park. It's not far from here. I also traveled with him on his wartime tours and his meetings with heads of state."

"What was the president like?" I asked.

"He had a fine mind and an overwhelming zest for life. He had a way of seeing things that made you take in more of life. He had a vision—I think that's the word I'm looking for. He loved nature and was especially fond of trees. He could go on and on about all kinds of trees, and he knew all their Latin names."

"How did you come to raise his dog Fala?"

"Yes, everyone asks me about that darling little Scottie. Mr. Roosevelt talked of nothing else; for so long, that was all he ever wanted. So when my friend's Scottie had puppies, I gave Mr. Roosevelt the pick of the litter. Since he was in Washington a good deal of the time, I brought Fala back here to raise him and teach him manners.

"Fala became the country's most talked-about and photographed dog. When FDR was up here from Washington, the three of us would go for long drives in his specially designed Ford convertible. That little dog meant the world to him.

"Fala also caused a political uproar; I believe it was in 1944. The Republicans made a big fuss when they found out that the president had sent a fully staffed warship to rescue Fala after he'd been left behind on one of the Aleutian Islands. His doghouse was out in back, but over the years it just fell apart. We tend to just let things fall where they may."

"The president's sudden death must have been very hard on you," I said, sensing she hadn't talked about these things in a very long while.

"I was with him in Warm Springs, Georgia, when he died, on April 12, 1945. That was a sad time for all of us. I still have all his letters; they're around here, somewhere," she said as she stared out the window at a bird that had perched on the porch railing.

"A cardinal," she remarked, and then paused. "You don't see many this time of year."

Her housekeeper emerged from the kitchen with a tray of fresh scones. She smiled but did not speak, then placed the tray on the small table next to the tea set.

"Thank you, dear," Miss Suckley whispered, then continued to stare out the window, lost in her own thoughts. After a long pause I asked: "Have you ever lived anywhere else besides Wilderstein?"

"Oh, yes. When I was very young my family and I lived in Switzerland for a time, and then I went to a boarding school in Stamford, Connecticut."

"What were some of the things you enjoyed most about life when you were younger?" I asked.

"The abundance of things in general; there was so much going on! Riding around in those new cars was the big excitement. Yes, that was quite a shock for me. You see, before we left for Europe, the carriage house had been full of fine carriages and horses. The building is still there, down the steep road in back of the house. It's a remarkable building, with scalloped painted shingles and a rather odd, onion-shaped tower that rises like a glorious citadel high above the roof. Now it's all but a ruin, filled with old garden statues and discarded furniture from the house.

River view of porch.

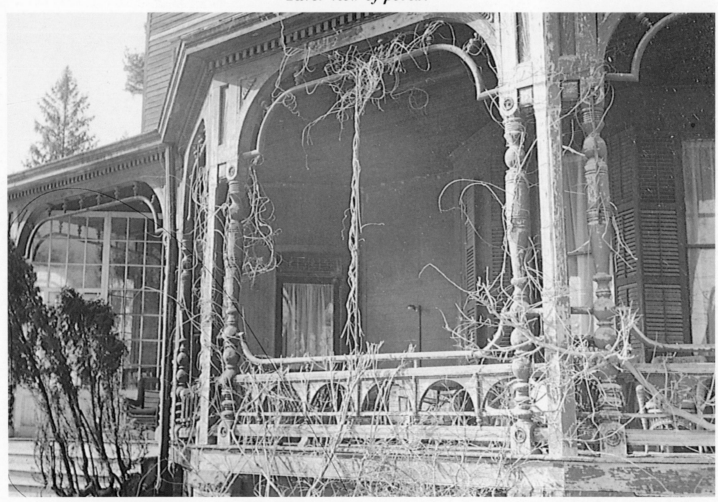

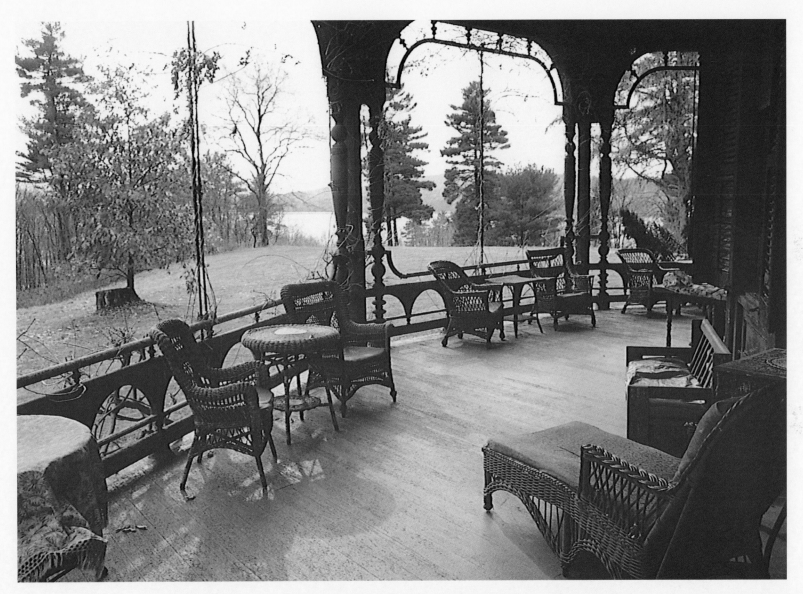

A collection of Victorian wicker is scattered about the porch.

"Anyway, when we came back from Europe, all the horses were gone, and instead there were automobiles: Studebakers, Chandlers, Clevelands, and the like. We would drive to Zeph's Restaurant in Hyde Park and go dancing.

"During the summer there was the regatta row on the river. It was an extraordinary river scene! All the fashionable people in hats and parasols turned out by the thousands to watch the races. Decorated houseboats would move out into the quiet coves and keep an open house. All along the shores, gaily draped stands and striped tents were set up, where spectators and their families could sit and picnic and cheer their favorite college team. There was much celebrating and dancing afterward."

"What do you think about modern entertainment? Movies, for instance."

"They're not what they used to be. I remember when movies were first invented. It was just the most exciting thing. We had one theater in town for picture shows. It's still there. We used to get all dressed up to go to the picture shows. It was an event, a real fantasy.

"Iceboating was a very big thing up here on the river during the winter months. Some of those boats went as fast as our cars do today. There were winter festivals and ice-skating parties on the frozen lakes, and beautiful horse-drawn sleighs and the jingling of harness bells as they made their way through the snow." Her eyes sparkled merrily.

"Is it true you won an iceboating race when you were ninety-two?" I asked.

"Oh, that—they let me win. I was just there for the ride. It was quite invigorating."

"Listening to all this, I'm hoping that Einstein was right," I said.

"What do you mean?"

"He had a theory that the past, present, and future co-exist. I would like to believe it may be possible to go back to your time. It all sounds so wonderful."

"Well, there was good and bad, just like now. A lot of babies died in infancy and a lot of mothers died in childbirth. Women had almost no rights. We didn't get the right to vote until 1920, and the women who fought for it suffered atrocities you never hear about," she said, reaching into her pocket for a tissue to muffle a sneeze.

"You're right. I sometimes forget and only see the beauty that survived from that period in history," I said, looking about the room and marveling once again at all the rich details.

"Have you ever had the feeling that the house might be haunted?" I asked tentatively, wondering if she might be offended.

"Well, we do have a ghost. It's a she, that I know, but she was here long before I was. She has her wing and I have mine, and we get along just fine," she answered with an impish smile.

"Which part of the house is her wing?"

158

An unusual domed tower graces the roof of the now derelict carriage house.

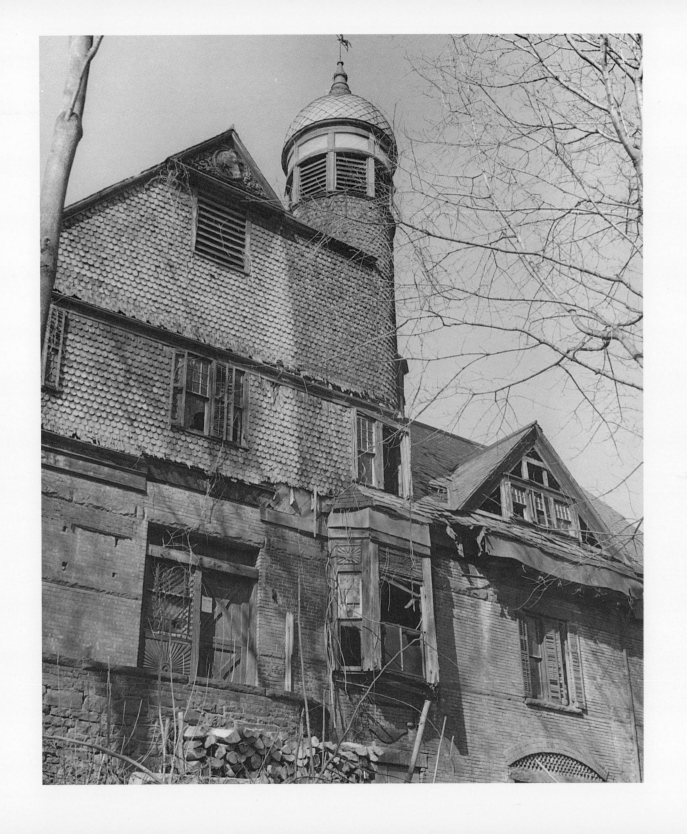

159

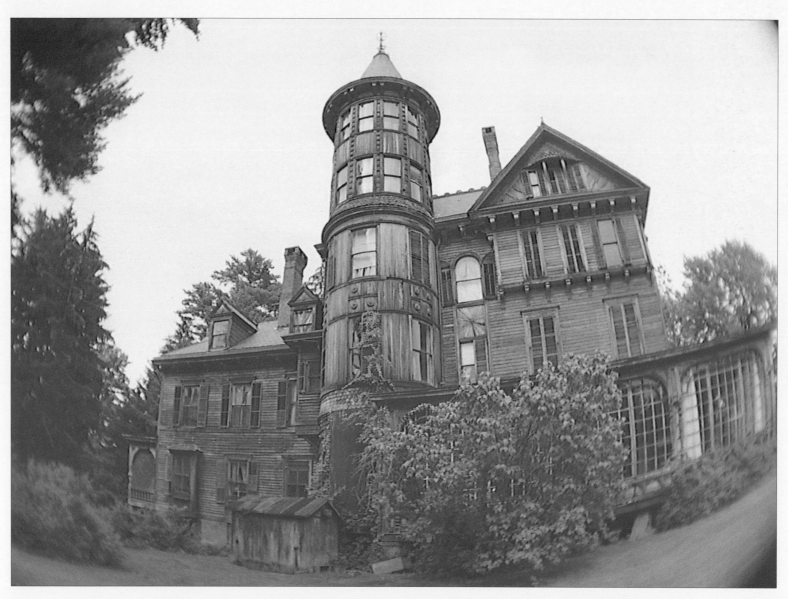

Wilderstein rises up from a river bank like a glorious apparition.

"Why, the tower, of course! You may go up there and have a look if you like, but it's cold and not very interesting. The attic is cluttered with thousands of boxes of letters, some dating back to the last century. I'll stay down here where it's warm and continue sorting some of these papers," she said, picking up a pile of envelopes and untying the faded ribbon that bound them.

I made my way back into the dark, unheated hall and up the stairs past the second floor. Everything along the way was a blur of Victorian colors—brown, fawn, cream, and burgundy—and everything was cluttered and comfortable. There were shell flowers under a glass dome, dried flowers in vases set on lace scarves, and diamond-shaped panes that glowed from a Tiffany lamp. Portraits hung on the walls, taking up every available space, and a huge glass cabinet was filled with works by Marcel Proust, Mark Twain, George Eliot, and Edith Wharton. The stairs wound their way up to the third floor, where a door led to another set of stairs and the walls were curved, forming the shape of the tower.

It was on the fourth floor that the house began to unfold itself like a Wagnerian opera. All the sentiment and taste of the Victorian era were embodied here. A lonely, eerie gleam filtered through the slats of a shuttered window. It was difficult to see amid the ambiguous shadows of slowly crumbling forms. Dozens of damp leather trunks stood atop one another. There was a vague aura of sorrow about a wicker baby carriage that stood near the window. Beside it, several ruffled silk parasols poked out of a tall porcelain urn. The wedding bell Miss Suckley spoke of lay on the floor, and a few scraggly gray flowers clung to the wire frame.

An ornate clock supported by two gold cherubs stood on top of a huge chest of drawers, secretly adding more hours to the whirlpool of time. Lying on top of a wooden box was an old leather copy of *The Cloisters* by Conrad Aiken; around it, dust had gathered. I noticed a ribbon stuck between two of the pages. I opened the book and read:

> The night comes on.
> You wait and listen
> to all the ghosts of change
> and they are you.

Miss Daisy Suckley died in her sleep at Wilderstein on June 29, 1991. Her love letters to and from Franklin D. Roosevelt were discovered in an old, battered trunk that she kept under her four-poster bed. These letters were published in the book *Closest Companions*, edited by Geoffrey C. Ward (Houghton Mifflin, 1995).

Wilderstein is now a museum and open to the public.

ROKEBY

Rokeby is a place where time has stopped. Disorder creeps ceiling-high, and pillars and posts are festooned with cobwebs. For two hundred years almost nothing has changed. This great monument of antiquity has been irreparably marked by its heirs' predilection for letting things slide.

It was three years after my initial request before I finally received an invitation to visit the house and its owner. It was worth the wait. As I approached the ancient gate that bore the rusting though lavishly engraved initials "J.A.," I was reminded of the opening scene in Daphne du Maurier's classic *Rebecca*. An elderly gatekeeper peeked out from the curtained window of his stone cottage, shuffled out and silently unlocked the gate.

A long drive took me past vast open meadows where dozens of deer were grazing. They took no notice of me. Heavy fog rolled in from the river, and in the distance Rokeby loomed from a hilltop, its tower lost amid swirling vapors. As I pulled into the circular drive, I found the house in a state of glorious shabbiness. The Corinthian columns were badly in need of paint, and several of the capitals had been removed and were lying in a heap on the front lawn next to a huge cauldron. As I pulled up to the front steps, birds flew from the rooftop with an explosion of noise.

The front door was wide open, and except for the birds returning to their perches on the roof, there was no sign of any life. There was no bell to ring, and calling out brought no response. Inside it was cooler. Two huge majolica urns stood on either side of the entrance to a long, dark hall. Family portraits hung from thin wires that went up to the ceiling moldings. Lining the walls on both sides were huge, hideous chests of drawers with grotesque faces carved into them. Low-hanging tapestries partially concealed a magnificent staircase and what looked like a pair of balconies leading to other wings.

As I headed toward the staircase, hoping to find the owner waiting for me, somewhere off in another part of the house someone began playing a violin. Whoever was playing it kept repeating the same notes, as if trying to master them. Drawn to the music, I turned left and entered a huge drawing room filled with dusty Victorian furniture, heavily carved and gilded. Burgundy velvet drapes hung in tatters from tall glass windows. Somewhere a clock I could not see began slowly to chime the hour. At the far end of the room there was a curving passageway that led to a narrow hall, where arched niches held huge Ming vases; long-dead hydrangeas, now stiff and brittle, sprouted from the top. A heavy carved-oak door made a low moaning sound when I pushed it open, and on the other side of it was one of the grandest rooms I had ever seen. I immediately recognized it as the famous octagonal library that William Astor had had built at the base of a four-story tower.

162

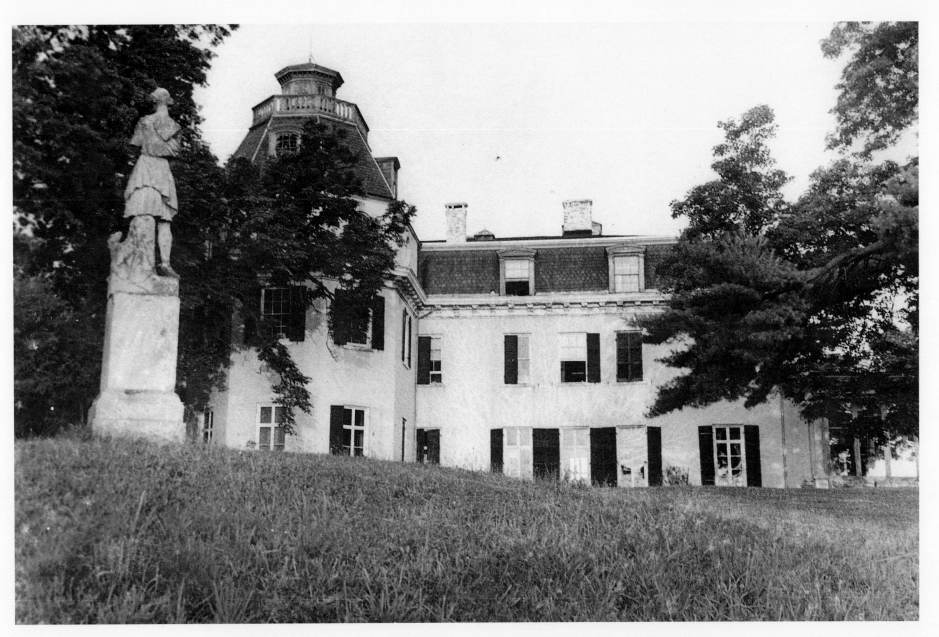

Rokeby with its haunted, five-storied tower as seen from the river.

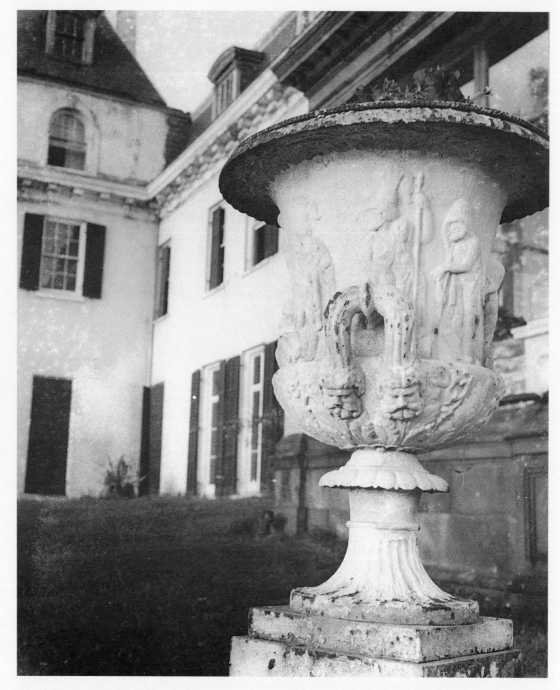

A giant classical urn graces the river view of the house.

Light poured in from several windows that rose to a dome-shaped ceiling. Marble busts of history's great men glared down from their shelves and were surrounded by thousands of gold-stamped leather-bound books on every conceivable subject. A huge mahogany desk dominated the room, and it was cluttered with rare and beautiful things: a bronze cigar box in the shape of a stag head, an ornate silver pen-and-ink set stuffed with quill pens, signed photographs of Franklin Roosevelt and Winston Churchill, a drawing of Richard Wagner, and a curious miniature of Napoleon. An ornate Victorian clock sat on a marble mantel; its face and hands were gone, and someone had replaced them with the head of a plastic doll. It stood out in jarring contrast to the foreboding seriousness of the room. Intricately carved wood moldings everywhere gave one the impression of being in a huge spiderweb. Completely entranced, I moved to the window and stared out over the sadness of the ruined garden. Poison ivy clung to everything, its leaves entwined like funeral wreaths around ancient statues of fawns, satyrs, and life-sized nymphs. A rusting iron fence ran along the back of the house; one section of it had toppled and seemed bound to the ground by creeping vines.

Rokeby has been in the same family since it was built in 1813 by General John Armstrong, who was secretary of war in 1812 and was compelled to retire after he allowed the Capitol to be burned by the British. Armstrong had also been ambassador to France, and his Rhinebeck estate was originally called La Bergerie, after a herd of Merino sheep Napoleon had given him. Armstrong devoted the remainder of his life to raising his sheep, and while living at La Bergerie, they were free to roam the house and its surrounding meadows. It was Armstrong's daughter Margaret who changed the name of the estate to Rokeby, after being inspired by a poem by Sir Walter Scott.

The Astors were introduced to Rokeby when Margaret Armstrong married William Astor, then the richest man in America. He was the son of John Jacob Astor, who bought the estate from Armstrong and gave it to his son as a wedding present. Some time later, the Chanlors, who were mostly Astor descendants, took over Rokeby, and then prevailed upon their friend Stanford White to make substantial changes to the house. White added the third floor and the lead mansard roof, then extended the front of the house with a stately columned porch and the four-story tower that faces the river. By this time, the beauty of Rokeby was legendary, for it represented the work of nearly all the great artists and architects of the nineteenth century.

In 1896, Stanford White was called upon to stage one of the most lavish weddings of the century: the marriage of Alida Beekman-Chanlor to Christopher Temple Emmet, a New York lawyer. White brought in truckloads of orange blossoms and asparagus vines. Neapolitan minstrels strolled amid thousands of colorful lanterns. Flower-drenched tents were set up on the lawn, where a Hungarian orchestra played. Herds of sheep roamed about, creating a pastoral effect. When

the wedding party arrived at the house, crates of pastel-tinted doves were set free. To add to the fanfare, miles of satin streamers hung from the rooftops and pillars of the house, fluttering in the river breeze.

Over the years, White continued to make changes to the house, and he added the steep white staircase covered with bright crimson carpeting. These stairs were forbidden to all Chanlor and Astor children. For them there was the backstairs region, which meant going along a dark passageway, through a door, then three steps up to the right, then to the left down another flight of dark stairs, which led to the servants' wing. These were the days when children were meant to be seen and not heard, but at Rokeby they were rarely even seen. At some point they discovered the dumbwaiter in the servants' wing, and they took to riding it to avoid getting lost in the confusing labyrinth of gloomy passageways. During that time, the house was dominated by the formidable presence of Margaret Livingston Chanlor-Aldrich, who is best known for establishing the United States Army Nursing Corps. She was also president of the League of Women Voters. She married Richard Aldrich, who was then the music critic for the *New York Times*.

Gray clouds swept across the sky, and the library grew darker. I lost all track of time. There was a faint rumble in the distance, and then the sound of a loud engine as a tractor made its way closer to the house, stopping suddenly in the drive. Heavy footsteps pounded the ancient floors.

"Hello, anyone lurking?" a voice boomed.

I made my way back to the main hall and was startled by the appearance of a person standing in the doorway.

"Oh, you made it up from New York. Sorry I'm late; been working on my tractor. Ricky Aldrich here," he said in a Humphrey Bogart voice. He quickly reached for my hand—and returned it covered with grease.

"I hope you found your way around," he said.

"Yes, it's very impressive."

"Well, I do my best to demolish it," he joked. He was in grease-soaked clothes that were also splashed with red paint, and he looked as though he had survived some ghastly accident. His hair sprouted from his head in tiny little corkscrew curls as though he'd combed it with a Cuisinart.

"Well, make yourself at home!" he said flamboyantly. "I've got to get back to my bloodbath." He turned and, with what appeared to be an unlimited supply of energy, was out the door.

I followed him as he hurried over to the pile of metal capitals that were lying on the lawn. He began dunking them into a huge vat of blood-red Rustoleum.

"Prevents rust," he said, working like a soldier ant. "Got to get those pillars back before winter sets in. The whole roof is about to cave in! There's no end to the work around here."

166

He stopped working for a second to stare up at the house. With an almost manic gaze, he scrutinized every chip of peeling paint. He then resumed working at a feverish pace, talking nonstop about the monumental difficulty of keeping up the building and contending with what he referred to as an eccentric family. I listened, and was both fascinated and charmed by his fusillade of curious comments. He was very entertaining, and the conversation would quickly shift from esoteric things to intuitive musings on the state of the world. But it appeared that his world revolved around the several hundred acres of Rokeby, a unique and derelict time capsule.

Richard Aldrich is the grand-nephew of John Armstrong Chanlor and the grandson of Margaret Livingston Chanlor Aldrich. Ricky Aldrich has worn many hats, few of which made use of his education at Yale, his genius IQ, or his ability to speak seven languages fluently. "I've attempted farming," he said, out of the blue, "but I always plant the wrong veggies at the wrong time in the wrong place and harvest them after they've died. Usually the goats get to them first. What the hell; they've got to live, too, I guess," he concluded.

I learned that Ricky saves and uses everything. It appears to be an inherited trait, for it is well known that nothing at Rokeby has ever been thrown out. There are farm tools dating back two centuries, as well as old tractors and trucks, their parts stacked high in every corner of the barnyard. A rare collection of iceboats is housed in another building. When a barn gets filled, the door is closed and the procession moves on. Curiously, one closet in the house is filled with old deer antlers.

Ricky has a soft spot for animals—they seem to follow him around. When Ricky married a Polish princess, Onya, in 1970, their pet cow attended the wedding wearing a top hat and is included in the formal wedding portrait. Ricky's friends regard him as a delightful fellow who can be endearingly silly but whose kindness and generosity are well known to everyone in the area.

When Ricky finished rustproofing the metal capitals, he wiped his hands on his clothes and offered to give me a tour of the house. At the top of the main stairway landing, a huge ceramic dragon overpowered a narrow ledge above a door; it stood there precariously, as though it would topple with the slightest vibration. Everything about the house was like that. Incongruities were part of its charm, as were unpredictable mixtures of styles from different periods, which were reflected by mementos of the Astors, Armstrongs, and Chanlors in each of the fifty rooms. Convention had never been a consideration, and the house's style seemed the result of the owners' idiosyncratic whims and momentary passions.

The second-floor landing was almost the size of a ballroom. There were two huge paintings on either side, one in the style of John Singer Sargent. The woman pictured was very beautiful; her eyes exuded such pathos and energy that she seemed almost alive. A long black satin Queen Anne chaise longue stood below the painting. At the far end of the hall, an armoire almost reached the ceiling. I was told that linens were stored in it. There were six master bedrooms off the hall; none of them appeared to be in use. A large nursery had delicate floral wallpaper. Lining one wall, dormitory-style, were four high arched Gothic beds,

In gloomy corners, incongruities and collections of curious things are seen everywhere.

Several magnificent rocking horses stand in a row, whiling away the centuries.

the silk covers pulled back as though awaiting the arrival of guests. Farther down the hall to the left was a locked door.

"This was my grandmother's room," Mr. Aldrich said in a reverent, hushed tone as he turned the key and strained to push the door open. I had the strange feeling that someone or something had just vanished from view when we entered. The windows were shuttered, and faint beams of light filtered through the dusty slats. Victorian wallpaper, lush with faded roses, set off a huge dark Gothic bed crowned with carved gargoyles. Next to it, a water bowl and pitcher stood on a linen-and-lace-covered table. The fireplace hearth was sealed and no longer used. On the mantel was a lifetime of clutter.

"Everything is just as she left it, but nothing has been the same since she died in 1963. She was the dominant force of the family for so long." He looked around the room one more time before closing the door behind us.

"Was someone playing the violin earlier today?" I asked as he headed down several stairs into a darkened wing toward the back of the house.

"Oh, that's my daughter Alexandra. She has a real talent for music, I think." He turned to the right, descended several stairs, and followed a hallway through an open door into the strangest room I've ever seen.

"This here is the Crow Room; used to be my Uncle Bob's room." The walls were painted with hundreds of sinister black crows. It immediately brought to mind Alfred Hitchcock's *The Birds*. There were crows everywhere—on the walls, ceiling, and furniture—in all shapes and sizes.

"Sometime in the last century, one of the Astor orphans kept a crow for a pet. It became a much-loved member of the family. After it died, my uncle, Robert Chanlor, believed it came back to haunt this room. I'm told they used to hold séances here to keep in touch with the bird. Robert Chanlor was what you call an 'original,' and that's understating it just a bit."

Chanlor was one of the noted artists of his day. He had studied in Paris, and his unusual murals were in great demand during the estate-building era in the early part of the century. He went on to paint a flamingo room, a weasel room, and the famous Buffalo Room at Coe Hall in Oyster Bay, Long Island.

Chanlor was a man who realized his dreams. One of his dreams was to create the House of Fantasy. He bought three large brownstones in New York and filled them with thousands of birds, left free to fly about the trees, which stood as high as the ceiling. Wild costume parties were a weekly affair. At one party, Chanlor is said to have brought into the ballroom two elephants that were trained to waltz. In this same room there was a grass hut built atop a thirty-foot tree, inside of which a gypsy read tea leaves. Influenced by the fantasies of the mad King Ludwig of Bavaria, Chanlor built a modified version of the king's famous grotto of Venice, with theatrical lighting, an artificial moon, a waterfall, and the music of Wagner in the background. Chanlor entertained the rich and famous, showgirls, and criminals alike. Ethel Barrymore is said to have spent one night at the House and said of it, "I went in one evening a young girl and emerged the next day an

old woman." It was there that Robert Chanlor met and fell love with Isadora Duncan and is believed to have been engaged to her at the time of her death in 1927.

Ricky ran his hand over a dust-covered chest of drawers as we left the Crow Room. "Come," he said, "I'll show you another one of Uncle Bob's horrors."

We went up a flight of stairs to a large hall where a dirty skylight allowed only the least bit of light to pass through. Above our heads hung a ghastly painting about ten feet wide. The painting depicted a phantom orchestra. All the musicians were corpses in various stages of decay. The family's history of alleged madness was so alive in it that it seemed to jump off of the canvas.

"This way to the attic," he said, trying to distract me from the morbid painting. "The tower is up here too, and we have a little blithe spirit who lives up there," he continued matter-of-factly.

"Blithe spirit?"

"Back in the last century, when the Chanlor boys were young, they had a nanny who had been a slave. 'Old Black Jane,' they used to call her. When the boys grew up and were on their own, she developed an obsession with sweeping floors; day and night she would just sweep and sweep. Finally she died from exhaustion. They found her body in the tower with the broom still in her hand; I'm told she was buried with it. Each year, on the eve of her death, you hear the sound of a phantom broom sweeping back and forth across the floor."

THE ROKEBY ATTIC

The attic at Rokeby is a kind of secret hermitage where the memories and collected treasures of two centuries are embalmed in time. Ricky Aldrich stood at the top of the glass-enclosed landing and looked around at the surreal accumulation of abandoned things, secure in his unconferrable knowledge of the history of each and every object that was stored there.

"There's no electricity up here. Never has been. Used to be gas fixtures, but I ripped them out. Too dangerous," he said defiantly. "Most of this stuff's accumulated by the Astors, the Chanlors, and us, but it's out of control," he continued, kicking an old hatbox out of the way. The lid tore away and rolled into a corner, where it collapsed with a faint thud in a pile of dust. Everywhere there were dark corners and deserted chambers that had not seen the light of day in perhaps half a century or more. Half a dozen magnificent rocking horses stood in a row, whiling away the centuries. Next to them, an elaborate dollhouse sat on a table in a cobwebbed alcove.

Off in a cobwebbed corner a pair of vacant glass eyes stared out at us as we passed.

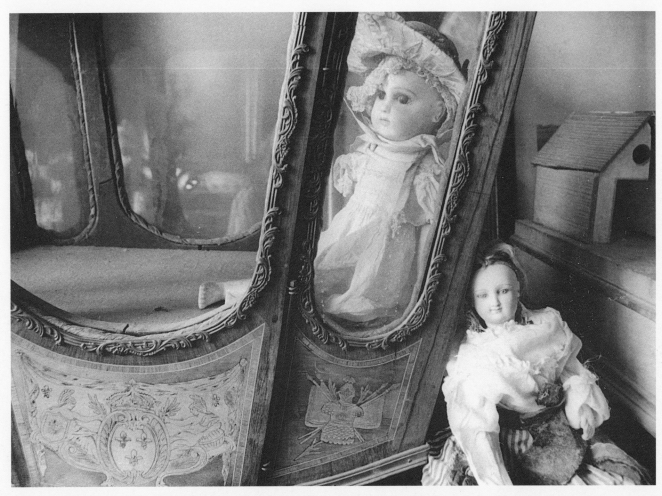

There was a timeless luminescence in the eyes of these long forgotten dolls.

I followed my guide as he climbed over what appeared to be a burial ground for broken furniture of every style, period, and description. Lying on the floor in a shadowy corner were two decayed mounted deer heads. Two pairs of vacant glass eyes surveyed this curious realm of human disarray.

Off the center hall there were several rooms, one filled with rare vintage dolls and a tiny wicker carriage. In another room, steamer trunks were filled with turn-of-the-century clothes. All around, in a textile jumble, silk fabrics, lace, and old uniforms were unceremoniously strewn about. Dozens of hats, lush with aigrettes and faded flowers, lined the shelves.

There was a glass case stuffed with old leather albums. Sepia-toned photographs reflected the odyssey of the fascinating people who had lived there. Pictured were weddings and social events where the pets were as important as the guests who attended. There was a haunting photo of the tragic Astor orphans and their governesses standing stiffly on the front steps of the imposing house. Tucked away in one of the pages was an old newspaper clipping:

CHANLOR CHAPMAN'S MEMOIRS—
CHILDHOOD HAUNTS, HUDSON RIVER MATRIARCHY

Sylvania and Rokeby, adjoining country places are laced into my memory like two vivid snakes, which tangle me in their coils. People make places and then places make people....If you stay around they will engulf you, swallow you whole after they have crushed every bone in your body and strangled you. The pleasure dome of the parent becomes the deadly arena of the second generation, a place of blood and sand where the exits are used by live beasts and dead gladiators who have been eaten up by their possessions.

I was struck by the gloomy similarity between these words and the painting of the dead musicians, as though some insidious discord pulsed through the very walls of the house and the minds of the people who lived there.

We came to a door where the stuffed head of a long-dead fox seemed to greet us. On its head was a Victorian lace cap tied with a blue silk ribbon.

"This is the war room," Ricky said. He gazed about at the barbaric artifacts as though he had not been there for many years. There was a shelf lined with metal helmets.

174

"My dad used to collect these." He picked one up, turning it in his grease-blackened hand. "He would go around the fields after battles and pick them up. But he only took the ones with the bullet holes blasted through them. Never could figure out why," he said in a hushed tone, poking his finger through one of the fatal holes. Turning away, he then moved about the room with a supple intensity, but his face seemed like that of an innocent child whose spirit had been wounded.

"Here's something my dad was proud of," he announced, screening himself behind an old dress form with a spear stuck in its chest. Next to it was an odd piece of machinery.

"This here was the tracking device used by the Nazis to locate fighter planes during World War II. It's probably the only one in existence," he proclaimed with a hint of satisfaction. It seemed that his pride came not from the objects themselves but from his father's memory. Ricky's father died when he was very young.

Excitedly, Ricky climbed over other oddities, neglected and forgotten. There were other war relics, as well as primitive blowguns, spears, and knives.

"These nasty things belonged to African Willy, who was William Astor Chanlor. He explored the Dark Continent before any other white man. Willy was a big-game hunter. Before that, he'd spent some time as a Turkish cavalry colonel. He lost his leg, though, in a fight over a woman. There were some shrunken heads around here, too," he said as he rummaged about, then rested his hand on his hip. "I bet that damned goat ate them. Everything disappears around here," he grumbled to himself. He then turned and made his way through the formidable pile of rubble and headed back toward the center hall.

"What goat?" I began, but the tour was over. Ricky paused at the landing for a moment, staring blankly at the endless boxes, as if he were somehow being drained by it all.

"I'm going to go finish painting those pillars before it gets dark." His voice trailed off as he disappeared down the stairs, then with renewed strength he boomed, "Oh, check out the tower! There's quite a noble view of the river!"

At the end of the narrow hall, there was a tall gilt looking glass enshrouded in gossamer cobwebs. It caught the reflection of a marble bust that stood on a pedestal in the corner. To the left was a narrow staircase leading to a wooden door with a porcelain handle. Beyond it was a large round room filled with abandoned statues. In the middle of the room, a steel spiral staircase rose up to the tower. A chill current of air blew in from a window, where a jagged-edged shade flapped relentlessly against the broken glass. From the window I could see the shimmering silver of the Hudson, and beyond the river the Catskill Mountains.

When I returned from the attic, it seemed there were more doors in the hall than had been there before. I opened the wrong door and discovered a curious closet with a tiny door just big enough for a man to crawl through. It opened with

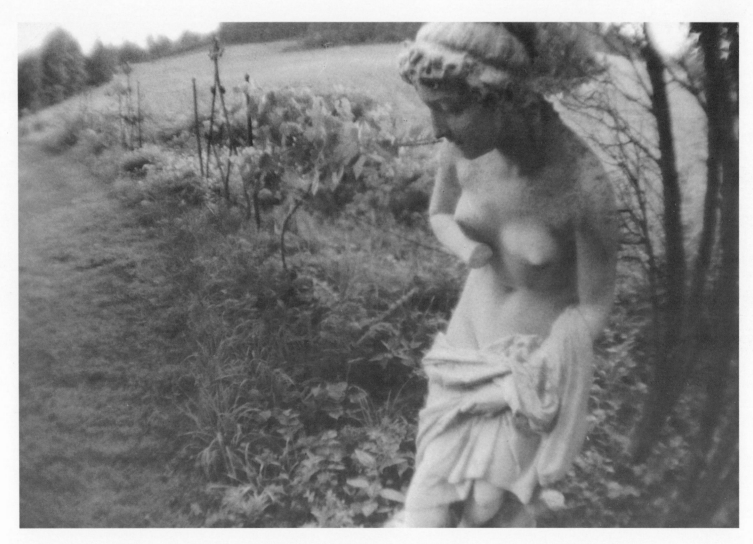

Vines entwined like funeral wreaths around life-sized statues of nymphs in the abandoned garden.

a reluctant creak, and beyond it was a series of small, gloomy low-ceilinged rooms no larger than six feet square. They were too small to have been used by the Astor children or their nannies, and I wondered if there had ever been slaves at Rokeby. According to record, it was through the unpaid labor of slaves from the West Indies and Africa that Hudson Valley aristocrats were able to develop their land. Many of the estates were cleared and the farms maintained by men and women in bondage. It was not until 1827 that slavery was outlawed in New York State, though it is believed that in some cases it continued illegally. Often slaves were quartered in the attics of their masters' homes and were said to have suffered from the extremes in temperature throughout the year.

I was about to investigate the tiny rooms further when I became aware that something or someone was standing behind me. There was no mistaking the heavy breathing. I turned around, and there, standing in the doorway, was a rather hairy goat with what looked like a shrunken head in its mouth. It was time to leave Rokeby.

SYLVANIA

My letter to Chanler Chapman arrived at Sylvania one week after he had passed away, but the trustees of his estate grant-ed me permission to photograph the property, which adjoins Rokeby. Several weeks later, I arrived to find the plantation-style house boarded up, its stucco walls all but covered in vines. It was raining, and there was a lingering sadness about the place, as if the house itself knew that its master would never return.

A limestone staircase led up to the porch, supported by four white Ionic pillars. The steps were covered with moss and sprouting weeds. Two huge terra-cotta pinecones sat at the top of the staircase. Off to one side, a lone statue of a mar-ble nymph stood on the tiled patio that faced the long, sweeping drive.

The house was locked, and it took some time to get in. I had to find the caretaker, who lived in one of the dozens of outbuildings. He, in turn, had to call one of the trustees, who lived in the village.

It was a warm spring day, yet inside there was a bone-chilling cold, for the house had not been heated all that win-ter. With the windows covered up, it was dark and difficult to make out details. Most of the furnishings had been taken away by family members, and what remained was covered with muslin sheets.

It was a stately home built just after the turn of the century. The rooms on the main floor were simply but grace-fully laid out, interconnected by French doors. Upstairs, the bedrooms were arranged off a long cream-colored hallway, and wood moldings were the only decoration. Peeling paint and dust had gathered in drifts in every corner.

The upstairs rooms were furnished tastefully in the usual manner of the late nineteenth century, with four-poster beds, Oriental rugs, and comfortable, faded, chintz-covered chairs. Regency and English-style fireplaces added warmth to the simple rooms. At the end of the hall, we entered the master bedroom.

So far I had not encountered anything that reflected the true Chanler Chapman, a man who had once been called "the most eccentric man in America" by the press. But there, hanging over the mantel in the master bedroom, was a classical por-trait of a woman. She was beautifully adorned, except for the fact that her eyes had been cut from the canvas with a knife.

"What happened to the portrait?" I asked.

My guide looked at the painting dully and stated, "Mr. Chanler Chapman was a most unusual man. That was prob-ably one of his ex-wives."

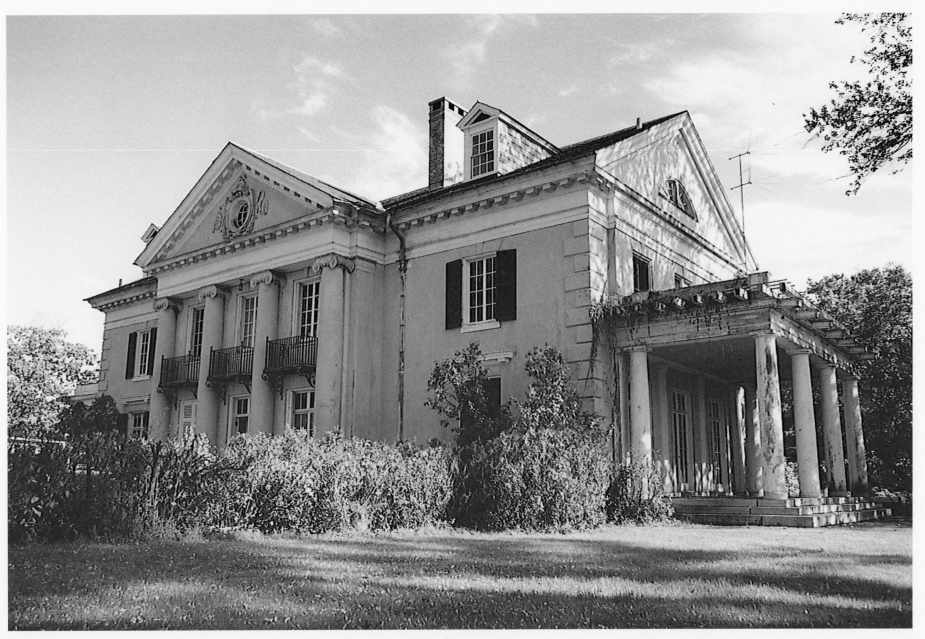

The front view.

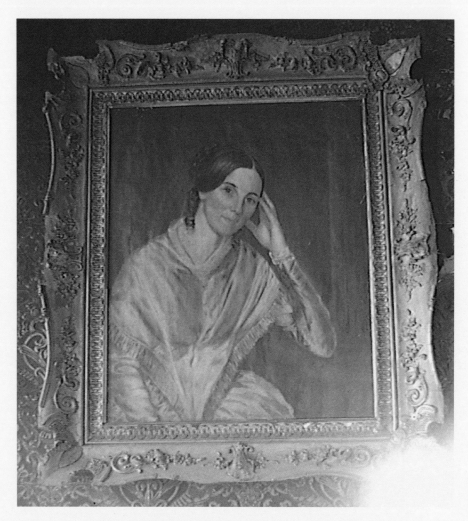

An unidentified portrait hangs on the faded wall.

I stared up at the portrait, half-expecting a pair of taunting fingers to wiggle out of the empty sockets. But everything in the room remained deathly still.

Not having had the opportunity to meet Chapman firsthand, I had to rely on press clippings and statements from people who knew him. The word "eccentric" was something of an understatement; he was regarded by many of the locals as dangerous and had on several occasions fired shots at poachers on his property. Chanler Chapman was a tall man with intense brown eyes, which gleamed and glittered when he was about to shock someone. He had hair like that of a wire-haired terrier, and he drove a pickup truck around town, randomly stopping to fire his slingshot at anything and everything.

Chapman, a former writer for the *New York Times*, was once described by a coworker as being "brilliantly daft." Longing to express himself uncensored, he quit the *Times*. He returned to his hometown and founded *The Barrytown Explorer*, a monthly newspaper that sold for twenty-five cents. His slogan, printed in large letters, read, "When you can't smile, quit." His logo was an American eagle flying upside down. The paper was filled with his observations, his philosophies, and whatever else tickled his fancy. When publishing his poems, the paper always gave the date, time, and place they had been composed. For example: "The outhouse in back of the cow barn, July 14, 6pm," or "The corn crib while surrounded by the pigs and chickens, Aug. 4, 3pm." Chapman also ran an advice column, in which he suggested his readers do things like "Close the blinds at night and lower the chances of being shot to death in bed."

Chapman also worked for a local radio station, where he told the news, gave advice and interviews, and advertised the local dairy company that sponsored the show. Chapman's show was a hit, for people in the area were unused to such outrageous comments. But despite his popularity, Chapman was thrown off the air when he suggested that the dairymen who worked for the sponsor were delivering more than just milk to frisky housewives.

One summer, Saul Bellow rented a cottage at Sylvania, and Chapman became the inspiration for Bellow's novel *Henderson the Rain King*. Like Chapman, Henderson goes around taking potshots at his neighbors with a slingshot.

Chanler Chapman did not come upon his eccentricities by accident. His father, John Jay Chapman, was a well-known essayist, lawyer, and literary critic. A man of high moral convictions, he carried them to hideous extremes. While attending Harvard, John Jay Chapman had assaulted a fellow student who he believed had insulted his betrothed. When he learned he had made a mistake, he held his own left hand over a burning stove until it was charred to the bone. The hand had to be amputated.

Chapman married the woman for whom he had lost his hand; Elizabeth Chanler, the great-grandchild of John Jacob Astor. As one of the eleven Astor descendants, she came into a huge fortune. She was also captivatingly beautiful, a quality captured in a famous portrait done for her by John Singer Sargent.

On the night Chanler was born (April 27, 1901), his emotionally unstable father was so afraid his wife would die in the difficult birth that he attempted to jump from the fifth-floor balcony of the Rokeby tower. A servant saw what he was about to do and managed to stop him in time. Elizabeth did not die, but the rebellious child nearly pushed both his parents over the edge. Chanler was prone to tantrums. At Rokeby, he would stomp on his aunt Margaret's flower beds and spill wine on the carpets. Chanler claimed he did these things out of frustration, and that all he ever wanted to do was play the organ in a quiet church one day. He was denied this wish, and was instead forced to play the violin, which he hated. Finally, in an explosive tantrum, young Chanler smashed the offending instrument against a marble bust, yelling "What a lot of mush!" Later, Chanler took to firing guns during outbursts. At one point, he had over 115 guns in his collection. He was known to use them often, blasting at any sound he heard on his property.

Chanler had also mastered some unusual skills from a passing circus entertainer. While attending Harvard, Chanler was known to fill his mouth with kerosene and spit fire across the room of his dorm, often blackening the walls. His bizarre antics nearly got him thrown out of school on many occasions, but he was very popular among his classmates.

When the war broke out, Chanler worked alongside his neighbor, Franklin Roosevelt, and then went to work as an ambulance driver in the American Field Service. Afterward, he boarded a freighter headed for Egypt. He never got there, for his ship was torpedoed off Trinidad and sank in seven minutes. Chapman and a handful of survivors spent a week in a life raft with no food or water. They were finally rescued by a passing ship off Georgetown in British Guiana.

After the war, Chanler returned to Sylvania and devoted himself to a life of farming, but things were far from peaceful. Feuds raged between the homesteads of the Chapmans and the Aldrichs. According to one account, when Chanler was angry with his cousins, he would drive over to Rokeby and dump a truckload of cow manure in front of the entrance. He usually did this just before a black-tie dinner. Guests were forced to leave their cars on the main road and walk the half-mile drive up to the main house.

Chapman actually married three times, his first wife was a practicing Druid. His second wife helped him start *The Barrytown Explorer*, but they fought constantly and nearly killed one another on several occasions. His third wife was a psychiatrist.

When Chapman's cousin Winty (who lived at Rokeby) heard of the marriage, he commented, "It's convenient for Chanler to have his own psychiatrist in the house."

"Winty has the personality of an unsuccessful undertaker, and he knits with his toes," Chanler retorted.

In his later years, Chanler took to giving guided tours of his ancestral home. One state landmark official recalls Chanler opening the front door and conducting a tour in his BVDs. Chanler seemed to take delight in shocking his guests as he rambled on, sharing stories and relating the house's history.

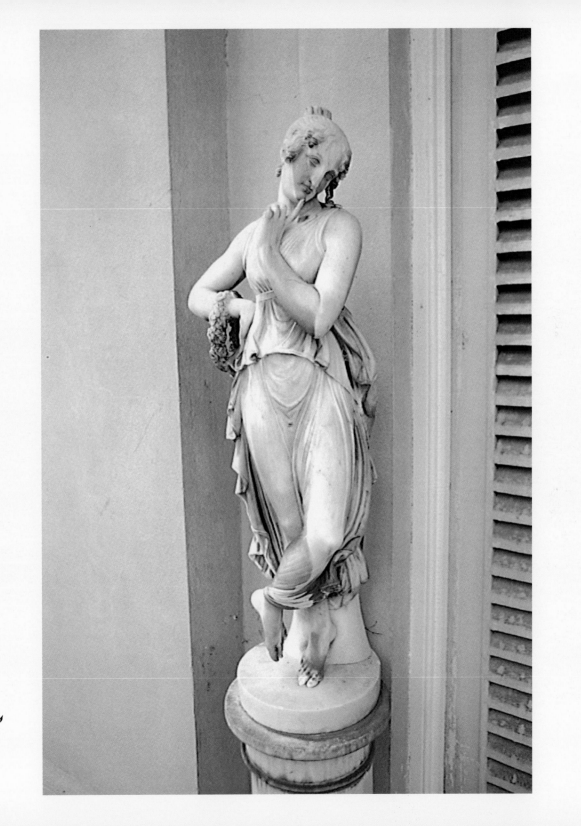

*A marble statue guards
the rear entrance.*

183

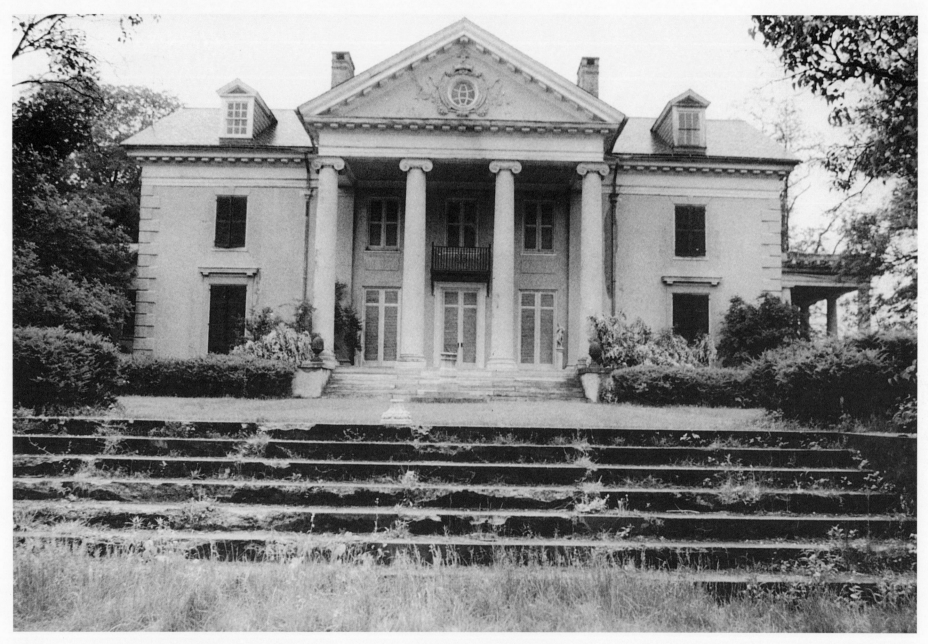

The river view of Sylvania.

After Chanler Chapman died, in March of 1982, the house was closed up for some time. By then, many of the stables and barn complexes had fallen into ruin. In the last issue of *The Barrytown Explorer*, dated January 1982, Chanler wrote of his childhood memories for the last time.

Sylvania, the house my parents built, overlooking the Hudson River was new to me and to everybody else when a box was sealed in a brick footing below the kitchen back door in the spring of 1905. We enjoyed laughing at the seriousness of the occasion. . . .The house was unbelievably new in flashing white stucco. It was unfurnished inside and filled with danger for a small boy. Outside the same newness shocked you wherever you looked. Shrubs were new and spindly, the lawns still raw under their first seed. Only the trees were at home. They did not have to be planted. They stood where they grew, tall feathery white pines to the west, below the formal gardens. Below the pines, straight on to the west was a small natural glimpse of the river. To the north and south the pines were topped to give a view of the blue Catskills, blue in the satisfying distance. From the beginning, Sylvania struck me as a chaste enclosure. The scale was large, a baby palace set in a pasture high above the river. The shock of beauty seemed clothed in modesty, secure, premeditated, unlikely to be disturbed. The great tonic note was the front drive. This was spectacular, level straight as a die for the last furlong between alternate pairs of elms and pines like alternate sentinels three hundred feet apart until the sixteenth pole was passed and you dipped slightly down on the dwelling, sprang into the front door. If the door happened to be open and both drawing room doors also unclosed, you saw that surprising patch of river, the dominant factor in our valley. Down there unseen by Sylvania was Edgewater next to the tracks where trains roared and the Donaldsons lived before my mother was born. It was the Donaldsons who laid out Sylvania's smashing front drive, selected the spot which Charles A. Platt knit into the place that I called home.

MONTGOMERY PLACE

Many mansions on the Hudson pale beside the stately beauty of Montgomery Place. Janet Livingston Montgomery built the house in 1804 on land purchased from a Dutch farmer, John Van Benthuysen. The existing farmhouse was demolished to make way for the Montgomery home.

General Richard Montgomery was very much in love with Janet. They had spent an idyllic two years together in a house in Rhinebeck before he was sent to Canada during the Revolution. On December 31, 1775, the young general was killed in an attack on Quebec. His young widow was devastated by the loss; she never fully recovered, and wore black for the next twenty-five years.

On July 6, 1818, Janet Montgomery relived her trauma. Montgomery's body had finally been removed from its temporary grave in Quebec and was brought down the Hudson in a steamboat procession. There was a special tribute on the shore of Montgomery Place. As the procession passed on its way to New York, the graying widow stood solemnly watching the spectacle, until, overcome by emotion, she collapsed in a dead faint.

After Janet Montgomery died, in 1828, the property was taken over by Edward Livingston. He was Janet's older brother, the mayor of New York City and secretary of State under president Andrew Jackson. Between 1840 and 1860, the Livingstons, along with their only daughter, Coralie Livingston Barton, substantially renovated the house with the aid of architect Alexander Jackson Davis.

The house was designed in a delightful and fanciful style, reminiscent of the plantation houses in the South. The house was enhanced by its wonderful setting; its vast, rolling lawns and gardens were created by landscape designer A. J. Downing. The manor house stands in a tranquil park, a huge wedding cake with an icing of classical decorations. The entrance circle is supported by gleaming white Corinthian pillars, with an Italianate balustrade along the upper level.

Outbuildings were added to the property, including a dairy barn, a farmhouse, a coach house, and a spectacular palm conservatory with a Victorian fountain designed by Frederick Catherwood. Inside the all-glass structure, aloe plants were raised, along with a very rare century plant that had been given to Janet Montgomery by her mother. The plant finally bloomed in 1873, the day Coralie Barton died.

Alexander Jackson Davis also designed several guest cottages, including a charming Swiss chalet that still stands

186

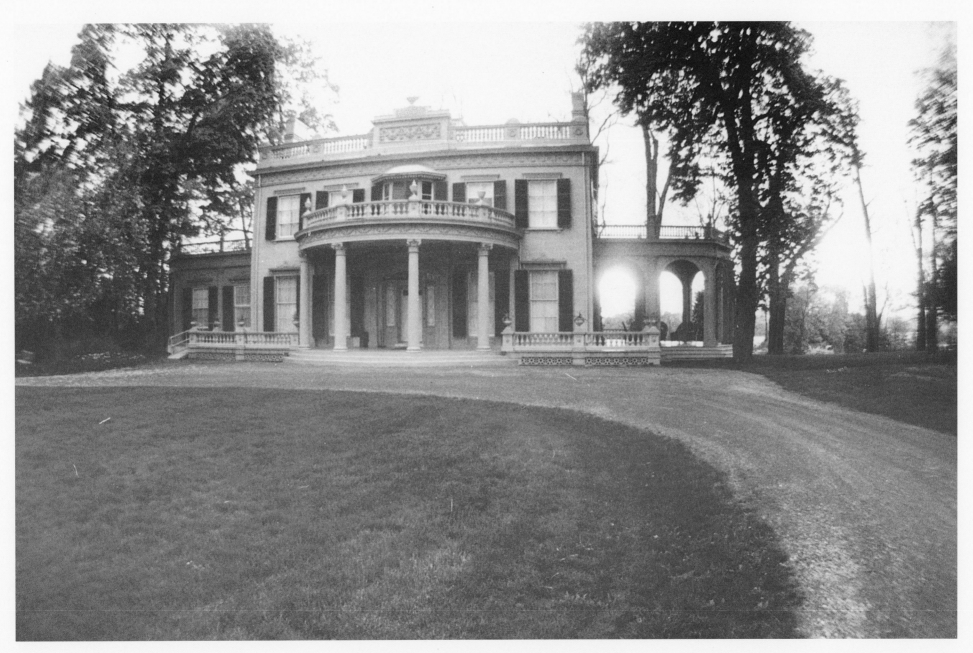

The main entrance recently restored.

Flower pots neatly stored in the potting shed.

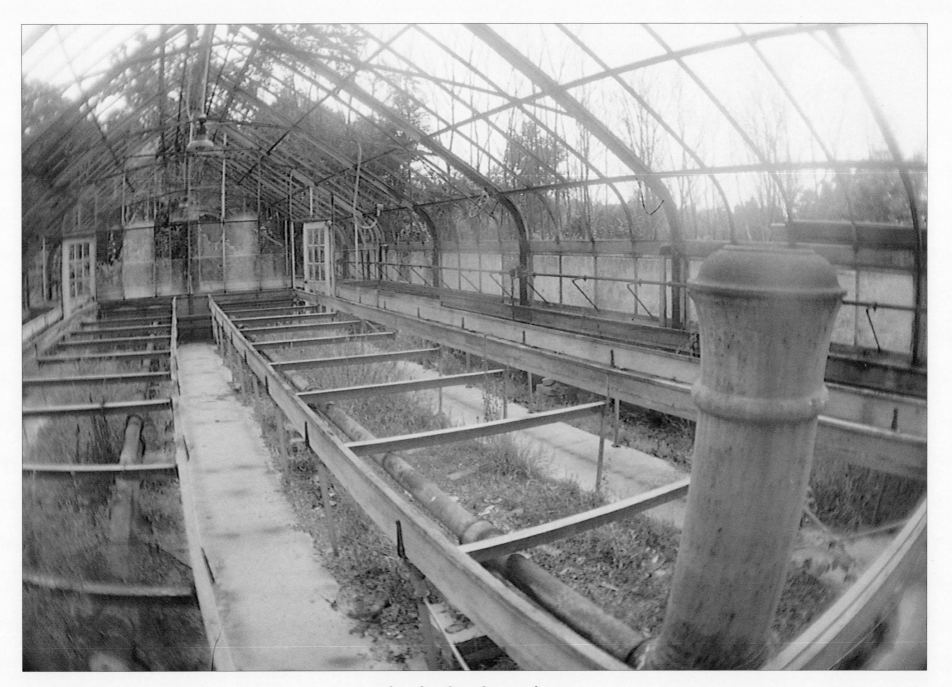

The abandoned greenhouse.

beside Sawkill Creek. A one-story stone house known as Spur Cottage was built alongside one of the dams on the property. Miles of carriage drives, with drystone walls and bridges, were created through the woods and along the sparkling streams that lead to a pair of scenic waterfalls. At one time, a long wooden dock and a fanciful garden stood on the edge of the river. Here, supplies for the main house arrived from the city and were carried to the service entrance by a team of oxen. Locust trees 250 years old and a rare, exotic arboretum can still be found on the 450-acre estate.

To the left of the entrance drive is a solemn reminder of the past. In an open field there is an overgrown cemetery of moss-covered tombstones for the black servants who came from New Orleans to serve the Livingstons. Those who survived had been dismissed from service by their master in 1828 when slavery was outlawed in the North.

Until recently, Montgomery Place was the private residence of Major John White Delafield, a prominent New York attorney. He had inherited the estate in 1964 from his father, General John Ross Delafield, a descendant of Coralie Barton's. With only a small staff, Major Delafield maintained the property as it always had been: a working farm on which ten thousand apple and pear trees were harvested every year. Like his father before him, Delafield had a love for art, history, and the classics, and he was deeply committed to keeping traditions alive.

It was early spring when I visited Montgomery Place. A collection of heirloom Easter eggs was arranged carefully in a bed of plantation moss on a round table in the entrance hall.

"The paint is peeling off the outside walls as we speak," Delafield said glumly.

Inside, however, everything seemed to be in perfect order. As with many estates in the area, nothing has changed since the house was built. The rooms are well designed and comfortably furnished, with exquisite Victorian furniture and pieces of fine art. The entrance hall is classical, with a high molded plaster ceilings and a graceful ormolu chandelier.

Mr. Delafield paused before a room in which the walls were covered with blue morning glories; the same design was emulated on the Bohemian-glass chandelier above. One wall of the spacious room was dominated by several fine gilt-framed portraits. John Delafield spoke about his beloved home with incredible clarity, never fumbling for a name or a date.

"That's Mrs. Thomas Pennant Barton, the former Coralie Livingston. She was the third owner of this house. The two portraits on each side of her were painted by Gilbert Stuart. One is of Chancellor Robert R. Livingston, and the other is of his mother, Margaret Beekman. The one down at the end is of the ill-fated General Richard Montgomery. It was sent to his widow from Ireland by one of his cousins."

He moved on to the drawing room, where he proudly pointed out that the antique wallpaper had just been painstakingly restored. It was a pale-green pattern of flowers and stripes. He then turned abruptly and faced the front of the house.

"You probably noticed when you drove up that one of the porch pillars is askew. Back in the forties, when my broth-

er was just learning to drive, he drove a truck up the front steps. Just to get our attention. Then, unable to stop the damned thing, he crashed into one of the pillars. We've been trying to fix it ever since. The bees keep building their nests in the cracks, and the honey drips down the side of the pillar, making a terrible mess."

I followed Mr. Delafield back into the main hall and out onto the porch. I could hear the buzzing of the bees above. He stared out at the endlessly rolling lawns. His pale-gray eyes dimmed behind the lenses of his spectacles as he noted the crumbling stonework.

"My late wife loved this place. She designed the rose and herb gardens down by the new greenhouse. It was her idea to put in the wrought-iron gate at the garden's entrance. It adds a lot of charm to the area.

"We put in a tennis court; that's now overgrown. The net has rotted and only the posts remain. Everything else is covered in vines. My father built the dam that's down there at the bottom of the hill.

"The old Catherwood conservatory was lost when a forest fire swept through the property in the twenties. We were very lucky it didn't reach the house," he concluded, turning back into the hall. He looked up at the damaged pillar one last time, shaking his head in quiet resignation.

John White Delafield passed away a short time later, on May 4, 1985. He was masterfully precise and had a vivid memory. He took with him the estate's legends, heartbreaks, and poetic secrets.

Montgomery Place stands unchanged and forever enchanting. Its great pine forests mourn the passage of time, and in the forgotten graveyard, where the spirits of dead slaves linger, a lone daffodil grows. The house and grounds are now owned by Historic Hudson Valley. Over the past eight years, the house has been painstakingly restored. The building, with all its original furnishings, is open to the public from April through October.

BLITHWOOD

Standing proudly on the east bank of the river in Annandale-on-Hudson is the two-hundred-foot-long wedding cake of a palace built by Captain Andrew C. Zabriskie. Created from plans drawn up by Francis Hoppin around the turn of the century, Blithwood is built of brick and faced with white stucco. It features soaring Ionic columns, and decorative scrollwork adorns the doors and windows. When viewed from its vast, rolling lawns, Blithwood resembles the palace featured in the television version of Evelyn Waugh's *Brideshead Revisited.*

Zabriskie was a cattle breeder, a noted bibliophile, an art collector, and a National Guardsman. His first wife considered herself a Druid by religion, which made for an odd mix. But Blithwood parties were legendary and often recorded in the press. With a direct view of Cruger's spectacular island, many of their regattas and dinner parties included a tour of the ancient ruins. Musicals and theatrical performances were staged on the lawns and in the garden. A rare gilt harp imported from England was often played under the wisteria-bowered pavilion.

Andrew Jackson Downing is credited with the landscape design and with the magnificent formal English garden with its brick walls, terra-cotta balustrades, wooden-pillared pergola, and fountain. Though many of Downing's designs survived, some of the original details of the landscape have been lost. There were portal gates along the garden walls, and a sundial graced the entrance to the pavilion. The reflecting pool once featured a marble nymph, which splashed amid the jet sprays and was surrounded by colorful periwinkles, deep-blue delphiniums, coral bells, phlox, and exotic irises. Herds of Shropshire sheep and imported Ayrshire cows used to graze in the sylvan parks and meadows. In all, the estate consisted of almost 825 acres, which included long avenues of lofty pines, locust trees, a greenhouse, and an American Gothic gate cottage designed by Andrew Jackson Downing.

A stream that once ran along the property led to a forty-foot waterfall. A long series of marble stairs extended from the main portico and led to the garden. Unlike most of the river houses, Blithwood had a long façade that faced south to take advantage of the southerly winds that came off the river in summer and the sunlight that flooded the front of the house in winter.

Inside the house, a black-and-white marble floor extends forty-five feet to the rear veranda, setting off a graceful staircase. Three Palladian arched windows flood the second-floor landing with light, and here and there a gilt-framed por-

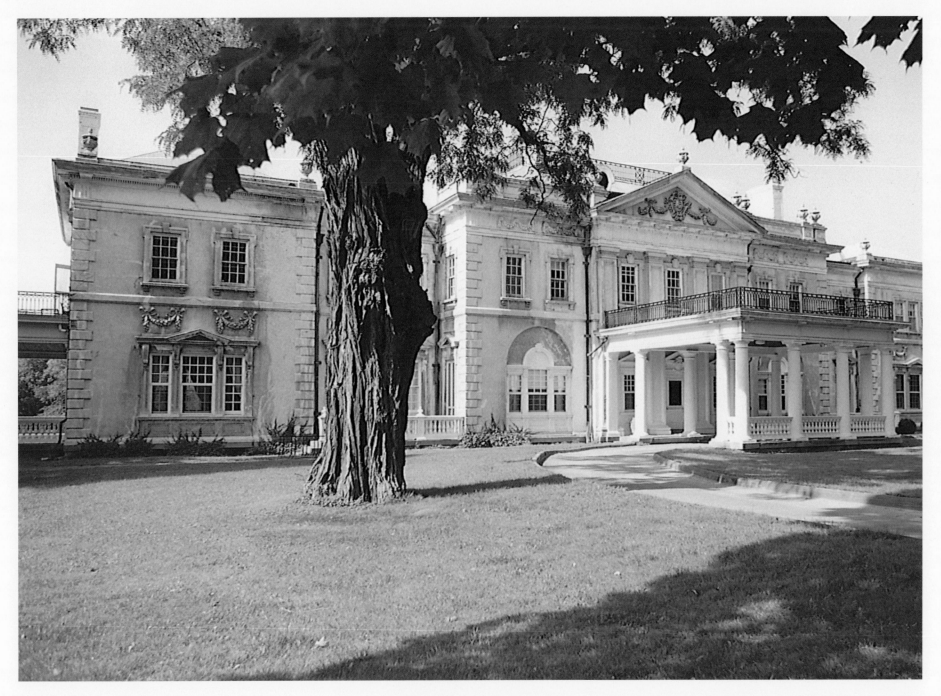

The main entrance.

Second floor verandah.

A marble nymph overlooks the garden.

trait hangs. When the house was first built, the rooms were decorated in the traditional Georgian style, with richly carved designs along the moldings and fireplaces. Today, many of those fine details are buried under layers of paint.

In 1951, Captain Zabriskie's son Christian donated the estate and outbuildings to Bard College. The rooms remain intact, but they are filled with file cabinets, neon lights, offices, and student dorms. The gardens are maintained by student volunteers. Cruger's famous island is at the base of the property, on the water's edge, but it can no longer be reached. Quicksand and marshes make walking there hazardous, if not impossible.

CRUGER ISLAND

In 1840, John Church Cruger, a New Yorker distinguished for his civil service, hired explorer John Lloyd Stephens to acquire and ship an ancient Mayan village from the Yucatán to his small island fantasy on the Hudson. Consequently, the Hudson river obtained ruins that were older than any along the Thames or the Rhine. Located in Barrytown, about thirty miles north of Bannerman's Island, Cruger's whim is an island of antiquity. Cruger himself designed extensive gardens, pathways, waterfalls, artificial caverns, and stone arches.

Though owning an entire ancient village seems almost unthinkable today, in Cruger's day it was all the rage. It is said that the trend was inspired by Europeans traveling in the United States, who remarked that our young country lacked the charm of having ruins. Ruins were often designed like stage sets, with Roman façades and marble pillars carefully arranged at odd angles to create the haphazard effect of a natural disaster. Stone pavilions and classical follies were left half-built, and vines were allowed to engulf them. Theatrical lighting and flaming torches were used to dazzle guests at gala evening events. The Clews family, who had an estate at nearby Hyde Park, imported fragments of Italian ruins, coral grottoes, and crumbling balustrades and bridges to display amid the wild growth of their unusual gardens. Franklin Roosevelt once remarked how much he had enjoyed playing among them when he was a boy.

At nearby Blithwood, the estate that borders Cruger Island on the mainland, guests would row their lantern-festooned boats around Cruger's ruins and gaze in wonder at the spectacle. The island was lit by Bengal flares and fireworks, reminiscent of Versailles during the reign of Louis XIV.

One of the best-recorded galas took place near the island in 1906. The party was hosted by Captain Zabriskie, who built Blithwood. On a moonlit night, while music from an orchestra floated across the vast lawn, twenty costumed guests boarded a red-and-gold Leviathan gondola. A silk chiffon tent formed an arch over a huge dining table surrounded by gold ballroom chairs. Fresh red roses and vines cascaded along the arch, while a dinner of pheasant and champagne was served from a nearby boat by servants in livery. Japanese lanterns strung from the masts cast a cheerful glow upon the tranquil waters.

Today, after seventy years of neglect, the island ruins are barely discernible. Most of the stone arches have crumbled into heaps by the water's edge. The grottoes and pathways are all but drowned in a sea of vines and foliage.

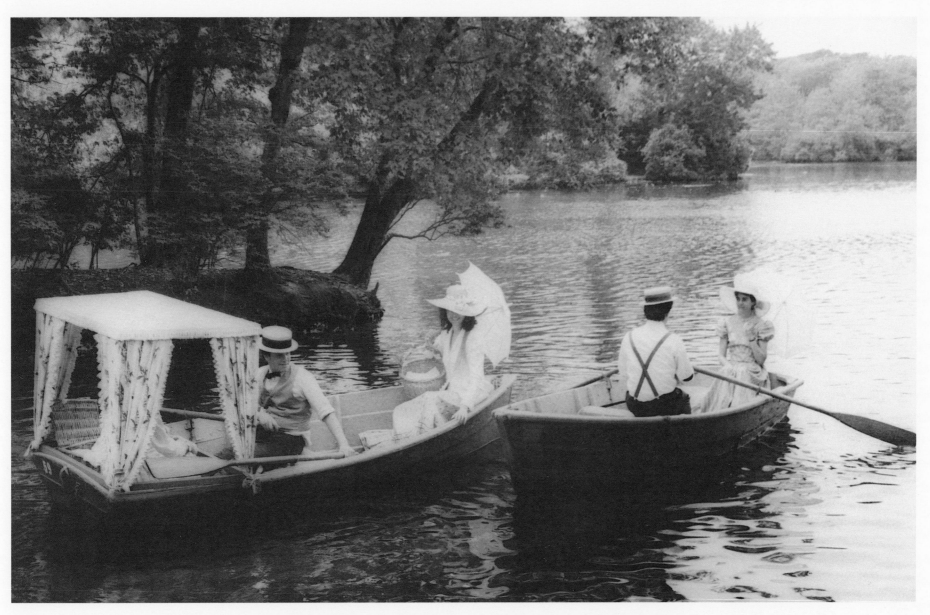

On moonlit nights guests rode around Cruger Island to view a spectacle of ancient ruins lit by Bengal torches.

EPILOGUE

About the Ghosts

The idea to recreate some of the ghosts that are said to haunt many of the old river estates came to me after discovering the trunks full of old gowns at Beechwood. It is documented that on very rare occasions ghosts do appear on film. But experts claim that the chances of this happening are one in a million. So using an old Rolli-Flex camera with an automatic timer and that priceless collection of vintage gowns, I set about to bring the unearthly spirits to life, playing the role of the phantoms myself. From that experience I came to believe that there is an etheric field of energy that lingers in the tiny crystalline fibers of the old clothes. This energy pulsates and can be sensed by touch, very much in the same way that a psychometrist can sense information about a person while holding a well-worn piece of his or her jewelry. Psychic researchers have for centuries referred to a resonance or living vibration that permeates certain inanimate objects and perhaps all things, including houses that have been touched by people over long periods of time. Although the concept remains an enigma and seems to evade scientific explanation, as an artist I have attempted to reflect that possibility poetically.

Anyone wishing to share their own experience can write to me at: P.O. Box 75 Oyster Bay, New York 11771

CREDITS & ESTATE INFORMATION

The Octagon House

Joseph Pell Lombardi, architect, Liberty Tower, NY 10006

"Octagon House to be Restored" by Marge Leahy, March 5, 1979, *Gannett Westchester Newspapers*

"Restoring a Victorian Whimsy" by Michael DeCourcy Hinds, *New York Times*, July 16, 1981

The Gardens of Greystone

Hudson River Villas, by Robert Stimpson, Rizzoli International, 1986

Estherwood

The Masters School, Jensina Olson Feldstein, Director, and James Finger

My Kind of Country by Carl Carmer, David McKay Publishers, 1966

J.J. McInerney, *Suburban News*, November 28, 1970

Beth Weiner & Ann Kolozsvary, *The Tower* (Dobbs Ferry), February, 1983

Villa Lewaro

Madame C. J. Walker, Entrepreneur, by A'Lelia Perry Bundles, Chelsea House, 1991

Engo Appel

Warner Castle

Life magazine, September 23, 1946

Warner Memorial Library in Tarrytown

Beechwood

Frank Vanderlip

Christopher Mills

Dudley N. Scoals

Benjamin Cheever, *New York Times*, January 22, 1984

Carrollcliffe

Kenneth Ives & Co., 17 East 42nd Street, New York, NY
Mrs. M. A. Salvador
Axe Houghton Funds
Axe Castle, 400 Benedict Avenue, Tarrytown, NY

Kykuit

Great American Mansions and Their Stories, by Merrill Folsom, Hastings House, 1963
Hudson River: 1850-1918: A Photographic Portrait, by Jeffrey Simpson, Sleepy Hollow Press, 1945

The "Elephant" House

The Clarkstown Country Club
Nyack Public Library
Gloria Mayernick
Nyack Historical Society
Dr. Viola Bernard
Mellany Solomon
Rockland Historical Society
The Fate of the Elephant, by Douglas H. Chadwick, Sierra Club, 1992
To Whom It May Concern, by David Gucwa and James Ehmann, Norton, 1985
The Encyclopedia of Occultism and Parapsychology, edited by Leslie A. Sheppard, Gale Research Publications, 1991
Fads, Follies and Delusions of the American People, by Paul Sann, Bonanza Books, 1967
"The Great Fuss and Fume Over the Omnipotent OOM," by Charles Boswell, *True* magazine, January 1965

The Sheppard Estate

Dale Nelson, Sleepy Hollow Country Club

Lyndhurst

More Great American Mansions and Their Stories, by Merrill Folsom, Hastings House, 1967
Architectural Record, Vol. 38 (1915)
Portrait of a Village: Irvington on the Hudson, by Francis B. Young, 1938, reprinted by Ayer Publishing.
"The Screaming Ghost" by Carl Carmer, published in the collection *Wolforts Roost*. Washington Irving Press, 1959.
Country Life magazine, June 1923
Gary Lawrence, architect
The Lyndhurst staff
National Historic Trust

Dick's Castle

"A Castle on the Hudson" by Charles Grutzner, *New York Times*, October 26, 1958

Castlerock

The Daily News, October 26, 1977
Charles Marks and Douglas Banker

Bannerman's Castle

"An Island in Our Midst," by Mark Miklos, *Hudson River* magazine, December 1982
"Return to Bannerman's," by George McDonald II, *The North South Trader*, Volume IV, March 1977

The Story of Bannerman's Island, by Charles S. Bannerman, privately published 1962. Reprinted July 1973

The Great Gun Merchant, by Joseph E. Persico, Taconic Parks Department, June 21, 1982

"Fire Destroys Castle" *New York Times*, August 9, 1969

Francis Bannerman & Sons sales catalogue

Neil Caplan, The Bannerman Island Educational and Cultural Project

Robert King—vintage photos

Mrs. Jane Bannerman

The Frederick W. Vanderbilt Mansion

The National Park Service, U.S. Department of the Interior

The Vanderbilt Homes, by Robert King, Rizzoli International, 1989

Great American Mansions and Their Stories, by Merrill Folsom, Hastings House, 1963

The Payne-Whitney Estate

"Colonel Payne's West Park Legacy" by Julie O'Corozine, *Ulster* magazine, Fall 1992

The Ogden Mills Mansion

Wallace Workmaster

John Feinny

American Estates and Gardens, 1904

Town & Country magazine, December 14, 1907

The Locusts

Justin Colin

New York Times, March 9, 1993

Architectural Digest, June 1957

Valentine Lawford

Wyndcliff

Charles Eggart

Richard Crowley

World with a View, by Richard Crowley, Yale University Press, 1978.

Elizabeth Vangel, architect and part-owner of Wyndcliff, restores landmark buildings all over the world. She has recently undertaken plans to restore Wyndcliff.

Ferncliff

Munsey's magazine, August 1899

Country Life magazine, 1915, Orin Finkle

Rhinebeck Library

History of Dutchess County, Rhinebeck Library, 1927

Edgewater

Richard Jenrette

Mr. Justin Calui

William Nathaniel Banks, *Antiques* magazine, June 1982

Wilderstein

"Architectural 'Gem' on Hudson Secured" by Harold Faber, *New York Times*, May 5, 1980

"In F.D.R. Country 'Cousin Daisy' Helps Keep the Past Alive" by James M. Perry, *The Wall Street Journal*, November 16, 1989

Rokeby and Sylvania

Robert H. Boyle, *Sports Illustrated*, June 13, 1977
Ricky Aldrich
Mrs. Ulrick, trustee for the Chapman estate
Commodore John Hicks
New York Times, November 16, 1981
Christopher Norwood, *New York* magazine, November 16, 1981
Pride of Lions, by Lately Thomas, William Morrow & Co., 1971
Charlotte Thompson

Montgomery Place

John White Delafield
Country Life magazine, 1939
Hudson River Heritage

Blithwood

"A Seasoned Order" by Douglas LaFrenier, *Garden Design*,
 Winter, 1986

ESTATE INFORMATION

Some of the glorious estates of the Hudson Valley have been restored and are now museums. The following is a list of estates that are open to the public.

The Ogden Mills Mansion
Old Post Road (off Route 9)
Staatsburg, NY
Phone: (914) 889-4100

Lyndhurst
Route 9
Tarrytown, NY
Phone: (914) 631-4481

The Vanderbilt Mansion National Historic Site
Route 9
Hyde Park, NY
Phone: (914) 229-9115

Wilderstein
Morton Rd. (off Route 9)
Rhinebeck, NY
Phone: (914) 876-4818

Montgomery Place
River Road (off Route 9)
Red Hook, NY
Phone: (914) 758-5461

INDEX